10/03

10/03

The ALLIGATOR Book

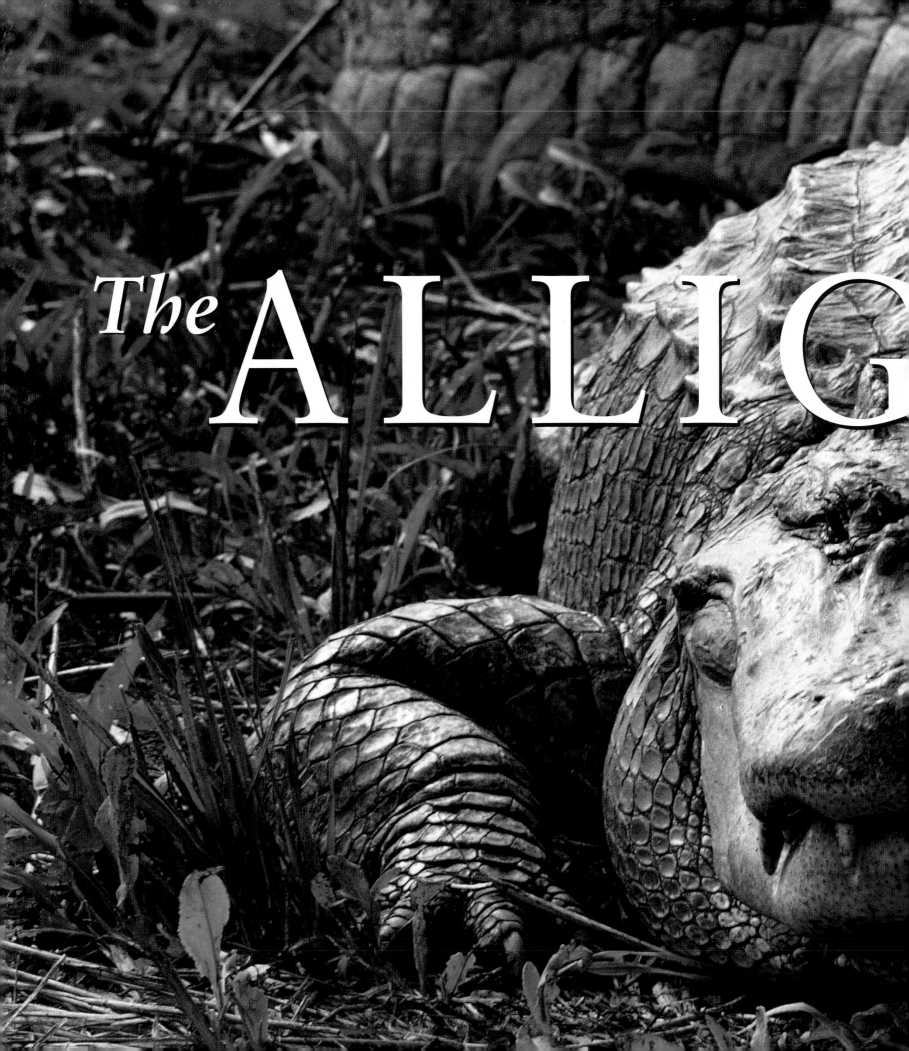

The ALLIG

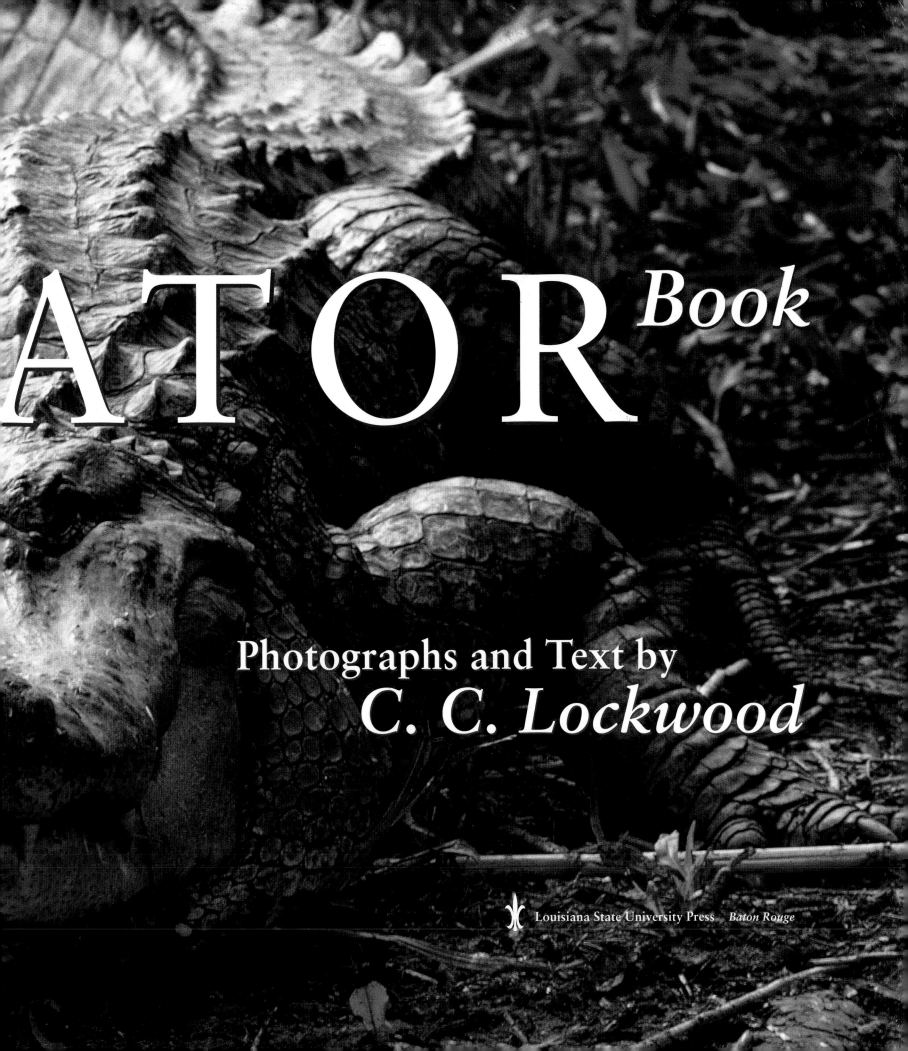

ATOR *Book*

Photographs and Text by
C. C. Lockwood

Louisiana State University Press *Baton Rouge*

Also by C. C. Lockwood

Atchafalaya: America's Largest River Basin Swamp

Gulf Coast: Where Land Meets Sea

Discovering Louisiana

The Yucatán Peninsula

C. C. Lockwood's Louisiana Nature Guide

*Beneath the Rim: A Photographic Journey Through the
Grand Canyon*

Around the Bend: A Mississippi River Adventure

Still Waters: Images 1971–1999

Copyright © 2002 by C. C. Lockwood
All rights reserved
Manufactured in Hong Kong

11 10 09 08 07 06 05 04 03 02

5 4 3 2

Designer: Amanda McDonald Scallan
Typeface: Sabon
Printer and binder: Dai Nippon Printing, Inc.

ISBN 0-8071-2828-7 (cloth)

The paper in this book meets the guidelines for permanence and durability of the Committee on Production Guidelines for Book Longevity of the Council on Library Resources. ∞

To my Granddad, Clyde Crafts, whose tales

of pulling alligators out of holes in the

Georgia swamps intrigued me

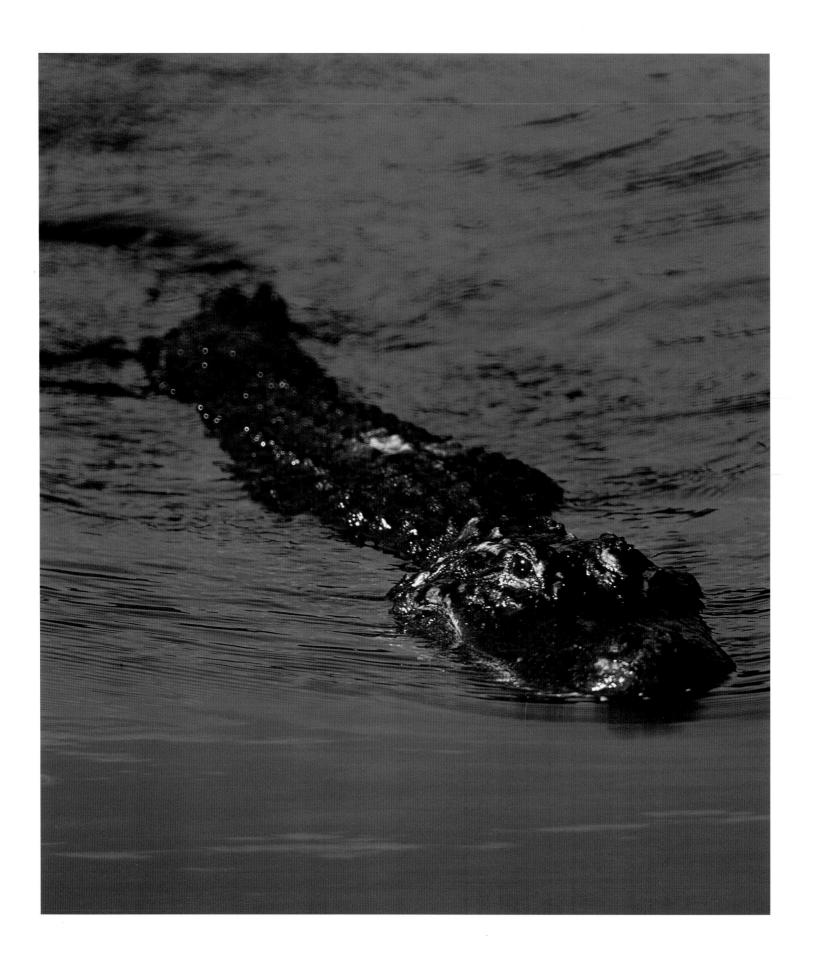

Contents

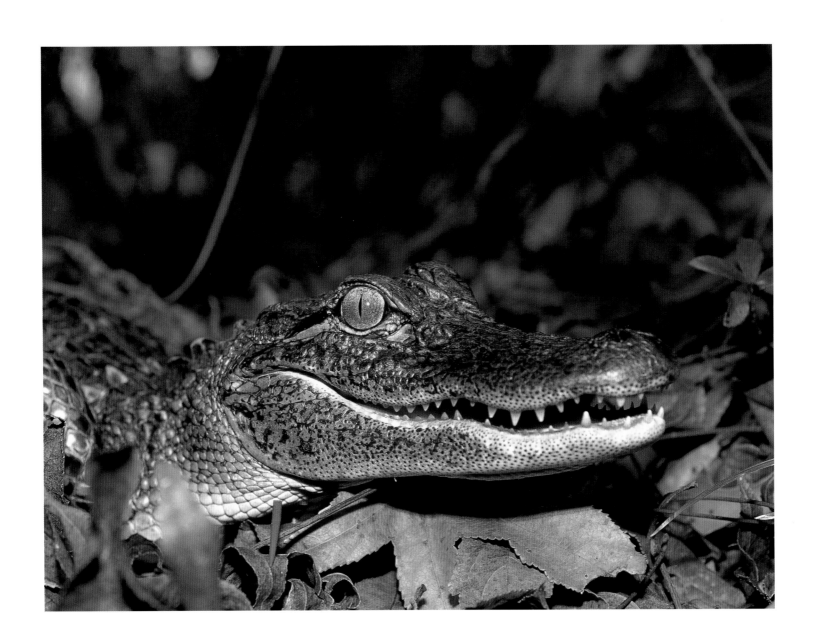

Acknowledgments

THANKS to you, Louisiana, for having alligators in the backyard. I know not everyone has one resting by the barbecue pit, but some of us do, whether we like it or not. In my first dealings with picture editors in New York City, I learned they thought we Louisianians really lived in the back woods. When one called to get a photo of something, I would turn on the Cajun swamper charm that would entice them to keep calling back. Though my house was not on stilts, I did live in a houseboat for a while. I did nothing to dispel the myths: crawfish for every meal with a boudin chaser, pirates and alligators in the backyard, and visitors that paddled in by pirogue. So I must thank all the alligators for keeping me in business and giving me the opportunity to do this project. The next thanks to my family—Sue, Lee, and Adam—for putting up with the travel, the deadline stress, and the endless array of skins, teeth, eggs, hatchlings, books, souvenirs, notes, tapes, and other piles of junk that cluttered our house for six months.

Dr. Ruth Elsey, Noel Kinler, and the rest of the biologists, technicians, and staff of Rockefeller Refuge and the Louisiana Department of Wildlife and Fisheries were extra special help with the photographs, the text, and the adventure of this project. Ted Joanen, Allan Ensminger, and Larry Mc-Nease have been helpful to me on projects since 1972. Others at Rockefeller who deserve credit are Tom Hess, Bill Hughes, Vida Landry, Jeb Linscombe, Dwayne LeJeune, Karen McCall, Joseph Mc-Gowan, George Melancon, Megan E. Pearson, Darren Richard, Eric A. Richard, Phillip "Scooter" Trosclair III. Allan "Woody" Woodward of the Florida Fish and Wildlife Conservation Commission also helped with many of my Florida photos and the related text.

Many others helped by giving me information, letting me on their property, taking me on boat rides, carrying tripods, and doing myriad other labors. I truly hope I leave no one out, but that'll probably be the case as I have met so many wonderful people on this project. My thanks to you too.

Thank you Manuel Acosta, Tina Adathakkar, Don and Pam Ashley, Rick Atkinson, Dennis Bearden, Leslie Anne Benton, Bobby Boudreaux, Richard Bouregeois, Todd Braden, Chris Brochu, Carl Brossard, John Brueggen, George Burgess, Lance Campbell, Tom Cattell, Joe Clements, Richard Cole, Sandy Cook, Amos Cooper, Leon Corbett, Dr. Paul Coreil, Kermit Coulon, Reed Crappell, Jim Darlington, Dan Davis, Fred Dijulio, Tena Dudley, Mike Duran, Frank Ellender, Ted and Erole Falgout, fourth grade class of St. James Episcopal Day School, Bob Freer, Kermit George, Dave Hall, Bob Hallett, James Hartobey, Julian Hilliard, Jay Humphries, Kelley Irwin, Richie Kay, Dr. F. Wayne King, David Kledzik, Harvy Kliebert, Merval and Grant Landry, Remy Lazare, Greg Linscombe, Eva Mathews, Michelle McInnis, Annie and Eddie Miller, Jimmy Miller, Bruce Mitchell, Abby Montpelier, John Moran, Bruce Morgan, April Moriarty, Peggy Ordoyne, Ron Paille, Betty Provost, Thomas Rexroad, Walt Rhodes, Terry and Deborah Rogers, Jimbo Roland, James Perran Ross, Jack Rudloe, Wayne Sagrera, Bruce Scharwath, Frank Seebacher, Charlie Simpson, Hazel Sinclair, April Sollars, Wayne Stevens, Steve Stiegler, Rufus Stratton, James Taylor, Mike Taylor, Kristy Thibodeaux, Dr. Robert Thomas, Shelly Triplett, Chris Turbish, John K. Turner, Ellen Valenti, Wendy Venable, Dr. Kent A. Vliet, Coerte Voorhes, Mary Wall, Joe Wasilewski, Al Wehmeier, Ron Whitaker, John Wiebe, Phil Wilkinson, Scott Williams, Tim Williams, Dr. Robert Woods, Isaak Wyatt and Paul Yakupzack.

The institutions and attractions that helped are The Atchafalaya Experience; Audubon Zoological Garden; Bayou Pierre Gator Park; BREC's Baton Rouge Zoo; Burlington Resources; Cajun Houseboats; Crocodile Specialist Group; Everglades Outpost; Flamingo Lodge; Florida State Parks; Four Points Sheraton; Gator Ventures; Gatorland; Gatorama; International Shark Attack Files; Jungle Adventures; Kissimmee–St. Cloud Convention and Visitors Bureau; Kliebert's Alligator Farm; Louisiana Office of Tourism; Louisiana State Parks; Pelts & Skins, L.L.C.; Southwest Louisiana Convention and Visitors Bureau; St. Augustine Alligator Farm; St. Augustine Convention and Visitors Bureau; and Wildlife Gardens.

And last but not the least, thanks to the fine folks at LSU Press who are responsible for getting this project completed: Les Phillabaum, Maureen Hewitt, Rebekah Brown, Margaret Hart, and especially the creative force—my editor, Nicola Mason, and designer Amanda McDonald Scallan.

Introduction

IT'S funny how in life you get involved in certain projects. I've always liked alligators, but at one time I never would have imagined doing a book on a single species. Alligators—with their link to dinosaurs 230 million years ago—lazily lying in the sun, swimming through slimy swamp water with s-shaped strokes of their powerful tails, nesting and practicing parental care much as birds do, yet scary with seventy-eight or more sharp teeth and beautiful with their scaly skin and golden eyes. . . . My first sighting was in the Okefenokee Swamp of Georgia when I was three years old on a family vacation. Six years later, my brother got a pet alligator that was the hit of the household. I finally photographed my first one in the spring of 1972 at Aransas National Wildlife Refuge near Rockport, Texas. Marty Stouffer and I looked for the reptile later that year in the Everglades, working on a film about endangered species, but brown pelicans, Key deer, Everglades kites, and ospreys were also our prey.

Back in Louisiana, during the first alligator season in September 1972, Garland Richard, a true Cajun, took me along as he caught, tagged, and skinned alligators. He was living off the land, hunting, fishing, and trapping in what was as close to an old style of life as was possible. I met Ted Joanan and later Larry McNease, whose hard work would later lead to rebuilding the alligator population, giving it some value and thereby helping to preserve the coastal marsh for all species of wildlife. Then came my eight years in the Atchafalaya Basin, where I looked for, stepped on, swam with, and learned more about this swamp dragon. All this time I loved seeing alligators and occasionally needed a picture or two of the reptiles for a book, slide show, or magazine article, but to devote a whole book to these strange, compelling creatures? The thought never occurred to me.

Finally, it was a mouse that set me on the route to this monograph, not a house mouse, cotton

mouse, or jumping mouse, but a computer mouse—along with a keyboard, Pentium chip, monitor, hard drive, an Internet connection, and a web page. I was in Napa Valley, California, following one of my other passions—tasting red wine—when I visited a photographer buddy, Charles O'Rear. We were having a nice visit, chatting about various things, and technology came up as both a friend and a foe in our business. I was set in my ways, and faxes, FedEx, computers, and other digital things were hard for me to handle. Sitting in his office, we both knew we had to have a web-page presence. I was developing my page and needed a hook to stand out among millions and millions of other pages.

Chuck popped his home page up on the screen. He had set up a camera to show the scene outside his office window: a large outdoor thermometer with big numbers, and right behind it grape vines and the Napa mountains. So whenever a tourist to Napa Valley wanted to know what to pack, Chuck provided the temperature with a real-time scene in the background. Right beside this image were examples of Chuck's books.

I said, "Chuck, I need something like this for my web page. How about a swamp-cam? No, no, gator-cam would be better." As soon as I got home I started working on my web page. Then a few other projects I was working on fell through. I wondered, What am I going to do now? Well, I like wildlife, water, swamps, and the marsh. Alligators fit into all of those categories. Bingo! The American alligator, feared by some, but interesting to most. Could it be a whole book? I was worried at first. The more I researched and photographed, the more I learned, and the subject expanded, bringing in more, and more, and more stuff. In the end it was hard to stop; I became infatuated with these creatures—real citizens of our wetlands; probably a good signal, like the canary in the coal mine, of the health of the environment for us all. And when I get too close and a big twelve-footer lunges at me, wow! What a rush. Alligators will keep me young.

Alligators swim using their tails, which move in s-like undulations *(above)*.

Rows of bony scutes form parallel ridges down the back of a large American alligator at Ding Darling National Wildlife Refuge, Florida *(overleaf)*.

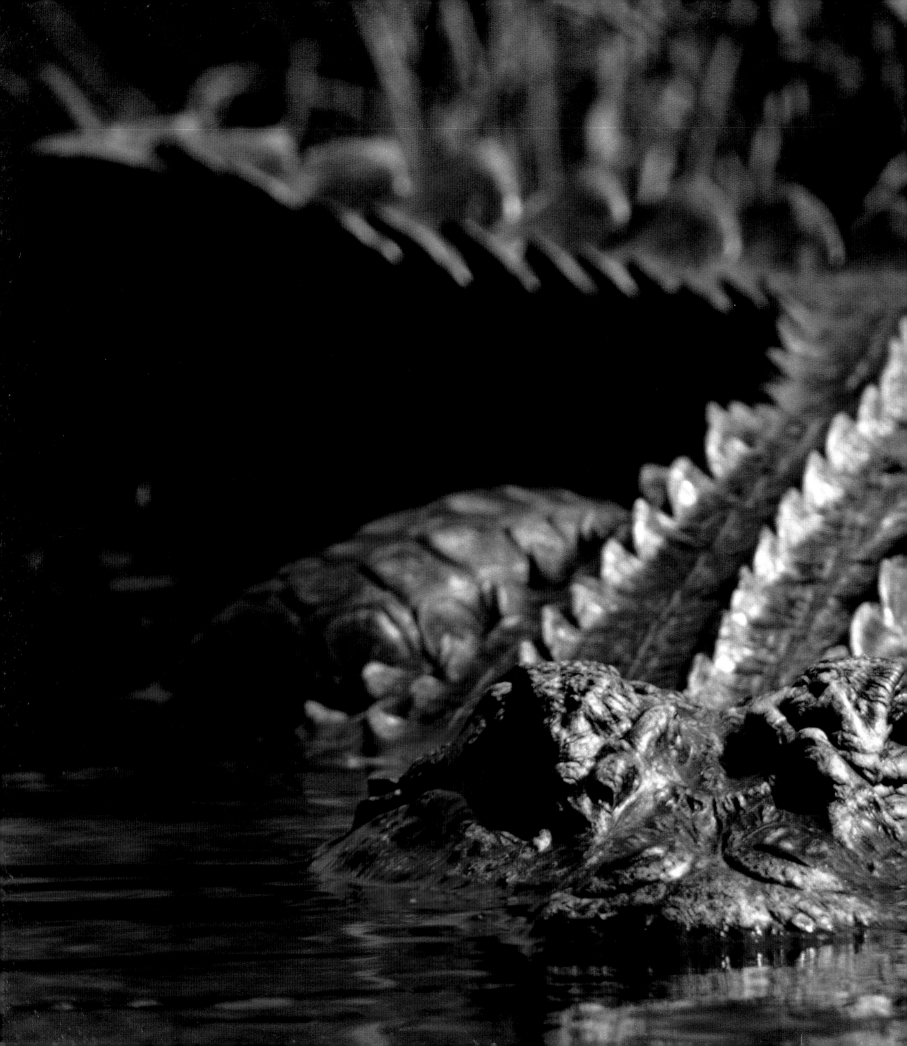

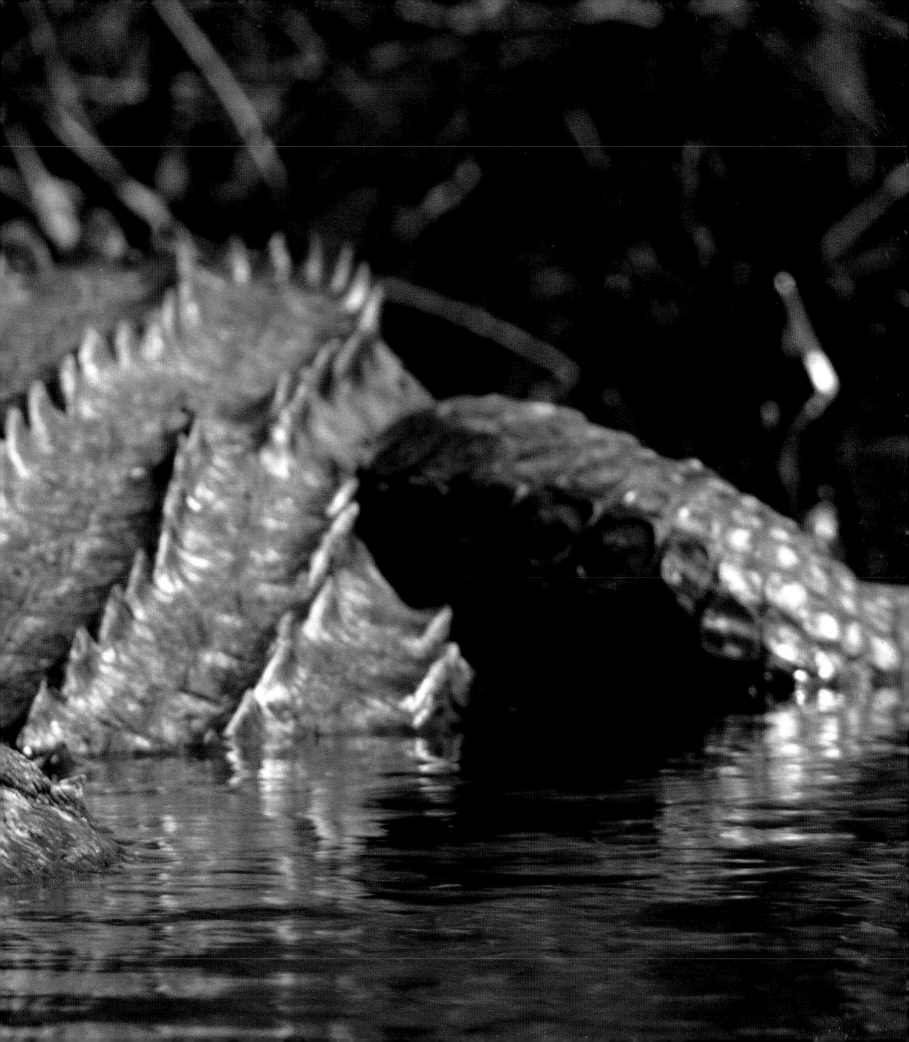

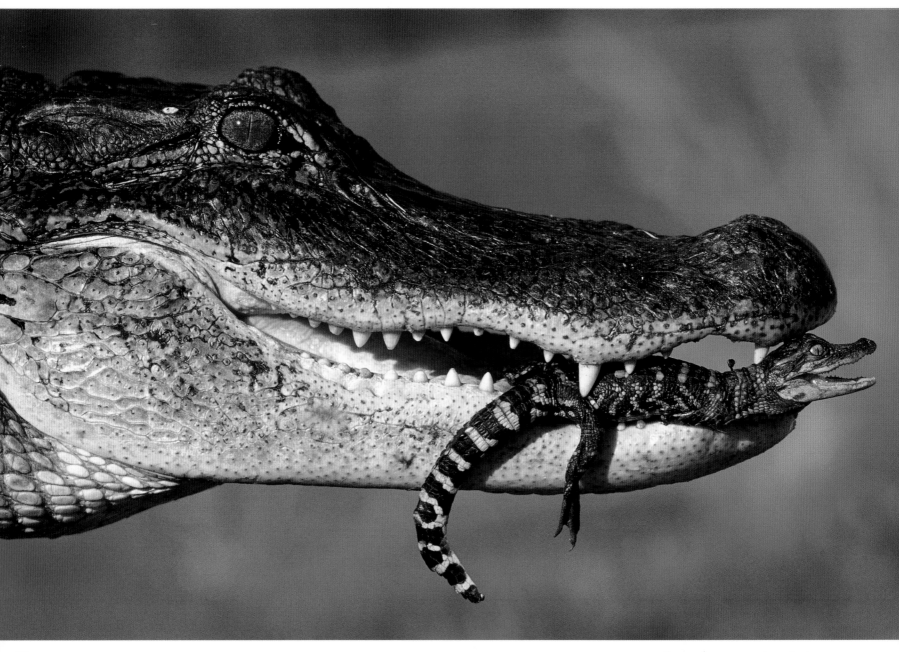

Parental care sometimes includes a mother alligator moving hatchlings to a safer place in her mouth *(above)* or threatening intruders with an open mouth and a hissing noise *(right)*.

A group of juvenile gators about four feet long take on a blue hue in shady light beneath trees *(overleaf)*.

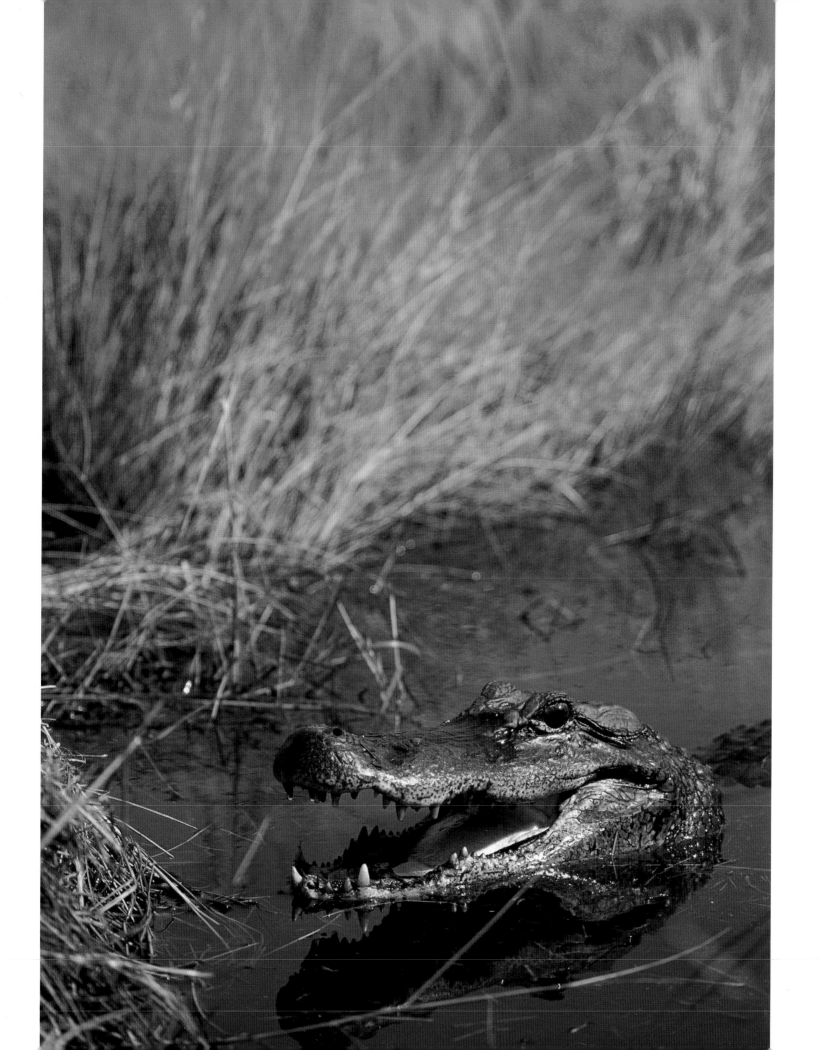

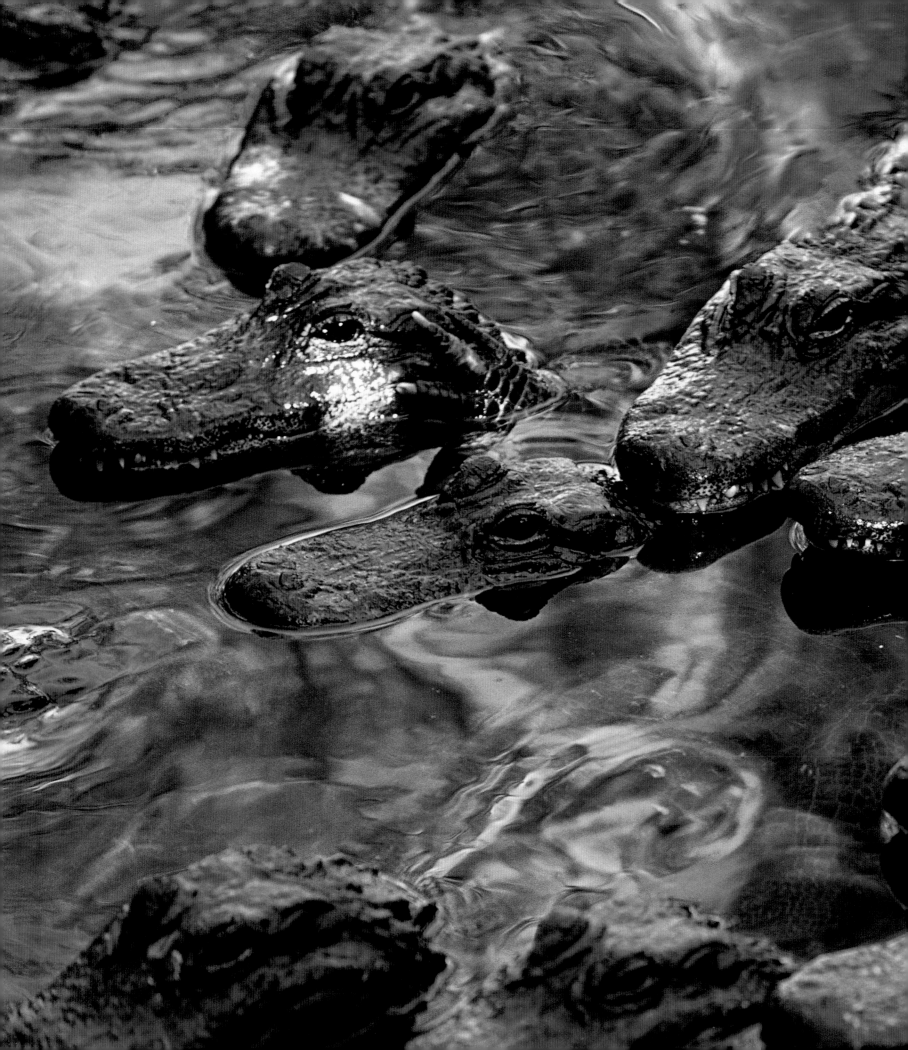

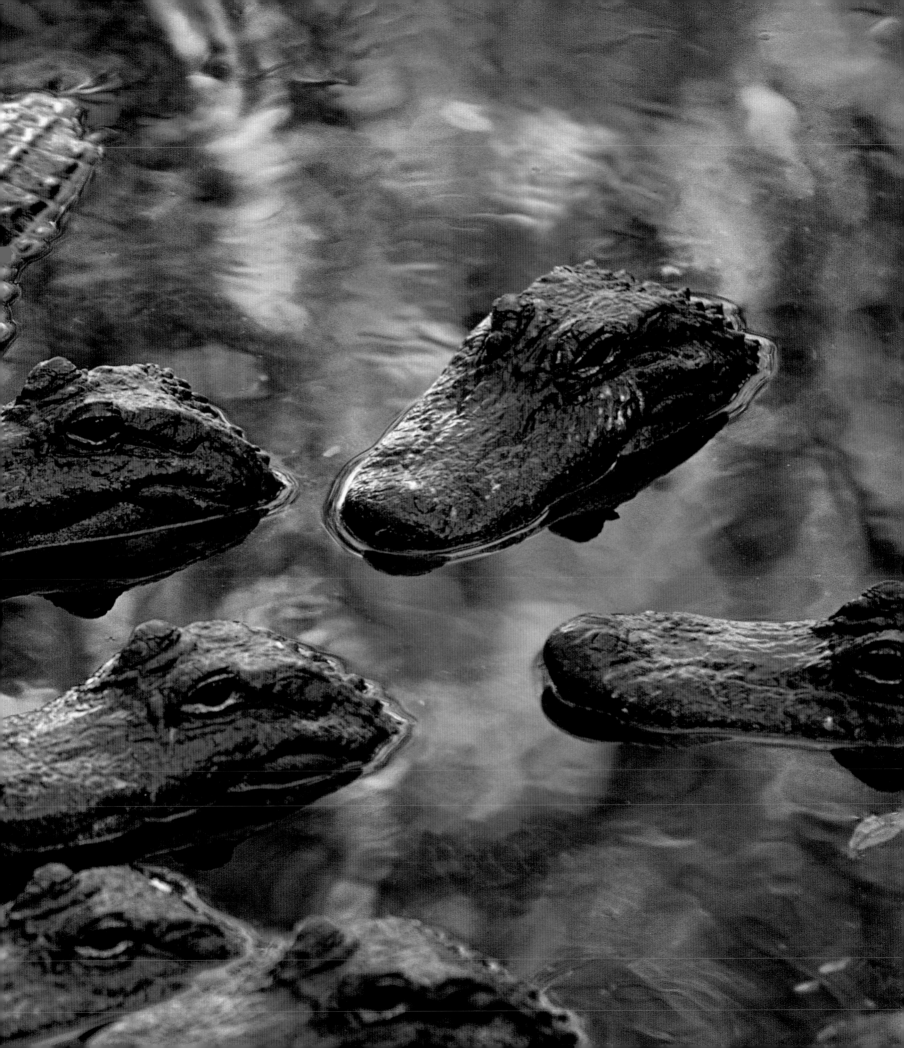

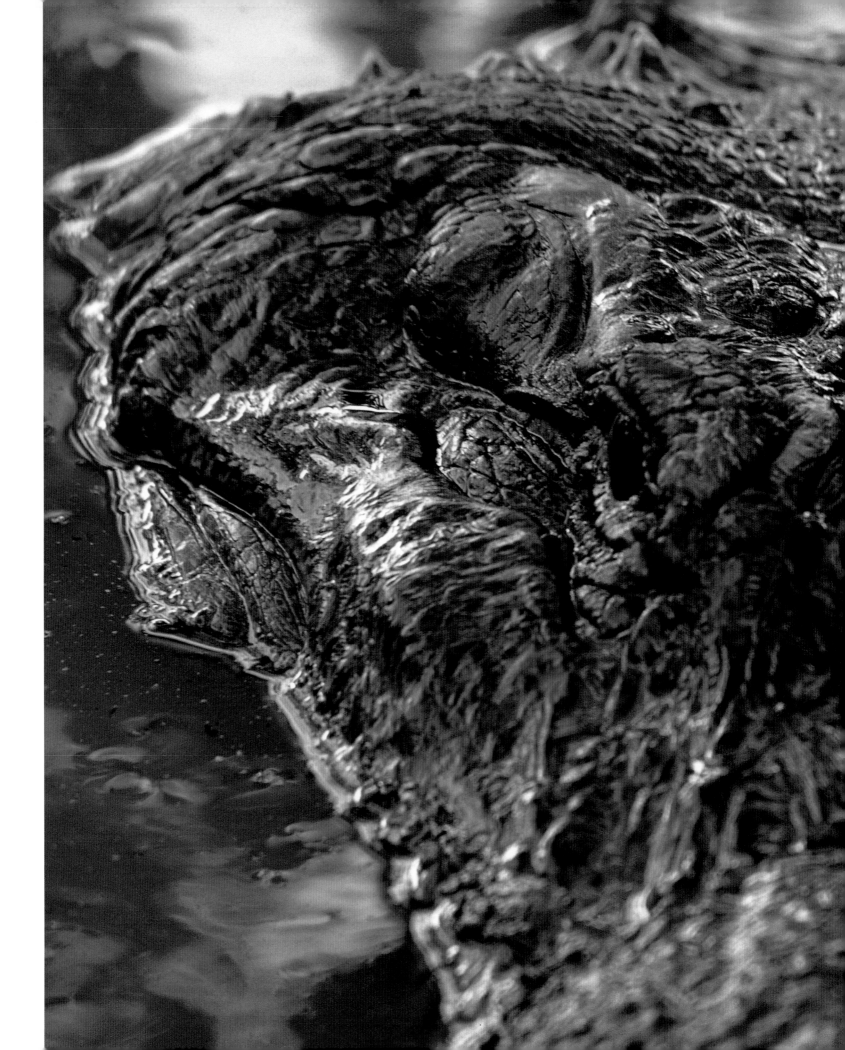

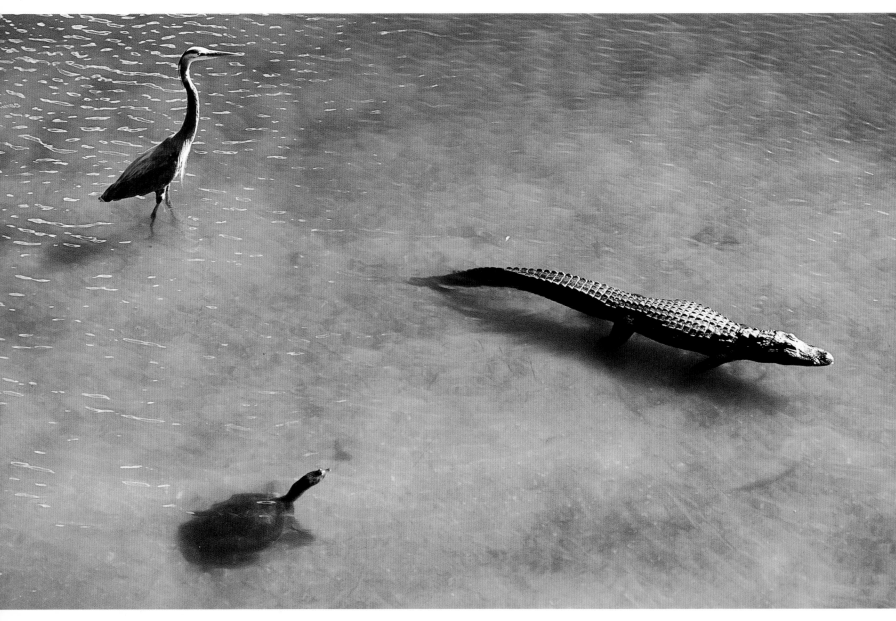

A great blue heron, soft-shelled turtle, and alligator share space in the breeding pond at Gatorland, Florida *(above)*. Winter temperatures slow the reptile's metabolism, making the two species, which could be prey, feel safe.

The massive head of a forty-six-year-old male alligator, Kliebert's Turtle and Alligator Farm, Louisiana *(previous spread)*.

I *Encountering the* ALLIGATOR

SMOTHERED in black water. "I remember thinking to myself, I am going to die," Kermit George told me as we walked along the east shore of Open Pond, tucked away in the pinewoods of southern Alabama in the Conecuh National Forest. It was there that a large American alligator had jerked Kermit underwater without warning. A split second later, the gator went into a death roll.

The attack happened around 7:30 A.M. on a hot July day in 1986. Kermit had taken off on a seven-mile bike ride from his log-style home at the edge of the national forest. Duchess, his big Doberman pinscher, ran alongside. Kermit was kind of in a hurry and didn't intend to go swimming, but Duchess was hot, so he pedaled up to one of two swimming areas at Open Pond. Duchess dashed into the lake, and Kermit doffed his tennis shoes and T-shirt and had just waded in to play with the dog when suddenly she lunged away from him and swam to shore (man's best friend!). Kermit recalled, "I waded into deeper water, fell back and swished my arms to cool off, when I felt this tremendous jerk on my right arm." The gator took him under, and an eternity seemed to pass before a startled Kermit surfaced in waist-deep water. He told me his first thought: "I was surprised to be alive. I felt no pain, but I knew something was wrong. I looked to the left and everything looked OK; then I looked to the right and my arm was gone, leaving only some bloody flesh and blood pouring out of my artery."

When he saw the blood, Kermit realized time was against him in his fight for survival. He got out of the water, started screaming for help, and saw a boat in the lake. He sensed he was going into shock, so he lay down in quiet desperation and floated in and out of consciousness. At one point, looking up, he thought he saw the boat going in the opposite direction, but later found out it was only avoiding the big alligator.

After a time he heard his dog barking and realized that the boat had come ashore nearby. He called Duchess away from the older man in the boat, who approached Kermit and said, "You are in bad shape." The man didn't seem to know what to do, just stood there and stared—shocked, Kermit thought, by all the blood. Remembering first aid from his Boy Scout days, Kermit thought one of three things had to be done: pinch the artery, use a tourniquet, or apply a compress. He told the man to take his shirt off and apply a compress to his wound, then passed out again. When Kermit woke, others had arrived with a truck. He was taken to the hospital in Andalusia, Alabama, and later sent by ambulance to the University of South Alabama Hospital in Mobile.

Kermit remembers thinking during the medical ordeal how hard it was to live with two arms and how much harder it was going to be to have to live with only one. His faith helped him through the difficult transition. While he was in the hospital, Kermit became a Christian with the help of his stepdaughter, Tracy, who had ordered a Bible for him six weeks earlier. By coincidence, the Bible arrived on the morning of the accident. Kermit George's ordeal was later reenacted for the TV show *700 Club*. He now witnesses for Christ in prisons and churches.

Though it took time to make the mental and physical adjustments to the loss of his limb, Kermit, once right-handed, has a good attitude now and has adapted well to one-arm, left-hand life. And he holds no grudges. As he told me: "The gator was in his territory, and I invaded it. I never had any bad feelings about the gator."

Later the day of the accident, the sheriff went out and found the alligator in the swimming area, acting aggressive. He shot it. Kermit's arm was found inside the animal's stomach. Almost twelve feet long, weighing 550 pounds, the alligator had

Kermit George at Open Pond, Alabama.

reportedly been fed by campers, and on occasion it would take fish from fisherman's stringers. A few years later the Forest Service closed the swimming areas at Open Pond. As Kermit and I walked around the pond fifteen years and two days after the attack, we came across a sign at the edge that read Do Not Feed Or Molest The Alligators. Kermit thought that was cute: Who's molesting whom? As we parted, he told me, "He got the arm, and I got away. It was a good trade."

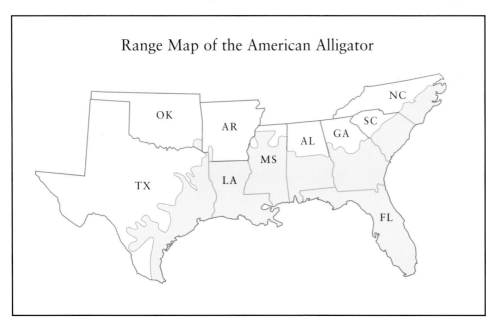

Range Map of the American Alligator

Dogs don't always retreat from alligators. At least one newspaper account of a gator encounter ends with canine heroism. According to an article in the *Tallahassee Democrat,* eighty-five-year-old Ruth Gray was walking about fifty feet from a canal where three alligators had been seen that day when she slipped on wet grass. She broke both shoulders in the fall, and Blue, a two-year-old Australian blue heeler who had been walking with her, lay beside her on the ground. Suddenly the dog growled and left. Ruth couldn't see, but she knew from the noise that the dog was in a fight. After 10:00 P.M., when Ruth's daughter and son-in-law arrived home, the thirty-five-pound cattle-herding dog raced to the

car Lassie-like and brought the family to the rescue. Blue received numerous puncture wounds, including a three-inch gash in his stomach, holding the alligator at bay.

Big alligators will occasionally attack dogs, as an 11' 9" male alligator did in Monroe, Louisiana, on Bayou De Siard in September 2001. Dr. Robert Woods was launching dummies to his three-year-old golden Labrador retriever. Perk was a champion bird dog with good bloodlines and weighed sixty-two pounds. The doctor had launched two dummies, one on land and one in the bayou. The Lab had retrieved the one on land and was swimming for the one in the water when Robert noticed a big wake—so big that at first he thought it was a boat. It was a 750-pound alligator swimming fast. It came up behind the dog. The doctor whistled, but it was too late; the gator snatched the dog and instantly took her underwater. It was so quick Robert doesn't think the dog even knew what happened.

Later that night nuisance trapper Charlie Simpson got the big gator in his spotlight. Plan A was to noose the outlaw gator and relocate it. The alligator had other plans. Under the spot, it dove and then resurfaced quickly, which is uncharacteristic for an animal of its size. The gator snapped its jaws four times. Putting his hand in the bayou, the trapper rustled the water. The gator swam toward the boat—another sign of aggression. Charlie had to shoot it. This was an aggressive alligator unable to cohabitate with humans in the confines of an urban area.

According to an August 29, 1995, *Alexandria Daily Town Talk* article, another gator with a taste for dogs was killed in the Black River State Forest, forty-five miles northeast of Pensacola,

An American alligator emerges from a pond covered with aquatic vegetation *(below)*.

Two large reptiles move quickly to Ron Whitaker's truck full of fish *(overleaf)*.

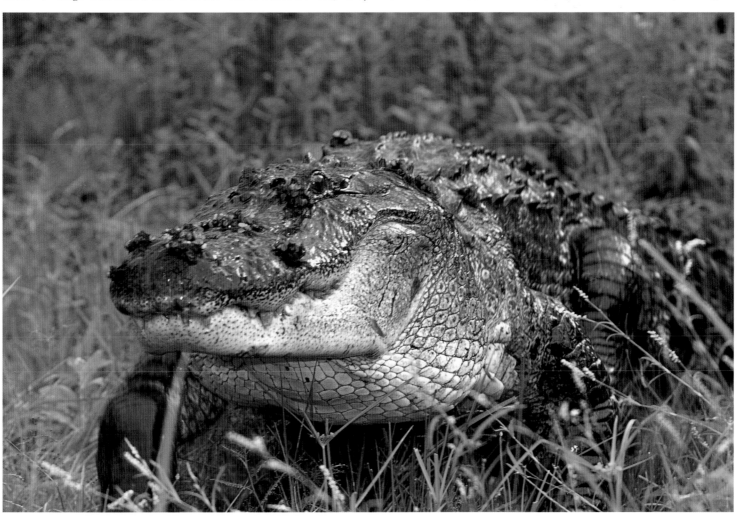

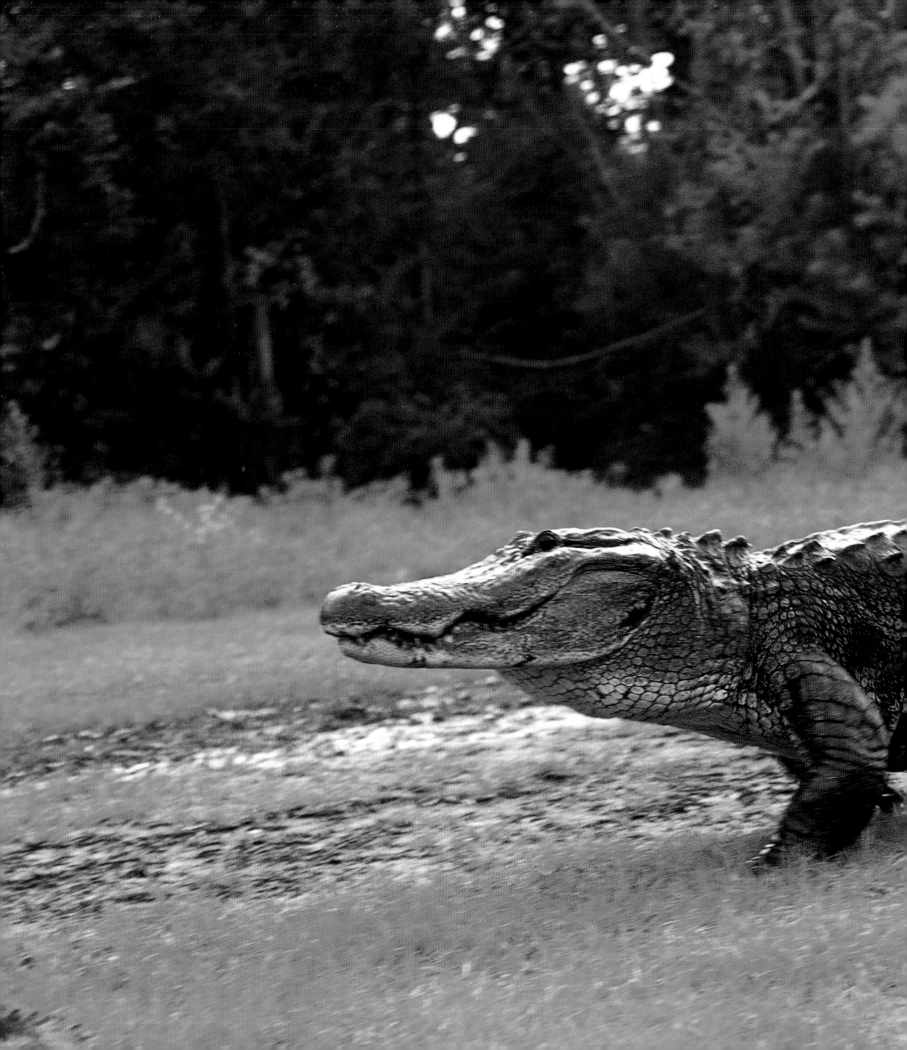

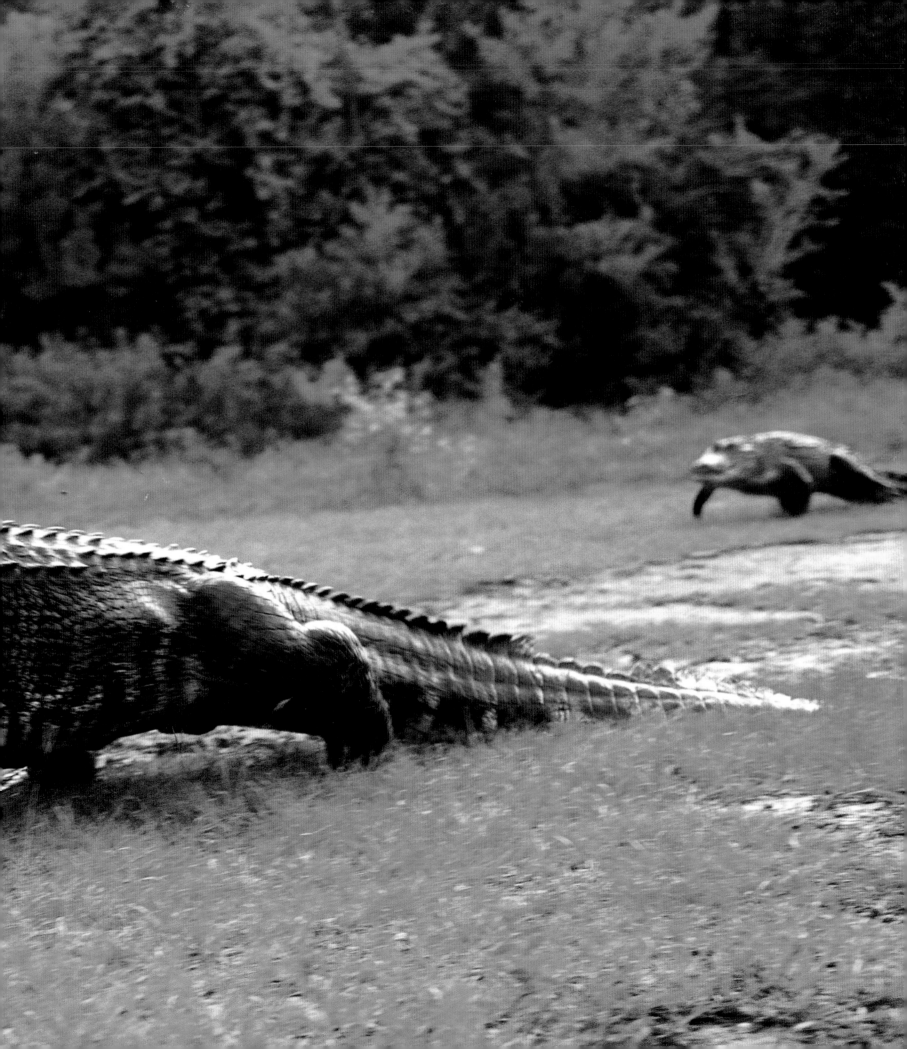

Florida. Nuisance trappers David Smith and Lonnie Stone harpooned a 10' 11" male they estimated to be fifty years old. They discovered seven dog collars in the alligator's stomach. One was from a dog that had been missing for fourteen years.

The big gator was found after Rufus Godwin lost his $5,000 purebred Walker foxhound, Flojo. Following the signal from an electronic tracking collar, Smith and Stone were led to a gator hole off Coldwater Creek. Another man who had recently lost a dog also got a signal there. The logical explanation of a gator underwater turned out to be true, and the nuisance hunters dispatched the guilty reptile. They later determined that about twenty-five missing dogs had probably crossed Coldwater Creek into the jaws of the dog-eating gator.

Both David and Lonnie are now retired as nuisance trappers, but I talked with Lonnie about his memories of the big gator. He said the older collars in its stomach were pretty torn up; the rabies tag was all that was left of one. Lonnie was pretty sure that Ripley's Believe It or Not Museum had bought the alligator's head and the collars.

Occasionally there is an unprovoked attack on man. One of the strangest happened in August of 2001 near Gallino, Louisiana. Forty-one-year-old Scott Bouzigard was fishing—drifting down a levee canal in a pirogue, a flat-bottomed Cajun canoe that one paddles or poles back into the shallow marsh. A person in a pirogue sits much lower in the water than someone in a canoe, and its sides are not as tall; thus Scott was nearly at water level when he saw the eyes and snout of a six-foot alligator a couple of feet off his left shoulder. He was startled, and his first impulse was to get out of there. When he looked away to grab his paddle he heard an explosion in the water and thought that the alligator was retreating, moving down and away. As he turned he found to his surprise that the alligator was torpedoing out of the water toward his head. Being an athlete, Scott has good reflexes, and he quickly ducked to the right, saving his head but leaving his arm in harm's way. The alligator kept coming, biting him while sliding into the front of the boat; then its momentum carried it over the other side. Scott said, "I grabbed my arm and saw I was leaking blood." The alligator popped up six feet away, and he yelled at it until it submerged again. Scott headed home to get a tetanus shot. His injuries amounted to a tooth hole in the side of his arm big enough to stick his finger in and four more tooth marks at the bottom of his triceps.

The scary part, Scott told me, was that he was at the same spot the previous day with his three-year-old son. He was teaching him to fish. That they didn't see the alligator the day before suggests it was not an aggressive female protecting a nest. Can we assume that there are a certain number of alligators, sharks, and bears that attack without provocation, just as a small segment of the human population does?

It's mostly our mistakes that cause alligator accidents—or bad luck of the sort that Ronnie Paille experienced while photographing in the marsh at Sabine National Wildlife Refuge in Southwest Louisiana. While wading in a knee-deep marsh, Ronnie fell in a floatant. This is a mass of muddy vegetation growing so thick it looks and kind of feels like land until you sink through it into a watery depression below, which could be an alligator hole. Carrying his tripod in one hand and camera in a waterproof ammo can in the other, Ronnie decided to be more careful after that swim and tested each step. He was in alligator country. A little later he stepped gingerly through a patch of vegetation similar to the one he'd previously fallen through. He hit something solid. Through his tennis shoes he felt the scutes, or ridged plates, of an alligator's back. Then, like a landmine exploding, the water erupted and the jaws of a nine-foot alligator closed on his thigh. Falling, Ronnie blacked out and woke up momentarily on his back, looking right into the gaping mouth of that gator. Thinking it was moving toward him, he rolled and retreated quickly to study his injuries. There were puncture wounds in the middle of his thigh and bad bruises above and below. Ronnie said when his heart stopped pounding and the alligator had calmed down, he was able to sneak back and recover his equipment.

I had a somewhat similar adventure in Louisiana's Atchafalaya Basin in the late seventies. I was spending the night in a photography blind in an egret rookery. I left the hiding place to do some night photography, wading into the darkness of the swamp. I wrote about the evening in my book on the Atchafalaya:

With supper down and the night dark as pitch, I know the time has come to set out. I pull my hip boots back on and wade over to the thicket hiding my canoe. Carefully, I stow my gear so that I can easily grasp what I need. My camera is rigged with 135mm lens and strobe to shoot gators or bull frogs. For the smaller green tree frog, my close-up unit is ready on the canoe floor. I tie a rope from the bow of the canoe to the back belt loop in my Levi's so I can drag the canoe behind and leave my hands unhindered to shoot pictures. Then I hook up my headlamp and gingerly scan the surrounding landscape. Eyes of red, green, and yellow light up everywhere. I am definitely not alone. Snakes and alligators have never bothered me in daylight hours, but now it is hard to take the first step. It's ten o'clock and pitch dark, and here I am, stuck in my tracks before I have even left the blind!

"Oh well, let's go. Most of those eyes probably belong to spiders. Alligators show two red eyes under flashlight, but luckily these are all single red eyes. Just spiders," I tell myself bravely.

After that first step, each successive one becomes easier. Then I stumble on a branch with a loose end, giving me a brief but heart-quickening scare as it pops up among the hyacinths. But soon sounds recede from my conscious attention and the life of the basin captures my thoughts.

I look and listen and absorb a new feeling for this swampland. Insects and frogs and even the egret nest become my subjects. As I wander aimlessly through the ponds and cypress ridges, time passes quickly. Remarkably, there is no sign yet of alligators or snakes, and therefore they no longer inspire fear. I still want to see them, but on my terms, which is to say, before they see me.

Hours later I finally find what I have come looking for: my headlamp illuminates hundreds of green tree frogs in one small area. Many, extending their throat sacks, are calling, and a few are mating. Quietly, I rein in my canoe,

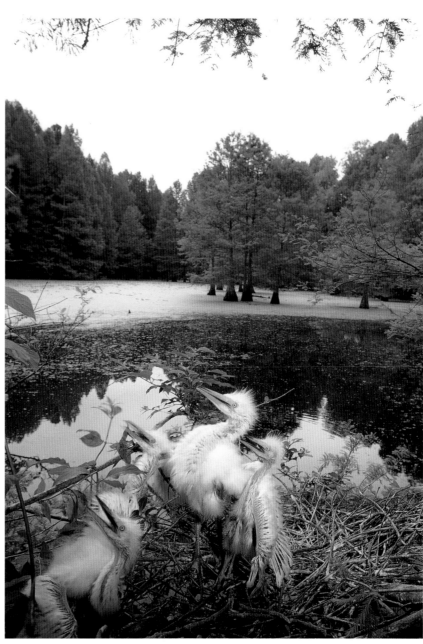

Four hungry great egret chicks await a meal in a bird rookery—the same spot where the author, wading at night, stepped on an alligator.

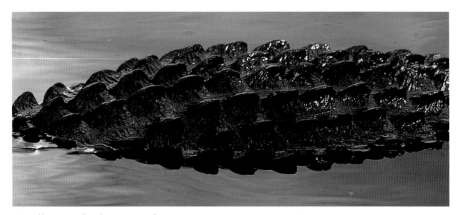

reach for the close-up camera, and begin my stalk.

To get the photograph I want, my camera has to be within two feet of my subject. So I put my beam of light on a mating pair and wade ever so slowly toward them. At four feet away the frogs part and jump. I move even slower; but each frog seems to have this four-foot limit for a large strange creature with one bright white eye.

An alligators back, armored with bony scutes, rises above the waterline *(above)*.

The American alligator is an opportunistic eater; its diet includes the blue crab, swamp rabbit, and nutria. *(right)*.

Then my luck seems to change. I am almost within four feet of a solitary male, and he is calling undisturbed. My strobe is ready, my camera focused on two feet. Another step, and I will have my shot. The water six inches above my knee scarcely ripples, I move so slowly. The frog still sits in my light beam. I am closer. Lowering my foot will put me within my chosen distance! Then my rubber boot strikes something. "Oh, not another log! Will it scare the frog?" WHACK! A tail slaps my face. I fall backwards, instinctively grabbing my camera with my left hand and lifting it towards the sky as my right hand and both legs paddle me backwards to what I hope is safety. Ahead of me I hear the splashes as the alligator submerges again and swims off.

Water gushes from my hip boots as I struggle to regain my balance. My left hand still holds my camera high and dry. Quickly I climb into the canoe, my heart pounding to the tune of the calling frogs and my mind trying to decide if I am still in good health. I am.

Safe; but enough is enough for one night. I empty my boots, hop back into the water and start towards my blind. Which way, though? I had been wading for over five hours looking for animals and paying no attention to my route. "Why worry?" I must have thought earlier, for I have been in this rookery over thirty-six times and know most bird nests by sight. But that was in daylight. The cypress stands, the willow thickets, the tangles of button bush, and even the ponds all look the same tonight.

I eventually found my blind just before dawn.

Ronnie Paille was a published freelance photographer at the time of his alligator accident, and he shared another story with me of an incident at the same refuge. "I was trying to get some photographs of night herons along a creek in the coastal marsh section of Sabine," Ronnie said. "They were skittish, so I made an inner-tube blind to sneak up on them floating." Turns out the tidal current was moving faster than he expected and took him right by the birds into a small lake full of jumping mullet, a fish that alligators like to eat. Ronnie quickly noticed that he was surrounded by large alligators snapping at the mullet in a feeding frenzy. He thought this was a great photographic opportunity until twice an alligator went between his legs. Then, just before he decided to leave, a big one he estimated to be eleven feet long crawled over the backs of his legs as he knelt in the shallow lake. "Although the gators were not too interested in me, it was time to leave," Ronnie told me.

It's not surprising that the feeding gators showed little interest in Ronnie. Human beings are not the normal prey of the American alligator. Its usual diet is small mammals, birds, fish, other rep-

tiles, amphibians, crustaceans, and insects. Accidents and rare attacks do happen, however, and when they do there is usually some blood spilled. Built to do quick and deadly damage, the American alligator is an efficient killer with a bite of three thousand pounds of pressure per square inch. This is enough to crunch bones, turtle shells, and stout poles. Alligator teeth are designed to grip, hold, and tear. Their tongues are attached to the bottom of their jaws; they are not useful to move food around. Thus, if alligators bite something bigger than they can swallow, they have to rip it apart. They do this by spinning in the water, the death roll.

With this arsenal of attributes, it's lucky that alligators don't have people on their menu. Deaths to humans have been few and far between. The only death recorded in Louisiana is purely speculation. A blacksmith, possibly a soldier at Natchitoches, Louisiana, was discovered naked and dead half in and half out of the water. Those who found Mr. Jacques du Bois decided from the three wounds on his neck that an alligator did this damage while the victim was bathing in the Red River on August 10, 1734. A long time ago, and we don't even know for sure the alligator did it.

Florida has had twelve fatalities since 1948. The Sunshine State holds the record, and for good reason. It not only has lots of alligators, but it also has a population of 15, 982, 878—people who have moved to the edges of lakes, rivers, bayous, and streams; people who have retired and come from the north; and lots of families with small children on vacation. People not familiar with wildlife. So problems of coexistence arise.

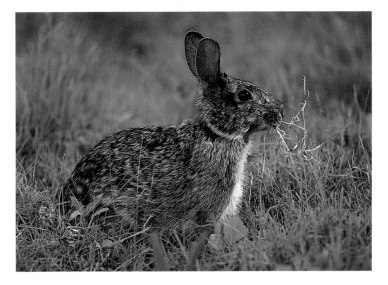

During the summer of 2001, while I was researching this book, alligators and sharks were both in the news: three deaths brought about by alligators in Florida and two from shark attacks elsewhere in the United States—sad and tragic deaths, but not nearly as prevalent as other kinds of fatalities.

According to the National Highway Safety Administration, one person dies on the road every thirteen minutes. If we look at it from that statistical perspective, by 2:49 A.M. on January 1 in a given year, just as many people have died in car crashes that year as from alligator attacks since 1948. Around water, a person is much more likely to be injured or die in a boating accident or by drowning than in an encounter with wild creatures.

The numbers speak volumes. Lightning kills an average of 94 people per year in the U.S., 10 people per year in Florida alone. Breast cancer kills someone every fourteen minutes, and a murder occurs every thirty-four minutes. White-tailed deer are much more dangerous to humans than alligators. In 1999 there

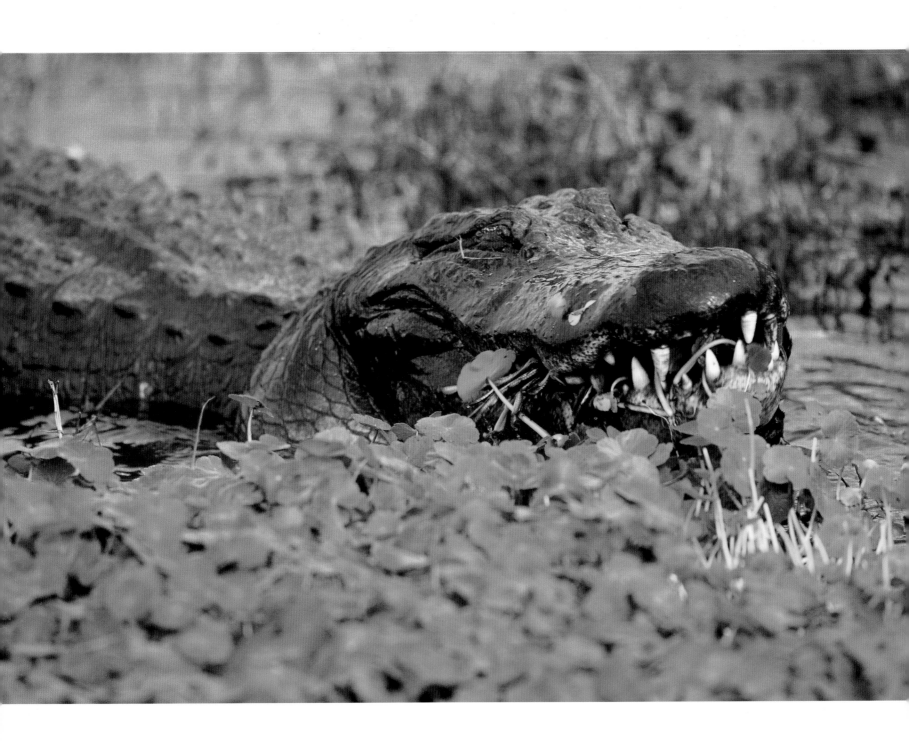

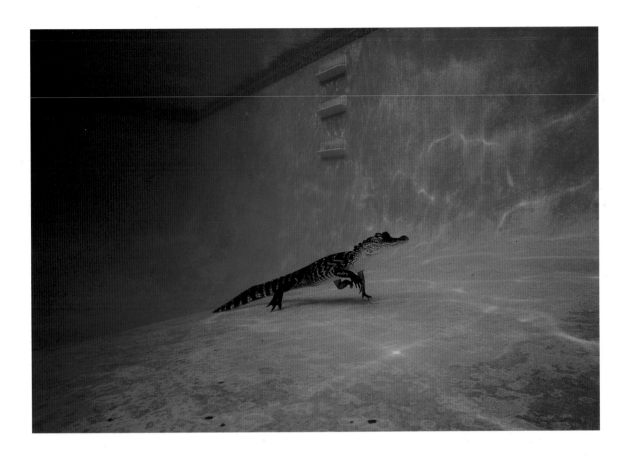

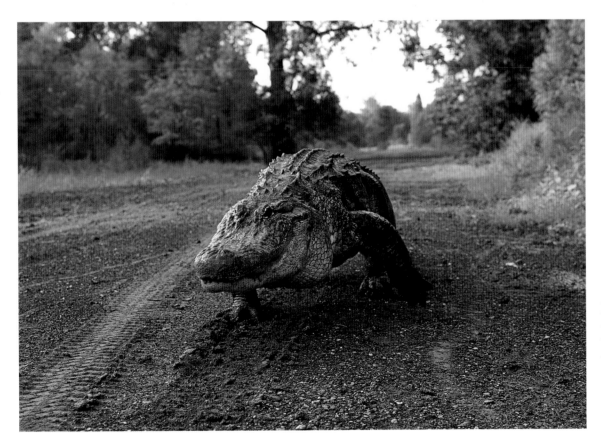

Drought conditions can cause alligators to move from their customary habitat, crossing roads *(bottom left)* and entering swimming pools *(top left)*. A large gator such as the one pictured far left, eating an American coot, can be quite fearsome when seen close up.

were 75,000 deer/car crashes resulting in 120 people dying. In 1998, 130 people died in tornados, and the following year 12 people died in airline accidents.

The summer of 2001 was a busy one for George Burgess, director of the International Shark Attack File. He told me he was getting twenty to thirty calls per day for interviews. His time in July and August was totally lost to the press, but the calls stopped immediately when the terrorist tragedy befell the World Trade Center. Although shark attacks and the related human deaths were down from 2000, the summer started off with the moving story about the boy who lost his arm then had it surgically reattached; one week later a surfer was attacked in the same spot, fueling media hype and causing minor injuries to be over-reported for the rest of the summer. There were fifty-five attacks in 2000. In 2001 the tally was forty-four with winter approaching. As with alligator attacks, the majority of shark attacks are in Florida, a state with 38.7 million visitors to its beautiful, abundant, and warm beaches.

My files are filled with clippings on shark and alligator attacks. One clipping shows a picture of a police car bumper with a hole taken out by an alligator's bite. The caption explains that police officers use their sirens to chase alligators off the road. This one must have taken offense to the siren. Another clipping tells of a little girl who was attacked while picking melons; she was bitten on the index finger. When the girl's mother and brother went to investigate, the four-foot gator lunged again as they searched the melon vines, forcing the mother to shoot it. In the *Journal of the American Medical Association* I found a brief story about a farmer walking home from a prayer meeting in a rural island area when an alligator attacked. The man was able to extract his leg from the animal's jaws only by beating it about the head with the family Bible.

Such encounters are frightening, to be sure, though these are unusual cases. Alligators may look dangerous, but they pose little threat to us humans if we are careful to give proper boundaries to the critters. Of course, the mere sight of an alligator in what we consider "people territory" is often enough to bring on a bout of hysteria. One night in south Florida a three-foot gator walked through a doggy door and on into the bedroom where a couple slept. When they woke and saw it, they panicked and, afraid to go to the phone, began screaming for help from the bed. A caiman about the same size was seen in Central Park in New York City. Obviously a pet that had escaped or been let loose. An area of the park was cordoned off, and alligator expert and wrestler Mike Johnson was brought up from Florida to catch it—overkill for that small a creature. Of the twelve deaths attributed to alligators in Florida, some were children who were attacked in the water, and others were bodies found with alligator bite marks. In most cases when bodies are found, authorities have difficulty distinguishing whether the person drowned first or was attacked first.

When I embarked on this book project, I visited the library at the *Morning Advocate* newspaper and did a search on the word *alligator*. There were 1,684 references for an eleven-year period. Some related to encounters with people, some to hunting seasons and leather goods, while others showed pictures of school kids at a zoo. A popular subject, this prehistoric, dragonlike reptile. People may love it or hate it, but there's no denying that the ancient creature attracts the attention of anyone who comes into contact with it.

Ancient it is; crocodilian-like fossils date back 230 million years, near the middle of the Triassic period. Later, in the Jurassic period, when dinosaurs ruled the earth, the first direct ancestors of the crocs lived with and probably feasted on dinosaurs. *Sarcosuchus imperator*—a monster of a crocodile almost forty feet long—could have pulled down any dinosaur under the right circumstances. Fossils of this giant were found in Africa and Brazil, where it lived about 110 million years ago, in the Cretaceous period. Its North American counterpart, *Deinosuchus*, which means "terror crocodile," was an alligatoroid 75 to 80 million years ago. A few million years later, genuses such as *Brachychampsa*,

Stangerochampsa, and *Albertochampsa* had rounded snouts, blunt teeth, and pits in the upper jaws to sheathe teeth in the lower jaw, such as modern alligators do. The alligator's youngest ancestor is either *Alligator thompsoni* or *mefferdi,* both of which lived in the Miocene. Today's species, *Alligator mississippiensis,* has been around for about two million years. Both alligators and crocodiles belong to the family Crocodylidae. A simple way to distinguish one from the other is to look at their jaws. Alligators have rounded or u-shaped jaws; crocodiles' jaws are pointed or v-shaped.

Strange as it may seem, alligators, crocodiles, birds, and dinosaurs all evolved from Archosaurs. Alligators are structurally similar to birds in numerous ways, including having a muscular gizzard, an elongated outer-ear canal, and complete separation of the ventricles in the heart. Even though birds fly and alligators swim, they share certain behavior; both build nests out of plant material, lay eggs, have some degree of parental care of the young, and use voice to communicate.

Although its brain is tiny—only slightly larger than a pecan—it has served the crocodilian well through its long evolutionary life, as has the creature's form. In appearance and function, crocs haven't changed that much over millions of years. Though many species of crocodilians have become extinct, the family lives on. Compared with other long-extinct creatures like the dinosaurs, crocodilians have been amazingly successful.

After Europeans came to settle North America, it took them about three hundred years to sort out all the differences and similarities between the alligator and the crocodile, a point Vaughn Glasgow makes in his book *A Social History of the American Alligator.* Today we have pretty well classified the twenty-three living species of crocodilians, but for centuries these creatures were misidentified. Glasgow quotes numerous explorers, artists, writers, and other travelers in early America who through ignorance or exaggeration referred to the alligator as a crocodile. Now the challenge is to fill in the gaps in the fossil record, so we can better trace the evolution of these tough, adaptable reptiles.

Appearance

Alligators are born about nine inches long and ready to rumble. Even in infancy the precocious lizard look-alikes can swim, bite, and make noise. In fact, they call even before they are born, each one curled up in a two-inch-long egg like the swirl in a cinnamon roll. The high-pitched chirp—umph . . . umph . . . umph—lets the mother alligator know they are ready to emerge from the eggs and the nest.

Alligators hatching.

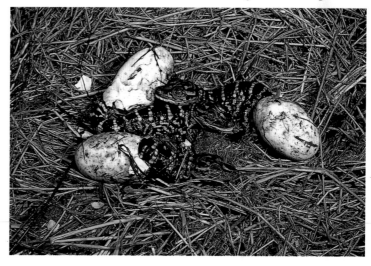

Most of the time the mother, hearing the call, will come and dig the top off the nest, though the hatchlings can crawl through and out of the pile of vegetation on their own if necessary.

Like most baby animals, young gators are strongly patterned. This camouflage helps them hide from predators. With their varicolored scales that alternate in rows circling their bodies—one to three rows of totally black scales, then a bright row that can range from yellow to orangeish brown to almost white—some babies look almost polka dotted, others as though paint splashed onto their scales. The cute little critters show up very well if held in your hand, but put them at the edge of a swamp or marsh and they blend in as salt does with sugar, making it difficult for egrets, herons, raccoons, and other predators to spot them.

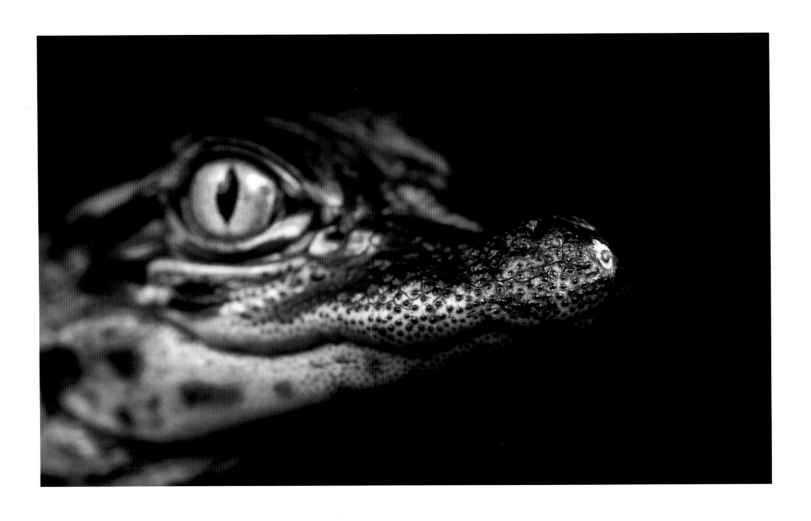

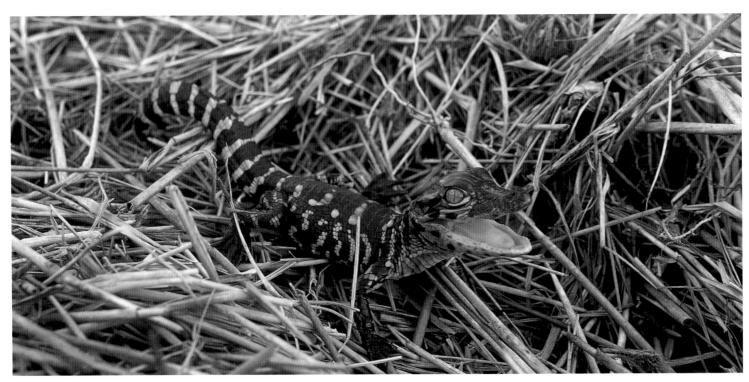

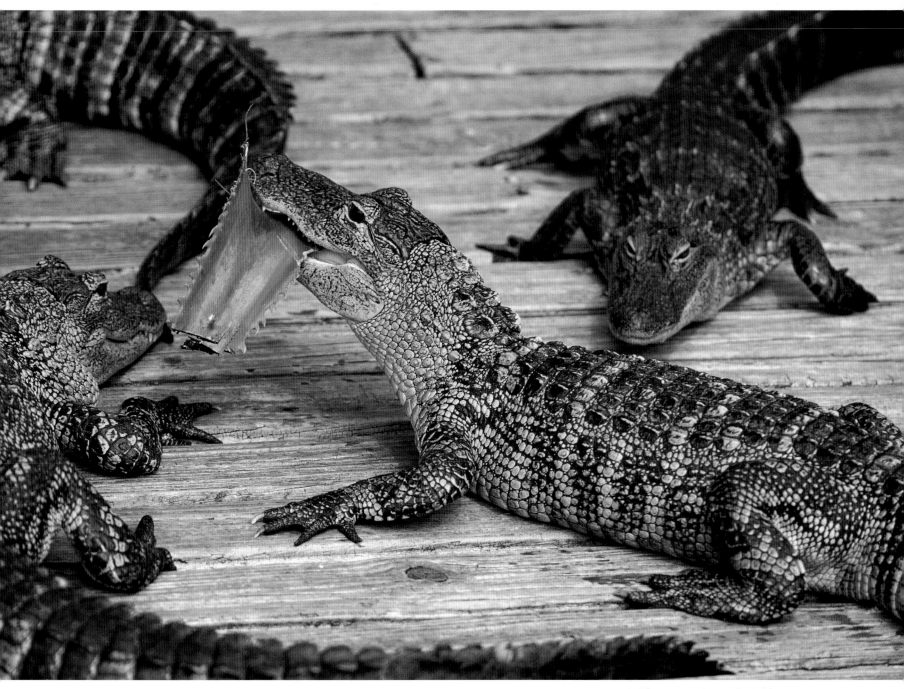

The egg tooth is still visible on this eight-day-old hatchling *(top left)*. This day-old alligator *(bottom left)* is already using its mouth to threaten the camera. A juvenile alligator plays with a palm leaf, perhaps thinking it is food *(above)*.

Color can vary among alligators, but habitat and other factors also affect their appearance. A wet alligator will look shiny black *(bottom)* while a dry skin appears grayish white *(top)*. Minerals in the water, mud color, and vegetation can turn them red or green *(middle)*.

The bellies of baby alligators are grayish white, the skin supple, already attractive. For about two weeks after their birth you can see the scar from the yolk sac on the abdomen. This three-quarter-inch opening is where the embryo got its nutrients for approximately sixty-three days in the shell. A hatchling's head looks quite different from an adult's: The eyes are disproportionately large, and the snout looks small. At the tip of the hatchling's snout is an egg tooth, a tough, horny piece of epidermis that the baby used to peck out of his shell. It is generally gone in less than three weeks, reabsorbed by the body.

Young gators keep their pattern for about three years. As they grow and develop into less likely prey, they become more uniform in color. At three years a well-fed alligator should be three feet long, the top of its body almost totally black or blackish brown, though a little of the yellowish pattern of youth can still be seen along the sides of adult gators, the colors gone duller with age. An alligator will appear grayish when basking in the sun and totally dry, or greenish if algae or other vegetation is abundant. The side of the reptile's jaw is white with hundreds of tiny black dots. Researcher Kent Vliet has suggested that these fluid-filled pustules, though structurally similar to taste buds, might function more as sensors of touch. In adulthood, the gator's belly remains an off white, smooth and soft, yet on its back, just behind the head, three pairs of scutes begin to grow taller, like armor plating. In fact, the analogy isn't far from the truth; each scute has a bony plate inside it. As alligators age their hides get tougher and thicker. Their strength becomes amazing.

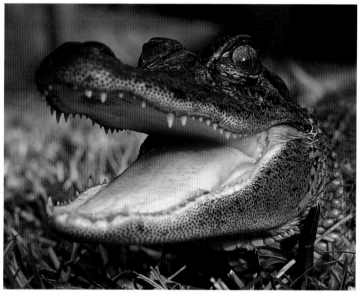

An alligator's mouth is lipless, but a special flap allows the reptiles to close off their throats, enabling them to open their mouths underwater.

One sunny day in September years ago, I was napping on the front of my bateau under a dead oak at the edge of Bayou Penchant. When I wake after naps in the woods, I always scan the area before I move, for there's no telling what animal has crept up on me. I learned early in my career that letting the critters sneak up on me was a lot easier than sneaking up on them. Sure enough, resting right under my bow in the shade was a two-and-a-half-foot alligator. I decided to catch and inspect it, so I quietly got into position, then grabbed it by its midsection with a lightning-quick lunge. I knew from this position it could not reach to bite me. But I had not planned on the strength of this little gator. Twisting and turning with the fever of a mad dog, it almost sprung my wrist.

Alligators have no lips, so their mouths leak. It makes them look kind of mean with those teeth hanging out from the top jaw. Water comes into their mouths while they are swimming, so their throats have a special flap that seals off the windpipe and gullet when they submerge. This lets gators open their mouths while underwater. Their eyes, noses, and ears are also equipped to protect them in an aquatic environment. An alligator can dangle its body into the depths, leaving only its eyes and nostrils to protrude. In this position it watches and waits for its prey. This clever camouflage makes the alligator quite proficient at its style of hunting: sitting and waiting. If the water is covered with vegetation of any type or debris, it is still harder for the gator's prey to see it. It also makes it tougher for us, the expert wildlife watchers, to spot a hidden alligator. Is it a log or is it an alligator?

An alligator swims using s-like undulations of its powerfully muscled tail, which is about as long as its body. Despite the slight webbing found between the reptile's toes, it does not use its feet for swimming. The webbing, along with the substantial claws found on the three innermost toes (of which there are five on each front foot, four on each rear foot), are useful in climbing up muddy banks.

As they reach sexual maturity, alligators get longer and heavier, and their scutes get bigger and tougher and the color more uniform. The teeth get deadly. They have seventy-four to eighty of them. I personally have counted the teeth in a lot of skulls and have usually found seventy-eight and a few times eighty. The secret to that scary grin is that alligator teeth replace themselves. If a gator loses one, another grows to take its place. They all look like dragons to me, especially when they raise up their heads to swallow. Looking at the underside of the big throat and teeth from the upper jaw while the tail is arched up is definitely frightening. A big gator is designed to bite like a pit bull grabbing a prime rib, then twist in a death roll like a Texas tornado. These prehistoric creatures' mouths are not made to chew, so they can only eat animals that are bite size or that they can rip off a piece of with their rolls. To swallow they need the help of gravity. Raising their heads up, they let the meal slide down into the throat. Even the young do the same while swallowing a bite-sized insect. It's easy to see how a gator might be mistaken for a dragon when viewed from a low angle.

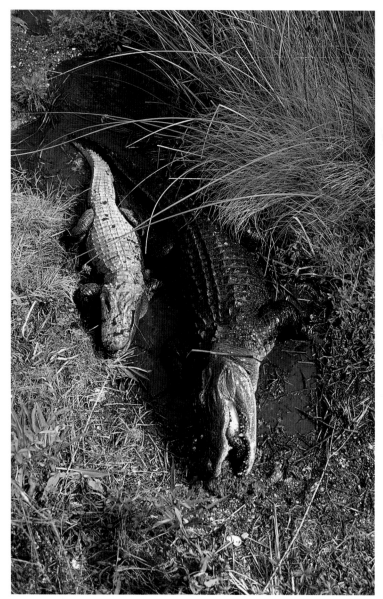

This pair of adult American alligators illustrates how much larger a male can grow. Here the male is turning his head to pick up food.

Males grow a little faster than females and get much larger. Both reach sexual maturity at six feet, but the male does so in about seven years, while the female takes nine to ten years to reach breeding size. The females rarely get larger than nine feet, while males keep growing as long as habitat, food, and life span will let them. E. A. McIlhenny killed the biggest one recorded while he was on a duck hunt on January 2, 1890, between Lake Cock and Vermilion Bay. The gator measured 19' 2" long. McIlhenny and two others tried to move it to shore to skin it but could not because of its great size.

In his classic book *The Alligator's Life History,* first published in 1935, McIlhenny talks about how he measured the big alligator: "I took the barrel off my gun and measured it with the gun barrel which was 30 inches in length, marking with my knife by a cut on the back every point where the end of the gun barrel stopped. After measuring the alligator three times to prove the previous measures, I found the length to be 19 feet, two inches. This is the largest alligator I have ever known of being actually measured."

McIlhenny of Tabasco fame lived from 1872 to 1949 on Avery Island, Louisiana, a natural salt dome that reached a height of 155 feet above the surrounding marsh, which seems to have been the perfect habitat for larger-than-average alligators. Between 1879 and 1916 McIlhenny, his father, and his chief game warden measured five alligators over seventeen feet in length. McIlhenny was accustomed to seeing very large alligators and figured that fifteen feet was the normal maximum size. E. A., who studied as well as hunted the creatures, had a standing offer of $100 for every live thirteen-foot alligator brought to him in good condition. During that time people brought him plenty of eleven- and twleve-footers. McIlhenny commented, "It is amazing how the length of an alligator shrinks when a tape is stretched along its back." I guess, from his writing, a dead fifteen-footer was easier to find than a live thirteen-footer.

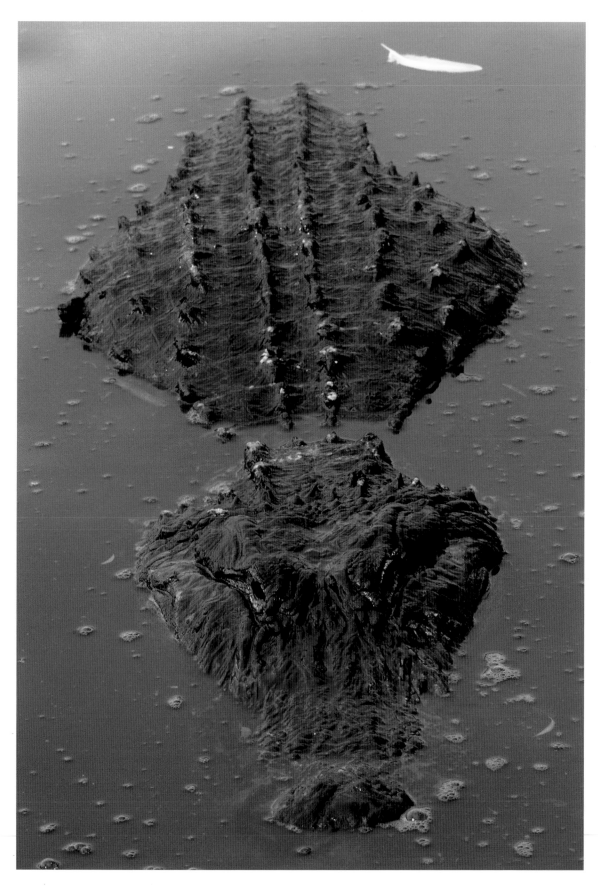

Like a log a large alligator waits patiently under a nest in an egret rookery.

A big bull alligator rests in shallow water *(overleaf)*.

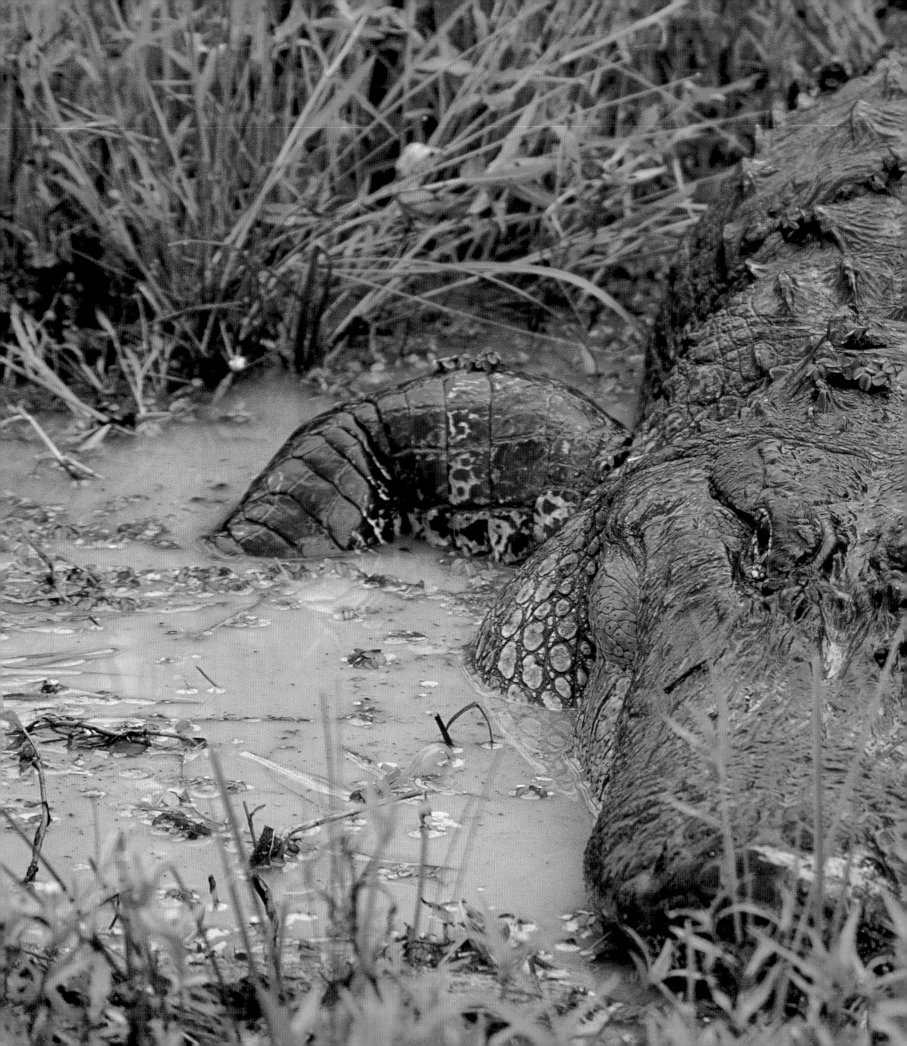

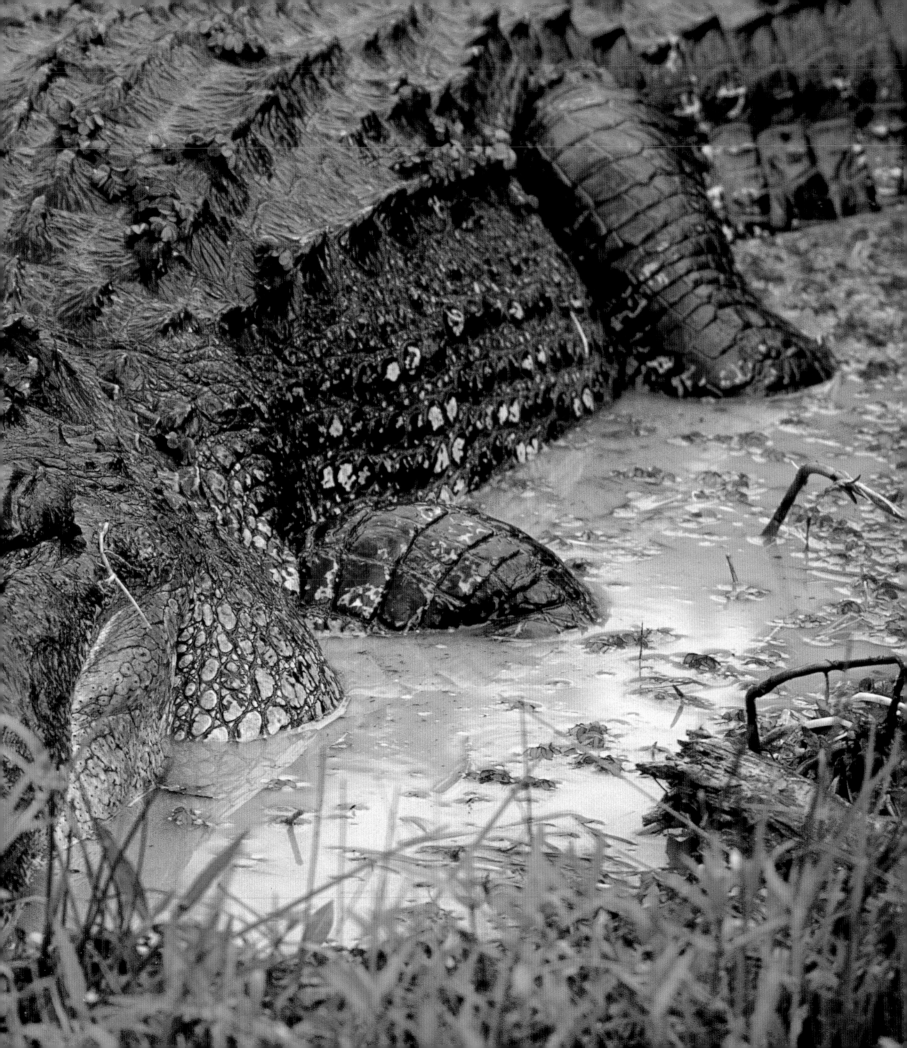

I had my own experience with the "unreliable eye" while waiting at the large alligator exhibit at St. Augustine Alligator Farm in St. Augustine, Florida, to interview John Brueggen, general curator. The farm keeps about thirty very large gators for the daily feeding show. Captive gators are usually a lot wider than their wild cousins, for their habit of lying out on land and stacking up on each other flattens them out. They also tend to get heavier, due to their eating more and getting less exercise. When John walked up, I commented on my enjoyment of watching these big boys and asked, "Is that one over there about twelve and a half to thirteen feet?" John said, "No, there is not a twelve-footer in that pond." "Wow, they sure look bigger," I replied. He said, "Men should not be allowed to estimate the length of anything."

Giant gators are a thing of the past, just like the virgin bald cypress trees that used to reign over the wildlife-rich waters of Louisiana swamplands. Occasionally a big one is caught in hunting season or, more likely, by a nuisance trapper. Don Ashley, a consultant in the alligator skin industry, has a 15' 6" skin from 13' 10½" gator. Once removed from the carcass, a hide stretches. Ashley's was taken at Orange Lake, Florida, in 1989 by Columbus White. Mike Taylor, the Florida Department of Fish and Wildlife licensed nuisance trapper for Seminole County, holds the current state record. He caught a 14' ⅝" gator at Lake Monroe in 1997.

Mike traps about three hundred nuisance alligators a year. He got the record using bait that he hung on a large hook placed almost five feet above the water. This assured that he would catch a bigger one. Only a large gator could propel itself that high out of the water. Mike lives near Lake Jessup, which once was a dumping ground for nuisance alligators before trappers were allowed to sell the skins and meat. At one time it was said to have the highest gator population in Florida, though with the issuance of sports hunting permits, the numbers have since leveled off. I asked Mike if he thought an alligator could reach nineteen feet, like the one McIlhenny described, and he agreed one could. Mike has also caught a few 13' 10" gators, and just recently a 13' 11" one was caught in the private land season.

McIlhenny grew up in the alligators' backyard and in his book recounts some amusing stories of himself as a boy, teasing the large reptiles near his Avery Island home. Once he was throwing mud at a large gator that was surrounded by a group of kids. The gator grew tired of the torment and headed to the bayou, walking right over E. A., who was mired down in the mud. The gator's claws left scratch marks on the boy's stomach.

Boys don't change much. Recently Neil Johnson, a photographer colleague of mine, e-mailed me his story of an Avery Island field trip in 1967:

> In seventh grade, on a school bus tour of the state, four friends and I had run ahead of the group up the path to see the bird rookery. Beside the path to the lookout platform was a gator no shorter than a dozen feet. Possibly longer. It lay there as still as a log. We froze and stared. There was no movement in the eyes or the chest. What? No blinking or breathing? Maybe it's on display, put there beside the path to scare kids. We stared longer and even began an argument about whether or not it was real or fake. Sure was realistic, but still absolutely no movement. You know how young naive boys are. Who cared about some dumb bird rookery? We were not moving until we found the answer to this mystery, and the gator was NOT cooperating. We dared a friend to kick it. My friend inched around to the back and did kick the tail.
>
> Let me tell you, that gator was not wood, not painted concrete, and not on any Avery Island tourism display plan. But he was happy to give a vivid and lasting lesson to a group of seventh-grade students. He whipped his tail around

with lightning speed and reared up at us. I will never forget how big the mouth of a large gator is when it is wide open. Simultaneously, we all sprang back like we had been hit with a cattle prod. When the gator was satisfied that we all had our hearts in our mouths, he smiled that distinctively crooked gator smile and slipped off into the water of the swamp in a nonchalant I-could-have-eaten-any-one-of-you-if-I-had-wanted-to gator kind of way.

Reproduction

From the bellow of the bull to the chirp of the newborn, alligator breeding behavior makes for interesting study. Alligators don't live together as a rule. The males like rivers, canals, and open waters, while females go deep into the marsh for private nesting places. They come together in mating season. In early April longer and warmer days signal the kickoff of courtship. Hormone levels rise, and the males' testes begin to enlarge. Bellowing becomes more regular, and territories are guarded. Breeding-sized males accept advances such as bumps, nudges, and pushes from females. Sometimes a female will swim above a male and try to press him down; this is thought to be a test of the bull's strength and breeding worthiness. When all is right, the pair mates in the water, usually submerging

This protective mother charged the boat while biologists were collecting her eggs. The four-foot nest is made of wire grass.

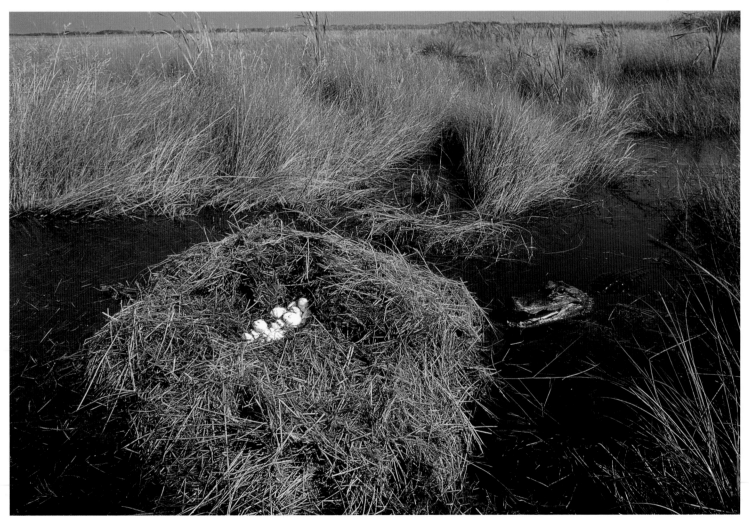

Like rain in reverse, water droplets vibrate as a bull gator bellows *(right)* while another male slaps his head in the water *(far right, top)* and one member of a pair lies atop the other *(far right, bottom)*. All these are examples of courtship behavior.

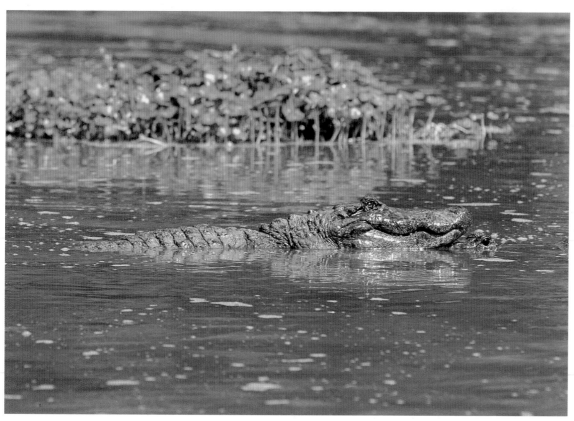

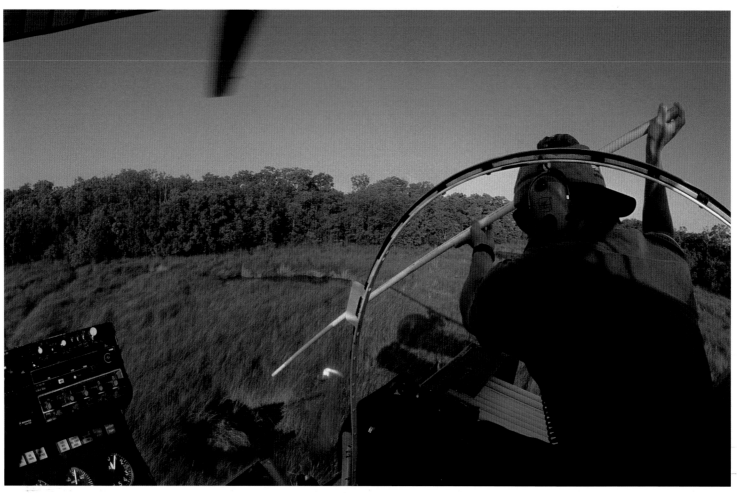

Biologists George Melancon *(above)* and Darren Richard *(right)* throw PVC poles from helicopters to mark alligator nests.

for copulation, which can last for a couple of minutes. Dominant males may mate with several females over a period of a few weeks, and evidence indicates that females will also mate with multiple partners. Dr. Ruth Elsey and colleagues at the Rockefeller Wildlife Refuge in Southwest Louisiana have done DNA studies proving that multiple males often fertilize one female. One clutch was shown to be fathered by three males; numerous clutches were fathered by two males.

When courtship and breeding are over, the male's job is done. It's up to the female to see that her young hatch and to protect them afterwards. In effect, female alligators are "single moms"—though they don't all have the same parenting impulses. Some females will leave their nests after laying eggs never to return; others will stay close by and vigilantly guard their nests and, later, their young. After fertilization, a female alligator's first item of business is to make a nest. In most cases she uses vegetation ripped off with her mouth from the surrounding marsh, pushing it up into a mound. The mother will crawl over the nest, compacting it and adding more material until she gets it about three feet tall. Sometimes she will make a few practice nests before laying her eggs. The nests I viewed in the wire grass marshes on Rockefeller Refuge were surrounded by water. This "moat effect" was the result of the female pulling the surrounding vegetation for construction materials. Many mothers had their dens (gator holes) near the nest.

Once the mound meets the alligator's satisfaction, she uses her hind legs to dig a hole from the top and then deposits an average of thirty-nine eggs all at once. McIlhenny found from twenty-nine to sixty-eight eggs apiece in hundreds of nests he checked. Ted Joanen, a onetime research leader now retired from Rockefeller, found nests with as few as two to as many as fifty-eight eggs. The female, in

most cases, stays close by at first, maybe for the whole incubation period, though some mothers leave, then return when the eggs are about to hatch. Incubation usually takes about sixty-three days or longer, depending on the temperature of the nest. The mother alligator will sometimes drag her wet body over the nest to dampen it and keep the temperature right. Sometimes she'll urinate on the pile for the same reason. Not only does the temperature inside the nest determine the time needed for embryo development, it also determines the sex of the hatchling. Warm temperatures of 90° to 91°F will cause baby alligators to hatch as males. Eggs incubated in medium temperatures of 87° to 90°F will give rise to males and females, while those that develop at lower temperatures of 82° to 86°F will hatch as females. Temperatures below 82°F and above 93°F may cause the embryos to die.

Both commercial farmers and biologists use helicopters or even ultralight planes to locate alligator nests. I tagged along one day with Rockefeller biologist George Melancon as he marked nests. We flew low over the marsh until we spotted one, then George would toss from the helicopter a long PVC pole painted orange on the tip, driving it like a javelin into the ground by the nest. His accuracy was amazing. Later Ruth Elsey and I went out in the airboat to find the nests George had marked. Ruth collects eggs to incubate and hatch for her DNA studies and for some other scientists to use in different research.

At one nest the female was particularly aggressive and came right up over the mound and almost into the boat. Dwayne LeJeune had to hold her at bay with a pole while Ruth collected the eggs. This wasn't the only protective mother I met that summer. Others charged us in Lake Jessup and Lake Tohopekaliga on airboat tours, yet another at Eco Pond in the Everglades, and I saw two aggressive semicaptive females in the breeding ponds at Everglades Alligator Farm and Gatorland. This protective motherly instinct is rare in reptiles. Snakes and lizards don't seem to have it at all, but most crocodilians do in one way or another. Perhaps it springs from necessity. Alligator eggs and babies are a good meal for many predators, and the mother gator's hissing, mouth-wide-open charges help keep a few of these dangers away.

When the young gators are about to hatch, they begin to chirp while still in their eggshells. This is a signal to the mother, who will in some cases come back to the nest, open it, and take the young in her mouth, then carry them to a safe spot near the den.

I got to see a variation of this behavior at Rockefeller Refuge, where a pair of alligators in a large pen were part of a captive breeding study started by Ted Joanen in the mid-sixties. The pair had mated most years, the female built nests and laid eggs, but every year they were infertile. This female had had little, if any, exposure to hatchlings or practice at maternal care.

With permission from Ruth, Phillip ("Scooter") Trosclair, Dwayne LeJeune, and Bill Hughes, I took the fifteen incubated hatchlings Ruth was going to release back in the marsh to this female's pen. We backed a pickup to the fence near her infertile nest. She charged right up to the fence. Then Scooter took a long pole with a net on the end and dropped the hatchlings on top of her nest. She heard the chirps, turned, and waddled back to her nest. Then she angled her jaw to the side and grabbed a baby

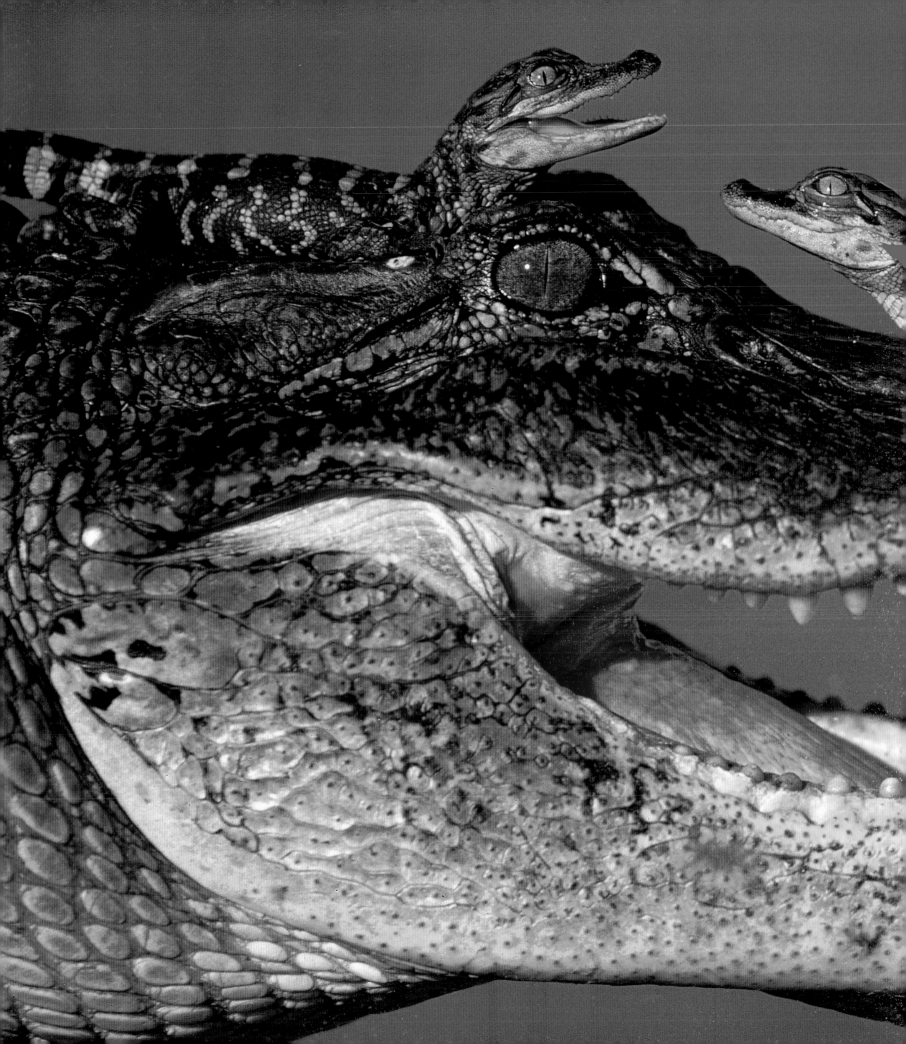

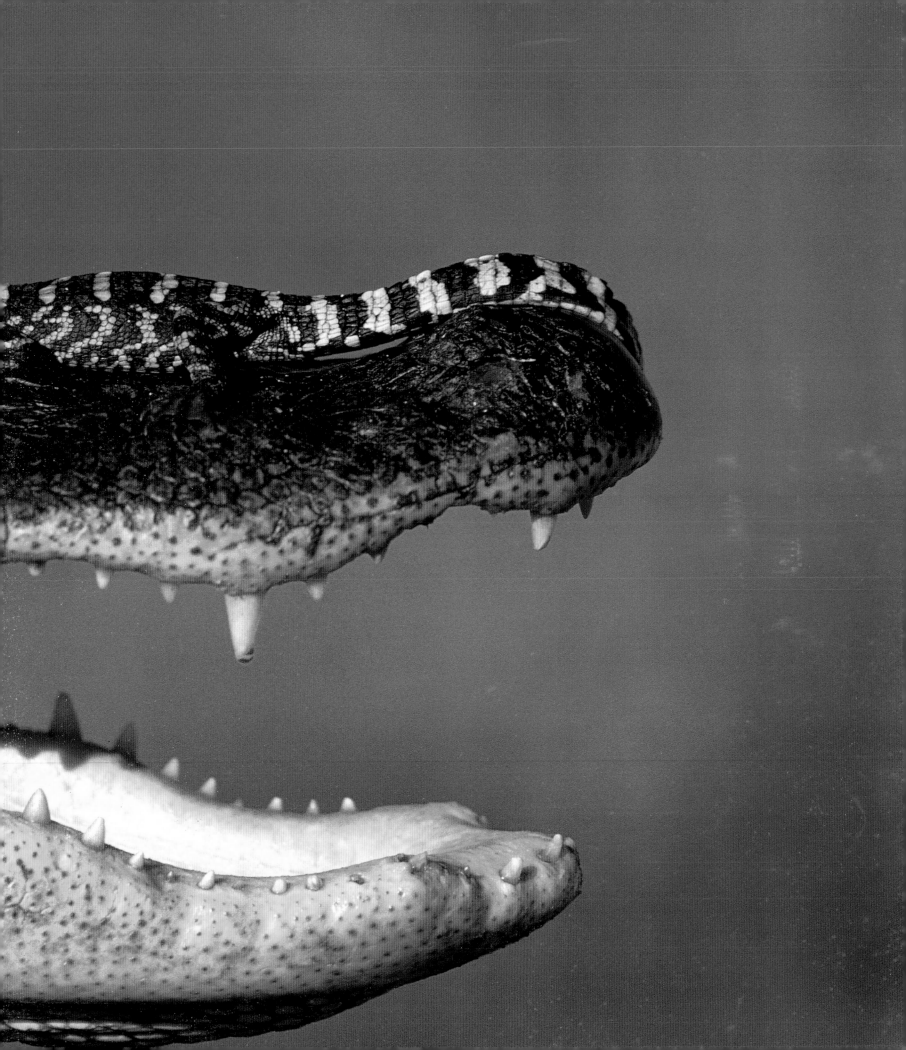

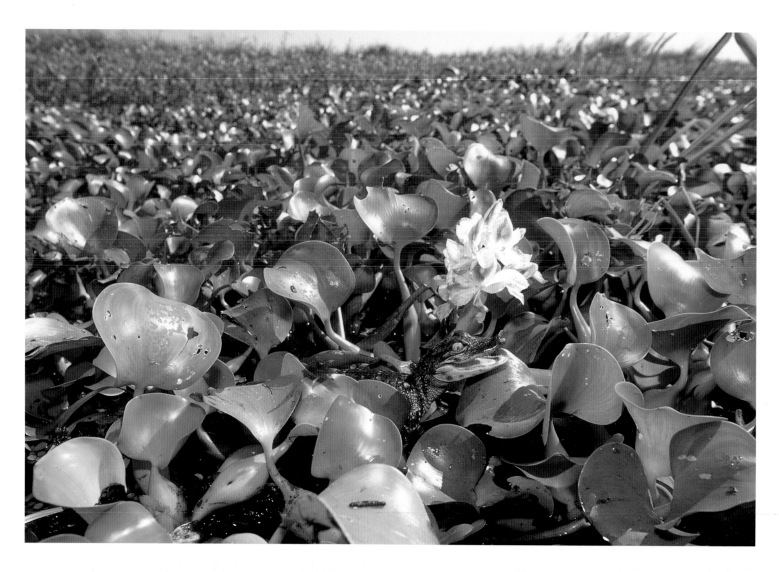

Often alligator mothers stay near the nest to care for their hatchlings, who sometimes crawl all over them *(previous spread)*. When protecting their young, mothers can be quite aggressive *(far right)* or very gentle; this infertile female at Rockefeller Refuge *(right)* carries her adopted young from the nest. Mother is not always nearby, however, so hatchlings use their natural camouflage to remain hidden. *(above)*.

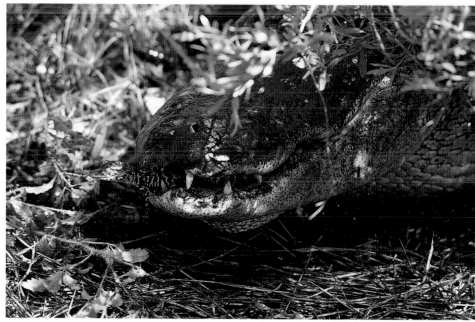

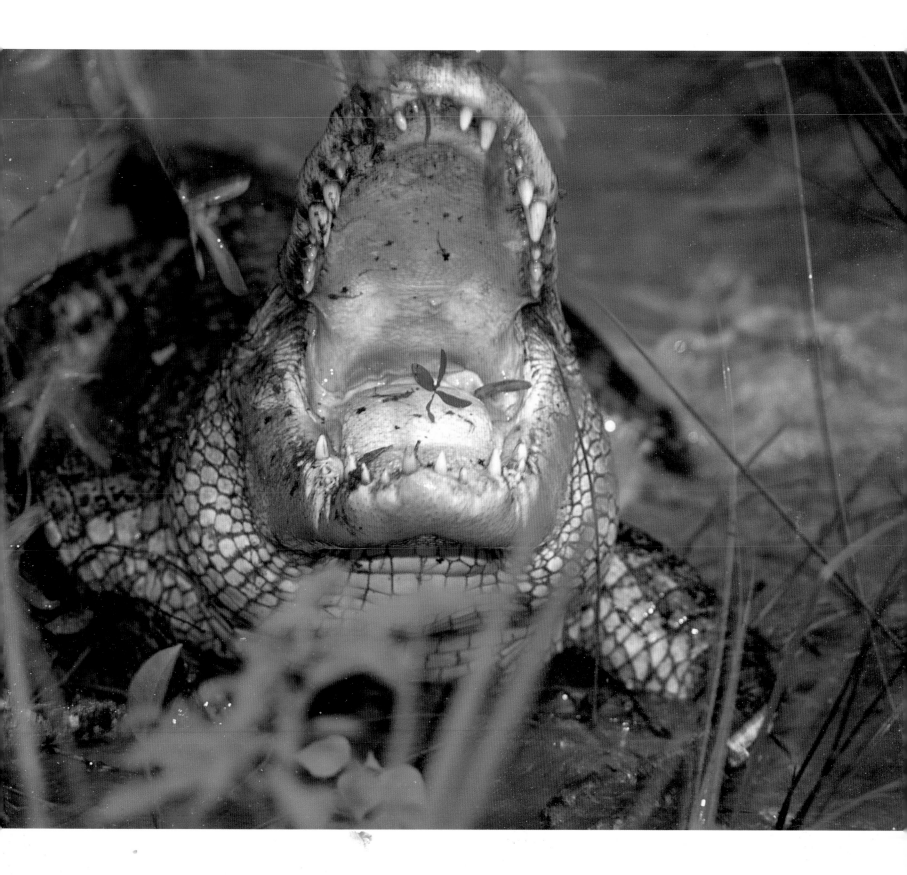

gator. It was a rough grab, and at first we thought she had eaten the hatchling. No, just a lack of practice, for she got better after the second and third shuttle and soon moved all the hatchlings one by one to a safe place in the California bullwhip. Touching to know that instinct remained after all those infertile years—more proof of the parental care that is so unique in the reptile world.

Ted Joanen told me some interesting stories about the early days of research in those pens. They started by capturing wild alligators and putting them in the variously sized enclosures with ponds, experimenting with the number of the alligators and gender ratio. Watching from the towers to see the gators bellowing, courting, and breeding, they worked by day and by night using night-vision scopes. In one pen, a female was bellowing, communicating with a male outside her pen. She obviously did not like the male in her pen, for she killed him. The outside male tried to break into the female's pen. Ted saw this and jumped on its back, capturing it and putting it in with the female. They immediately bred. In these studies they found the female did the mate selection.

In the wild, hatchlings may stay around their mother's den for a year, but on occasion longer. At Little Pecan Island, a chenier that was once a Nature Conservancy property, I was canoeing and came across a female in her den hole with three generations of young. It was October, and there was a group of the present year's hatch at ten inches, another group of eighteen-inchers from the previous year, and a few two-to-three footers born two years earlier—quite the family group!

Food

Alligators do not need a cafeteria, for they will eat just about anything wherever they are, including their own kind. Both sexes are cannibalistic, though a female usually protects her own young. Generally what an alligator eats depends on its size and what is available in its habitat. Its diet can include insects, crawfish, crabs, fish, snakes, frogs, birds, small mammals, and even deer and wild pigs. Alligators' sharp, conical teeth efficiently grab and hold prey, which they can then crush using their tremendous bite pressure. Their violent shaking and rolling can tear chunks off their prey, and if dinner still remains intact, on last resort they cache their catch in underwater caves until the meat putrefies and is soft enough to tear apart and eat.

Though seemingly equipped for voracious feeding, alligators can survive without eating for long periods, perhaps over a year. In most of their range, they stop eating altogether during the cooler months from October to March. Energy use is efficient. None is needed for keeping the body warm.

Digestion is aided by the strongest stomach acid known to vertebrates, which has given rise to many tall tales. I heard all through childhood that an alligator could digest large nails and even a railroad spike. Untrue. What they can do is digest and obtain energy and nutrients from bone. Examining the contents of alligators' stomachs, Ruth Elsey has found shotgun shell casings, fishing lures, pieces of glass, and bottle caps, among other things, rusty but not digested. She has also found balls of nutria hair. Ted Joanen took a picture of one of these fur balls next to and as big as a baseball.

In 1916 McIlhenny proved alligators eat what's most available. For four years he had closed alligator hunting on the three coastal refuges that he helped form. Gators had become numerous, causing the muskrat trappers to complain their quarry was declining. McIlhenny ordered fifty alligators caught; muskrats proved to be the principle food of every one. More recently, Ted Joanen's studies found nutria to be a major food source in the same areas. The nutria is a species that was introduced into the marshes of Louisiana and has pushed the muskrat out of much of its habitat, leading the opportunistic alligator to switch diets.

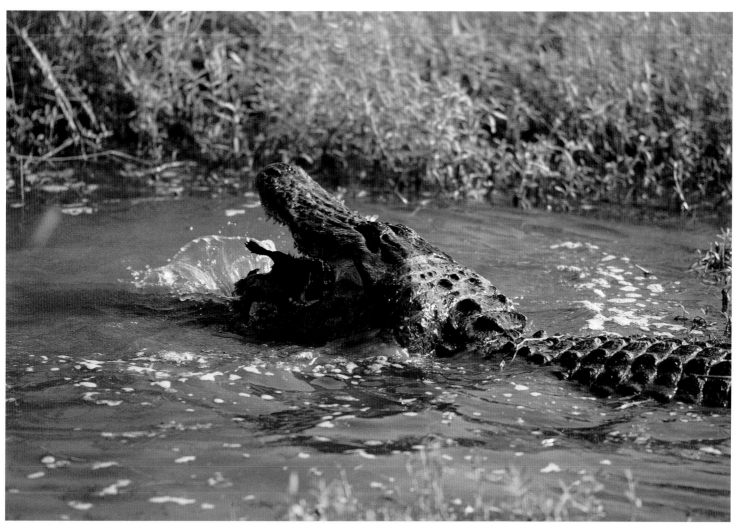

Alligators chomp on their food, in this case a nutria, to break it up *(above)*, then have to raise their heads to let gravity help them swallow *(following page)*.

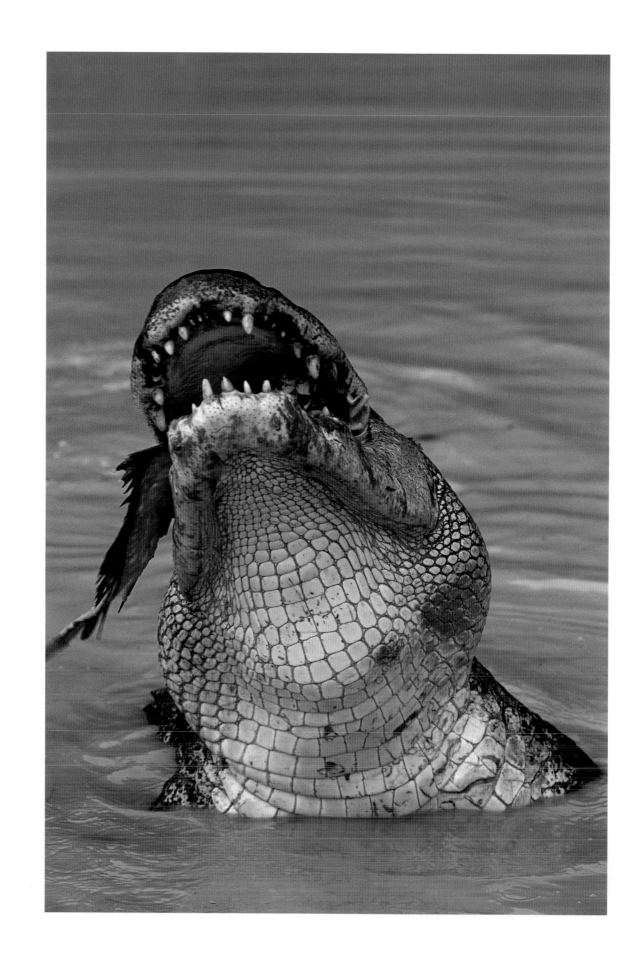

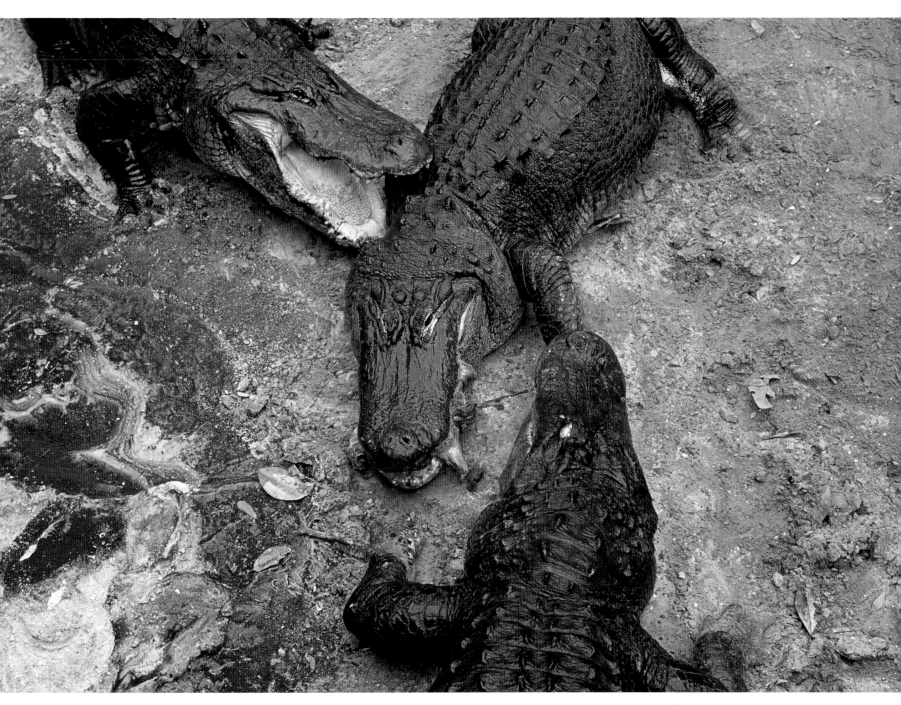

Gators fighting over a nutria during a feeding show at an alligator attraction (above).

Taxonomy

Most people call this creature of U.S. marshes and swamps the alligator, but that can be confusing because there are two species of alligators: the American alligator, which this book is about, and the Chinese alligator, a highly endangered species that has limited habitat in China. There are also twenty-one other species in the family Crocodylidae. The two species of alligator and six species of caimans are in the subfamily Alligatorinae. Fourteen species of crocodiles and a false gharial are in the subfamily Crocodylinae, and there is one species of gharial (distinguished from typical crocodiles by their long, slender jaws) in the subfamily Gavialinae. Each of these twenty-three species has a two-part Latin name (binomial nomenclature) to uniquely identify it when scientists of different countries discuss its characteristics.

The American alligator is known as *Alligator mississippiensis*. Its entire classification within the kingdom Animalia is listed below, followed by a list of all twenty-three species. On pages 122 and 123 you can see photographs of the other twenty-two species to compare them. There are many books on other species of crocs if you would like to learn more about the entire family.

AMERICAN ALLIGATOR

KINGDOM	Animalia
PHYLUM	Chordata
CLASS	Reptilia
ORDER	Crocodylia
FAMILY	Crocodylidae
SUBFAMILY	Alligatorinae
GENUS	*Alligator*
SPECIES	*mississippiensis*

SUBFAMILY ALLIGATORINAE: ALLIGATORS AND CAIMANS

American alligator	*Alligator mississippiensis*
Chinese alligator	*Alligator sinensis*
Common caiman	*Caiman crocodilus*
Broad-snouted caiman	*Caiman latirostris*
Cuvier's smooth-fronted caiman	*Paleosuchus palpebrosus*
Schneider's smooth-fronted caiman	*Paleosuchus trigonatus*
Black caiman	*Melanosuchus niger*
Yacaré	*Caiman yacare*

SUBFAMILY CROCODYLINAE: CROCODILES

American crocodile	*Crocodylus acutus*
Morelet's crocodile	*Crocodylus moreletii*
Cuban crocodile	*Crocodylus rhombifer*
Orinoco crocodile	*Crocodylus intermedius*
Nile crocodile	*Crocodylus niloticus*

African slender-snouted crocodile	*Crocodylus cataphractus*
Indo-Pacific crocodile	*Crocodylus porosus*
Mugger	*Crocodylus palustris*
Johnstone's crocodile	*Crocodylus johnsoni*
New Guinea crocodile	*Crocodylus novaeguineae*
Philippine crocodile	*Crocodylus mindorensis*
Siamese crocodile	*Crocodylus siamensis*
Dwarf crocodile	*Osteolaemus tetraspis*
False gharial	*Tomistoma schlegelii*

SUBFAMILY GAVIALINAE: GHARIALS

Gharial	*Gavialis gangeticus*

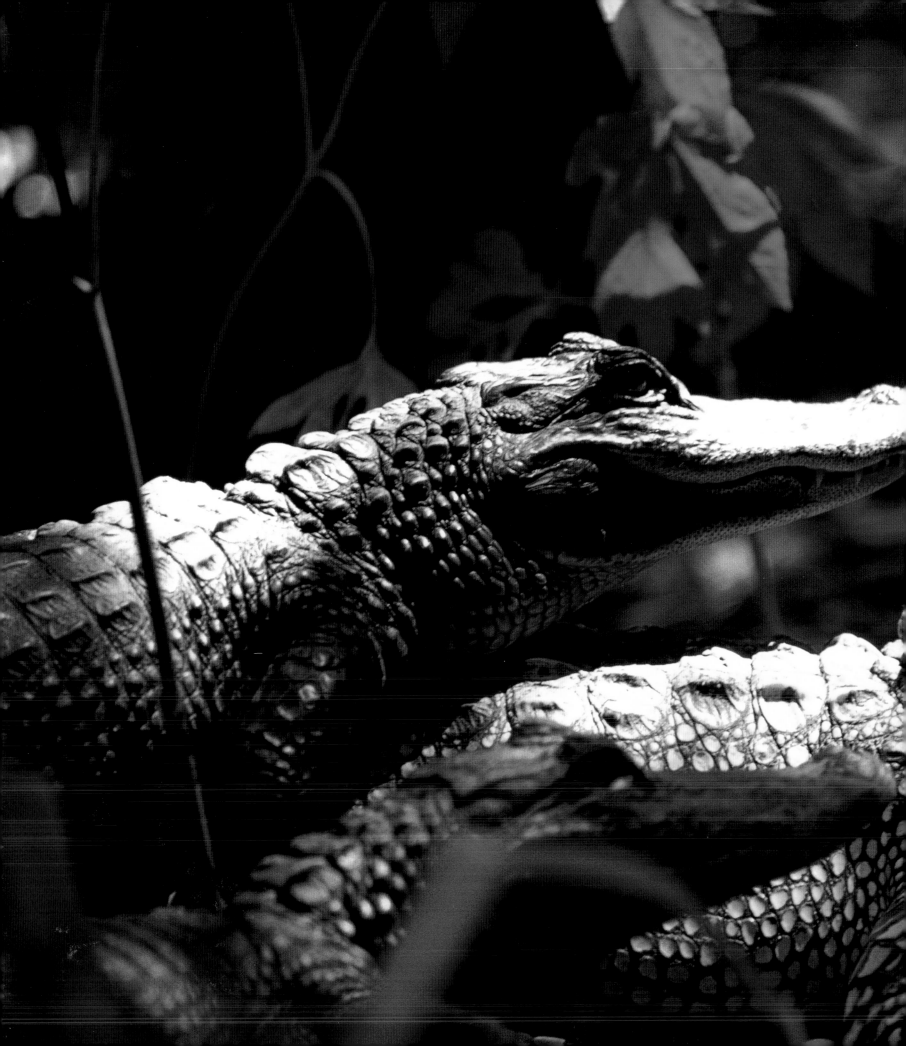

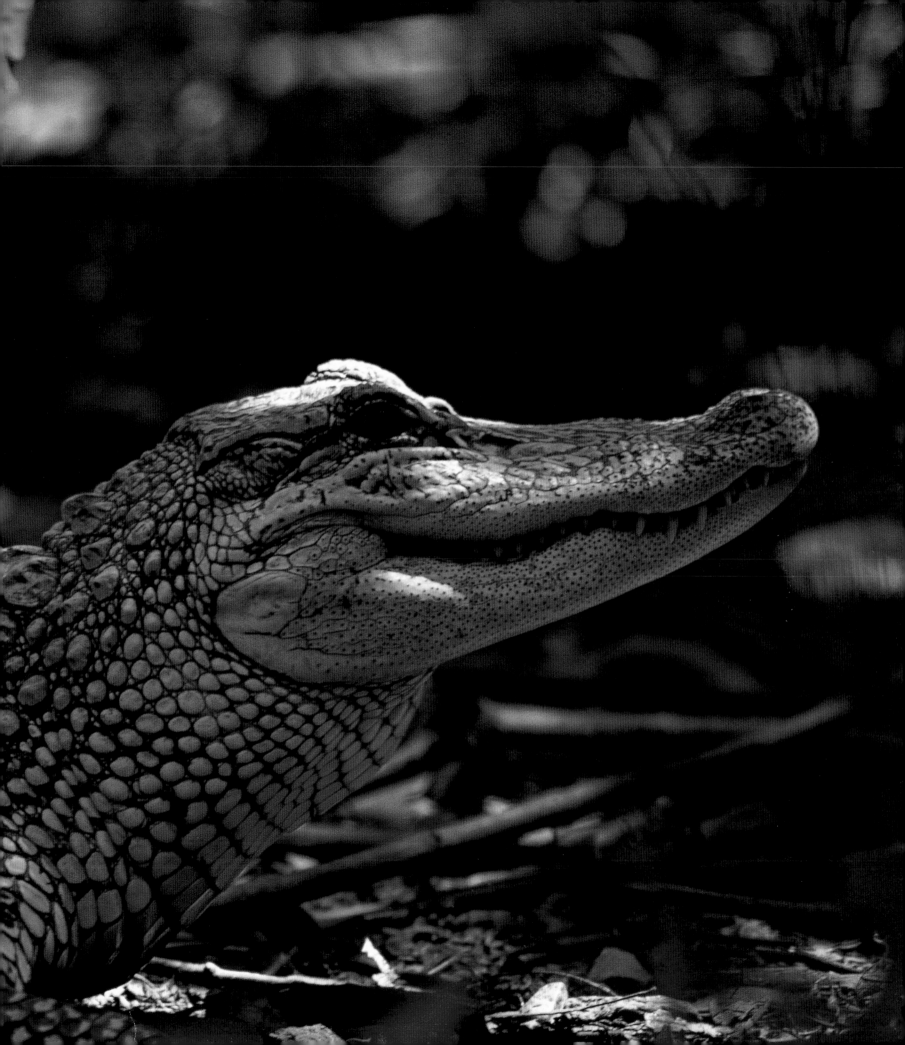

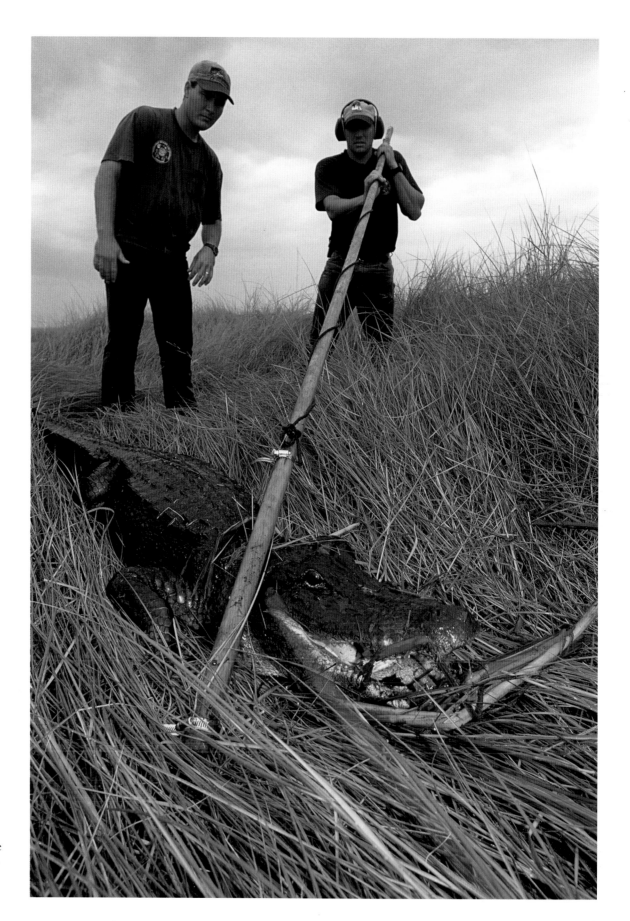

Scooter Trosclair and George Melancon catch a female alligator near her nest for Dr. Ruth Elsey's DNA studies.

Young alligators basking in the sun *(previous spread)*; one appears more greenish in the light filtering through fresh spring leaves.

II *Research and Regulation*

NOT even a day at Disney World combined with a ride on the world's largest roller coaster could match a night in the marsh capturing and releasing alligators with Dr. Ruth Elsey and her crew of biologists and technicians. Ruth's a doctor who turned down a career in medicine. Her fate was sealed when, the summer after her junior year at LSU, she took a course with Dr. Val Lance, helping him with his research. Unbeknownst to her, the research was on the alligator. Dr. Lance took her to Rockefeller Refuge in southwest Louisiana to do some endocrinology work, and Ruth was instantly smitten with the reptiles. She went on to finish medical school, do a residency in internal medicine, and accept a fellowship in nephrology, but when a wildlife biologist job in charge of alligator farming became available at Rockefeller, she took it.

Wildlife biologists study and manage both game and non-game animals on federal, state, and private lands around the world. If man were not here, or if he were living in Neanderthal conditions, biologists would be unnecessary. Nature has a way of taking care of itself as long as it is allowed to run its course without interference. When man intervenes, however, problems arise. Take the Atchafalaya Basin, for example. Without wildlife biologists to study and manage the basin, it would probably be drained and occupied by people. By maintaining this 18-mile-wide, 120-mile-long strip of hardwood bottomland, cypress tupelo swamp, coastal marsh, bays, islands, and the continental shelf of the Gulf of Mexico, we do a lot of good things. The billions of gallons of water that come in from the Mississippi River are in a somewhat polluted state at best, but the water is filtered as it flows through 1.4 million acres of trees and other vegetation. Those trees produce clean air. The water, the woods, the mud, and the marsh produce and sustain crawfish, owls, gators, snakes, deer, raccoons, shrimp, and oysters for our food and recreation. The sediment builds new land in the Atchafalaya

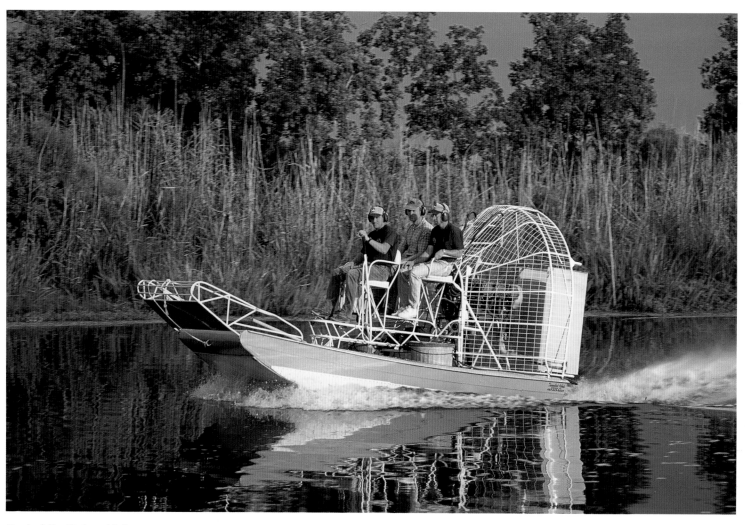

Rockefeller Refuge biologists en route to an alligator nest.

delta—land and marsh that provide a hurricane buffer to coastal towns and cities. So whether a biologist is studying ants or alligators, most of the time his job is for the good of all life.

Ruth and her coworkers George Melancon, Phillip Trosclair, Jeb Linscombe, and others go out about three times a month to catch and release alligators for their current study. I joined them one night at dusk at refuge headquarters, where they hitched up two airboats to the backs of their trucks and drove sixteen miles to a canal in the center of the refuge. George and Jeb dropped their boats in the canal, cranked up the powerful engines, drove the boats right up onto the bank, and spun them around—ready to load and go. At 280 horsepower, the Lycoming airplane engines that power these unique boats have a lot of bang for their weight. They are much lighter than the V-8 automobile engines that power many airboats, which allows the Lycoming crafts to go more places while doing less damage to the marsh. George tells me they can go up to seventy miles per hour in good conditions, though speed is not needed for alligator work. The bottoms of the boats are Teflon so they can slide more easily over the marsh. The engines make a lot of noise.

We put on our ear protection and took off very fast down the canal. Mosquitoes and other insects were splashing into my face, and I made a note to bring glasses or goggles next time. The very last burnt orange of sunset faded as a dory-shaped crescent moon set in the remnant glow. The bright Q-beam of the other boat threw the speeding shadow of our boat up on the roseau cane along the banks. An adventure to most is only another night's work for the biologist.

Less than a mile down the canal, George slowed and turned toward the bank, then popped up and over a levee twenty feet wide and eight feet tall—just like one of those rides at Disney World. We were now in a freshwater impoundment, one of many on 76,000-acre Rockefeller Refuge. The work began. Ruth took over driving, and George got on the bow to snare a gator. The Q-beam scanned the marsh pond that contained various marsh plants like California bullwhip, wire grass, cattail, and some roseau cane. When the engine was turned off, I could feel and smell the productivity of this habitat, and hear it too. Coots, teal, and moorhens would flush in front of us, and the eyes of alligators shined from everywhere. We picked a set of glowing orbs, eased up, and quick as the flash of a hummingbird's wing, George caught a four-and-a-half-footer, and then an eight-footer. The captures were quick, with lots of twisting, tail slapping, and water splashing. Normally Ruth and her crew don't go for bigger alligators in the airboats because the working space is cramped. They try to catch the big ones in the canals from a different type of boat on other nights.

With a little bit of a struggle, George got the eight-footer in the boat. One person then straddled the alligator much as you would a horse, while the other secured the dangerous part, the mouth, with heavy-duty rubber bands. Then, in quick succession, a blood sample was taken, the alligator was measured, tagged with two numbered metal tags, and finally its sex was checked. After Ruth got her data, the alligator was released.

By midnight we had tagged twenty-three alligators in our boat, the other airboat nineteen. The smallest was 2' 2", and the largest was the eight-footer. There were twenty-two males and twenty females. Just as they tagged the last one, the wind freshened quickly and the bullwhip grasses began waving wildly. Clouds were already overhead, and the smell of imminent rain was in the air. The rain came and came hard by the time we fired up the boats. The temperature dropped, and the rain burned our faces as we sped toward the boat ramp.

On another night I joined the group to catch the bigger alligators in the canals. We loaded up at the boathouse at refuge headquarters and headed south in two bateaus—flat-bottomed boats powered by outboard motors (what might be called johnboats in other parts of the country). Fires were burning in the marsh. Hot yellow flames stood out brightly below the dark gray smoke blending in to the overcast night sky above. Burning is a wildlife management tool that gets rid of the thick brown marsh grass to let new green tender shoots come up for the wintering waterfowl.

Down the canal we went, and I was shocked by the number of eyes that reflected back at us from the alligators. There were well over a hundred. Wildlife technician Phillip Trosclair, better known as Scooter, was at the snare that night. A local man, he grew up hunting alligators with his father on Miami Corporation property.

It was fun watching these pros get down to business. The bateau would edge up to an alligator with the Q-beam shining brightly in its eyes. The small ones were quick and easy. Scooter would close the snare, jerk the alligator in the boat to be instantly subdued, studied, and put back in the canal in less than five minutes. Big ones were a different story. For these they use a twelve-foot wooden pole with a wolf snare attached. Once a big gator is snared, the boat drags it to the canal bank, where everybody gets out to pull the monster up on shore. Covering the alligator's eyes with a burlap sack calms it so that it can be secured. Rubber bands keep the mouth closed. Gators of this size can really do some damage if they bite.

The big one we got that night was 9' 4", a real whopper. When the science was done and Scooter pulled the rubber bands to release the gator, it turned and leapt for the water and, not seeing the boat, almost jumped in where Ruth was standing. Exciting as all this seems and is, the Rockefeller biologist runs a safe ship. No one has been bitten yet in studies Ruth has headed up. Her current research involves looking at sex steroids—testosterone in males and estradiol in females—in animals of varying

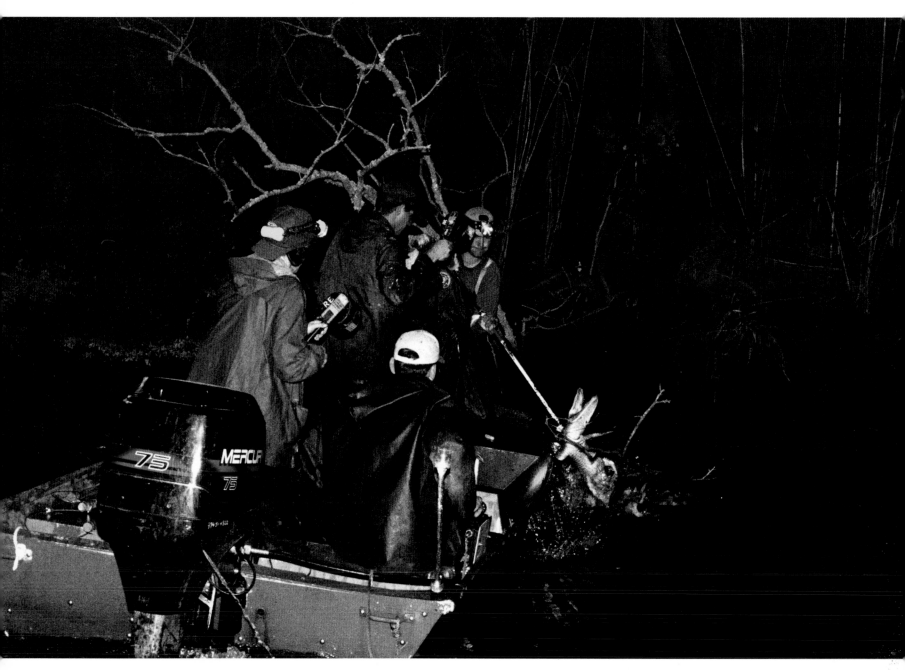

Dr. Ruth Elsey and her co-
workers capturing alligators
(above) on Rockefeller Refuge.
The reptiles are measured,
tagged, and blood samples are
taken *(right)*.

Headlamps and Q-beams blur
in the fast and furious action
when Scooter Trosclair snares
an alligator *(previous spread)*.

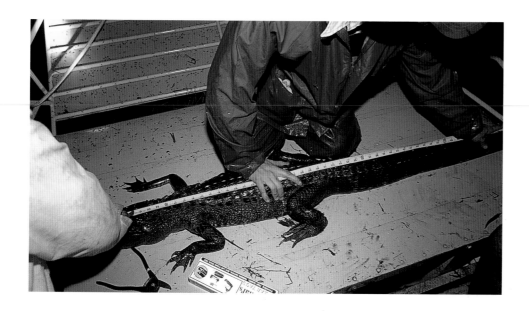

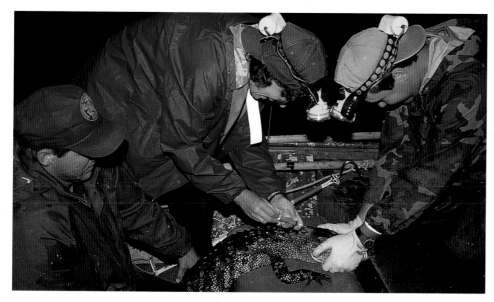

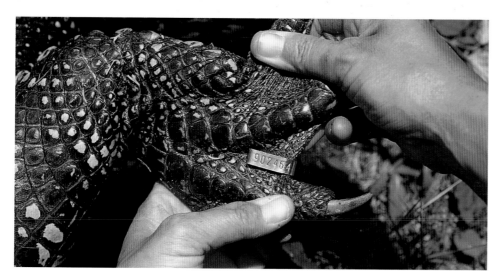

An American alligator lurking in the moonlit marsh vegetation of Rockefeller Refuge.

sizes, age groups, and habitats to answer many questions about alligators' sexual maturity. Working jointly with her former professor Dr. Val Lance, who is now at the San Diego Zoological Park, she has been collecting data on this study since July 2000. Her goal is to obtain data on 215 alligators of varying sizes from both the marsh and the canals each month. This would give her enough samples for statistically valid results. So far they have caught 1,070 alligators out of the 5,160 needed. Seventy-seven of them have been retraps, which will help determine the seasonal variation in individual alligators.

Louisiana and Rockefeller Refuge have led the way in alligator research, starting with E. A. McIlhenny. Ted Joanen, R. H. Chabreck, Larry McNease, Noel Kinler, and Ruth Elsey have carried on that work.

According to Don Ashley, a consultant who has worked with Louisiana alligator trappers, farmers, buyers, landowners, and biologists for years, Ted Joanen was the catalyst in the comeback of the American alligator. Ted started as a wildlife biologist at Rockefeller in 1963.

Ted told me he first got interested in alligators at six years old when he lived in Metairie, Louisiana. He got his first chance to spend time at Rockefeller Refuge in late 1960 while doing his master's thesis on the marsh ecology of widgeon grass. In our conversations it sounded like Ted would rather have worked on alligators, but this thesis work came with a grant, and it put Ted right in the middle of one of the largest populations of wild alligators. While working on his study he got to help out on some of this reptile work, then providence prevailed, for as he finished his thesis in 1963, a position as a wildlife biologist came open.

Rockefeller Refuge, resting between the Gulf of Mexico and the Grand Chenier Ridge six miles to the north, was originally 86,000 acres and was purchased by E. A. McIlhenny for $2.50 per acre. He in turn sold it to the Rockefeller Foundation, suggesting they donate it to the state as he and Charles Ward did with two other refuges—State Wildlife Refuge and Marsh Island. Rockefeller has since eroded down to 76,000 acres, but it is still the treasure trove of wildlife research centers, and Ted Joanen arrived at just the right time.

When the property was dedicated to the state, there was very specific language in the deed stipulating that all revenues coming from it were to be used by the refuge and could not be assimilated into the state's general budget. In 1963 oil and gas revenues were high, so Rockefeller Refuge had a lot of money for research and management. Alligator populations had hit an all-time low in the 1950s, and in 1962 the state was forced to close the season. The state then assigned Rockefeller the task of doing a life history of this declining animal. Ted spent the next thirty-one years studying the alligator and other wildlife, retiring as research leader in 1994.

Ted tells me the alligator is a resilient species. Alligators played an important role in the Civil War when cow leather was cut off from the Confederate army; the soldiers made do with alligator hides for boots, belts, and saddles. By 1875 alligator reached its height in the fashion industry, and most of the country's number one grade skins were going to New York City. The seconds went to the

European markets. Despite the demand for alligator bags, shoes, belts, and other sundries, the alligator population was never strained then, probably because so much of the habitat was inaccessible.

McIlhenny writes that the first hide hunters came to his little island-in-the-marsh paradise in 1883. He estimated that three to three and a half million skins were taken in Louisiana between 1880 and 1933 and predicted the demise of the alligator would come from the internal combustion engine, which would allow man to fully infiltrate its territory. The demise never came, but the alligator's decline was helped by World War II and the oil industry. Ted tells me the giant army-surplus rubber tires were used to make the first marsh buggies. Local boys back from the war took jobs driving these for oil industry seismic crews. Whenever they saw an alligator den, they would stop and probe the hole, snag the gator, skin it, and carry on with their real jobs. These alligators, taken deep in the marsh, were the breeding females. Another problem was that many returning vets could not get work, so they went to the marsh to hunt, fish, and trap for a living. These swampers, even without marsh buggies, had access to breeding habitat because the oil field location canals became highways into the back marsh.

Only 5 percent of the entire alligator population is breeding females. The number one rule of alligator management today is that you cannot put too much pressure on this group. With the opening up of the marsh in the late forties, however, the pressure was definitely on. Thus, right after the war, the decline began.

The only records of skins taken at that time in Louisiana were the severance taxes on alligator hides that left the state. From 1946 to 1948 fifty thousand skins were leaving the state each year. In 1960 only eighteen hundred skins left, and this wasn't due to a shortage of hunters. The Department of Wildlife and Fisheries realized there was a problem, so the season was closed in 1962.

Like all wildlife, alligators are hard to count. The problem, explained Noel Kinler, alligator program manager for the Louisiana Department of Wildlife and Fisheries, is that they are mainly nocturnal creatures, well camouflaged, aquatic, secretive, and they live in hard-to-get-to places. Wildlife managers have persevered and come up with at least three ways to count alligator populations. The most accurate method, and the one used in Louisiana, is aerial nest counts. The other two are night eye-shine count and basking count.

I flew with Noel and his coworker, biologist Tom Hess, one day during the 2001 nest survey. Noel sat up front with the pilot of a Bell Jet Ranger helicopter to do the navigating while Tom sat in the rear, spotting and counting the nests. This count has been conducted on since 1970 using basically the same techniques, thereby keeping the data consistent. Of course, modern technology has replaced the maps and landmarks they used for years with laptop computers and GPS instruments. Each year Tom sits and looks out the window in the same position so he can be assured of seeing the same 350-foot-wide strip of marsh on each of hundreds of north/south passes they make. The two men fly these transects at two-mile intervals through-

Alligators share the marsh with the oil industry. This particular drilling rig is accessed by a new type of plastic road that is less harmful to the marsh.

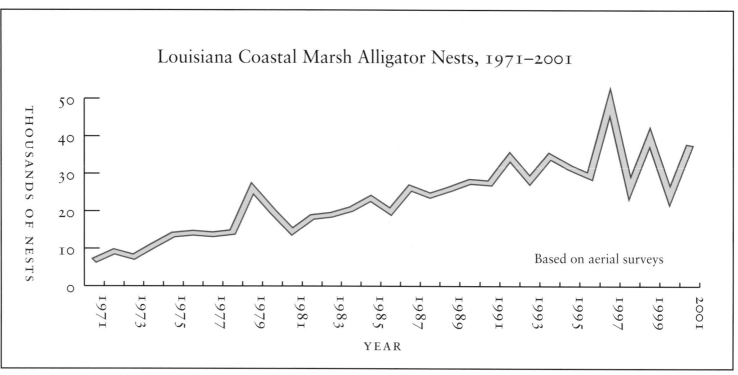

Louisiana Coastal Marsh Alligator Nests, 1971–2001

THOUSANDS OF NESTS

Based on aerial surveys

YEAR

Courtesy Louisiana Department of Wildlife and Fisheries, Alligator Management Programs

out Louisiana's coastal marsh from Texas to Mississippi. In nine days of flying they see 3 percent, or 89,416 acres, of the total territory. By knowing the number of nests in that range they can extrapolate to figure out the total nests on the 3,006,740 acres of wetland habitat they sample. After they arrive at that total comes the hard part of deciding how many alligators each nest represents. The nest count was 37,693 in 2001. By using information from many studies over the years combined with harvest data, Noel estimated that each nest represented sixty alligators. He showed me a bar chart that helped him come up with this figure; it gave a number for each size class. For every 265 one-foot gators there are 200 two-foot gators, and so on.

The surveyors not only take the nest count, they also map the area by habitat and ownership. Thus Noel can break down the numbers of nests in various marsh types: fresh, intermediate, and brackish. All these data are used to set the number of alligators that can be harvested from each habitat type as well as how many eggs can be collected. Noel showed me his table for Terrebonne Parish (a parish in Louisiana is like a county in other states). In the freshwater marsh column it showed 138

nests in the year 2000 and 266 nests in 2001 on the transects they flew. This big difference is attributed to the extreme drought conditions in 2000. Drought stresses alligators, and as a result, many females fail to develop the hormones necessary to ovulate and successfully breed. To level out such dips and spikes, they use a five-year average to set the harvest quota, which for Terrebonne was 163 in 2001. Multiply this out for the entire acreage of freshwater marsh and you get 5,642 nests and over 300,000 alligators.

I asked Noel how the population is doing, and he replied by showing me a graph of the active nests from 1970 to 2001. It was a continuous up-hill climb, a chart a CFO would love to show his boss. Noel has so much data you'd think he was a mathematician. He showed me two-inch-thick books generated by their software that have size data on all the alligators

Bayou Pierre Gator Park and Show, once a working alligator farm, built attractive exhibits to become a wildlife attraction *(left)*. Kliebert's Turtle and Alligator Farm uses rubber mats on the edges of its growing ponds to keep young alligators from scratching their belly skin *(far left)*.

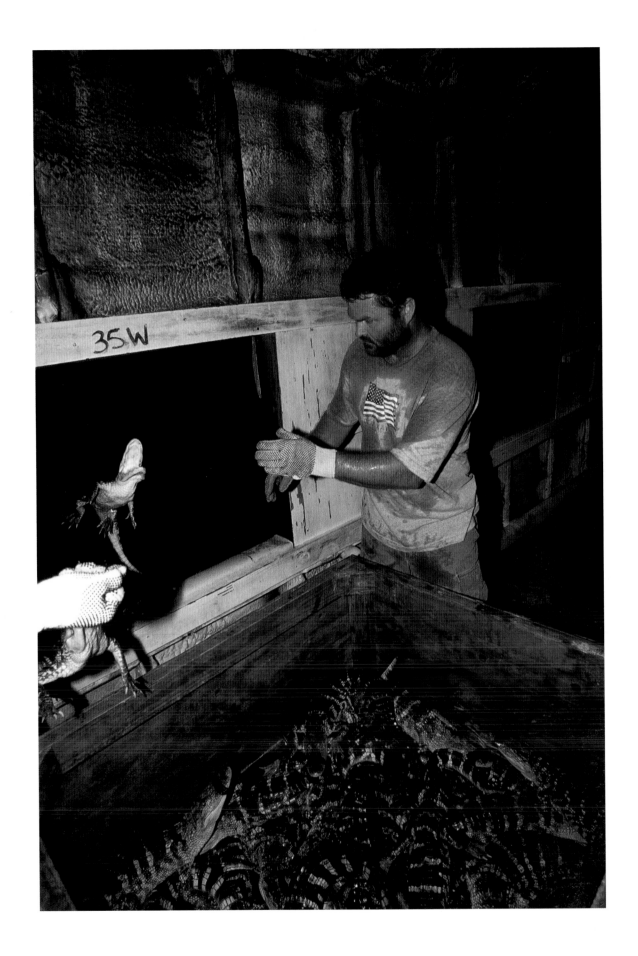

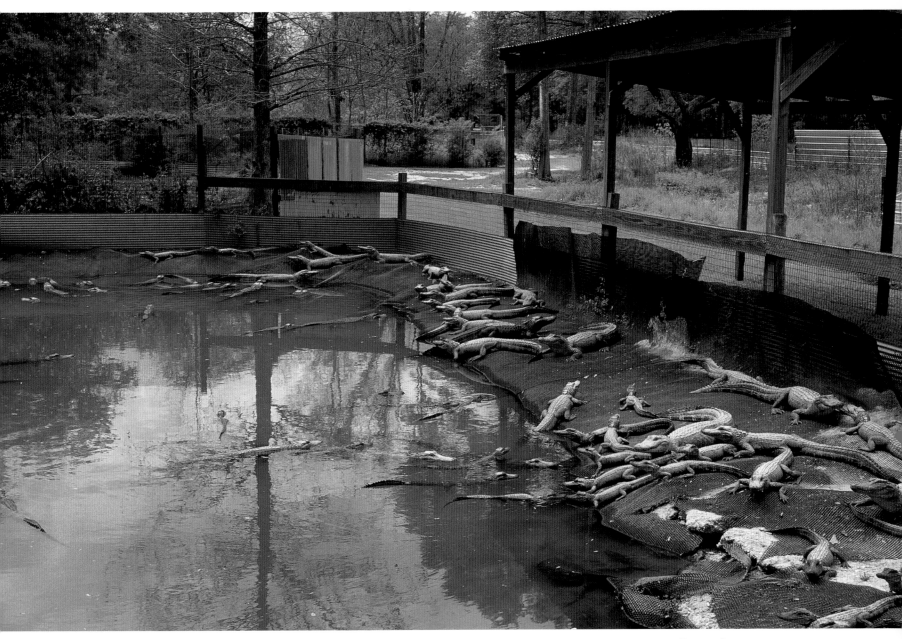

Many alligator farms use temperature-controlled barns to achieve maximum gator growth *(left)*. Other farms double as wildlife attractions and keep their alligators in outdoor ponds *(above)*.

Feeding time at Everglades Alligator Farm brings a group of large alligators together *(overleaf)*.

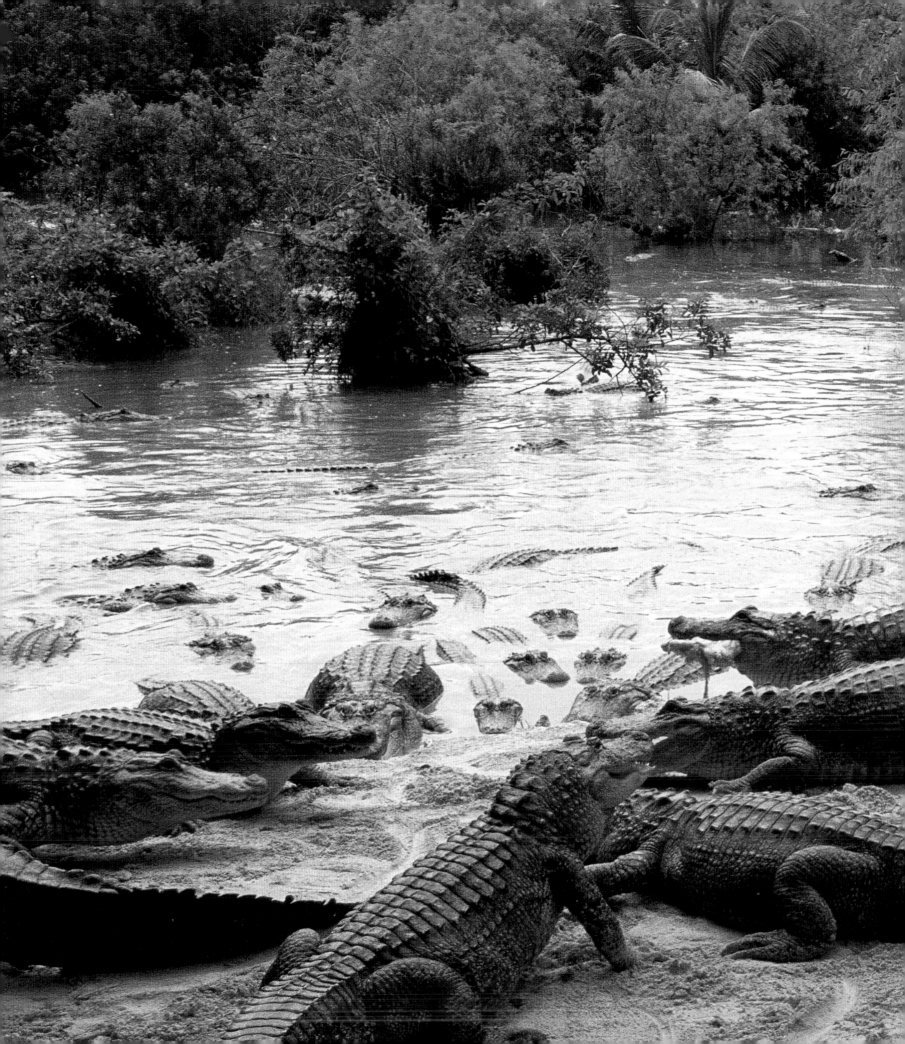

Al Wehmeier in his shop in the
New Orleans French Quarter
(above). Belts, boots, brief-
cases, and even golf bags are
made from skins sometimes
colorfully dyed *(right)*.

taken since 1970. When a trend goes askew, say in the seven-foot size class in southeast Louisiana, they can immediately make quota adjustments. Numbers are not all Noel deals with, for the public has its own ideas; some are afraid the alligator populations are getting too large and want more to be taken. The egg collectors may want fewer taken, theoretically leaving more females to make more eggs that they can collect and incubate in their farms.

There are ten states that have wild alligator populations: North and South Carolina, Georgia, Florida, Alabama, Mississippi, Louisiana, Texas, Arkansas, and Oklahoma. I surveyed them all and found Oklahoma has the lowest, with an estimated 150 to 200 alligators in its three southeast counties, in a habitat called the West Gulf Coastal Plain. Louisiana has the highest estimated population with 1.5 million alligators. Emphasis must be placed on the word *estimate*, for there is no way to get an exact number like you can with a jar of pennies. Even so, the figures are encouraging considering that in the 1950s and 60s there were fewer than 500,000 alligators in all ten states. This was the low ebb. Since then, the species has bounced back. In 2001 the alligator population comprised approximately 3,200,000 animals. This number does not include the population in farms, zoos, and alligator attractions—which might add as many as 1,000,000 more animals to the mix.

Alligator farms were first licensed in Louisiana in 1972. Florida started their program in 1977. Currently each of the two states has about sixty licensed farms, about half of which are active. Today skins come from two sources—wild alligators taken during the controlled hunting season or as nuisance animals, and alligator farms. The farms, sometimes called ranches, produce many more skins than do hunters and trappers, as much as five times as many in Louisiana, but the scales look more balanced when you take in to account the total feet of wild vs. farm skins. In 1999 the average wild gator was 7.17 feet long, while the average farm gator was 3.61 feet. Hide size greatly affects the end product. The skins of farm alligators less than four feet mostly end up as watchbands. It takes much longer and wider reptiles to make belts, shoes, boots, briefcases, and even the golf bag I saw sitting on the counter at Al Wehmeier's Belt Shop in the New Orleans French Quarter. The $15,000 bag was a beautiful piece of work that required some big skins to make it. Al's been fooling around with alligator and leather since the 1940s. He bought his retail business in 1962, at which time belts sold for $5.00 apiece. Today his high quality belts are priced at $210.00.

In 1982 Al moved his shop to Toulouse Street in the French Quarter. This small shop sells more Lucchese alligator boots than any other store in the United States. Al told me that the writer Roark Bradford once lived in what is now the shop and had William Faulkner, Ernest Hemingway, and other

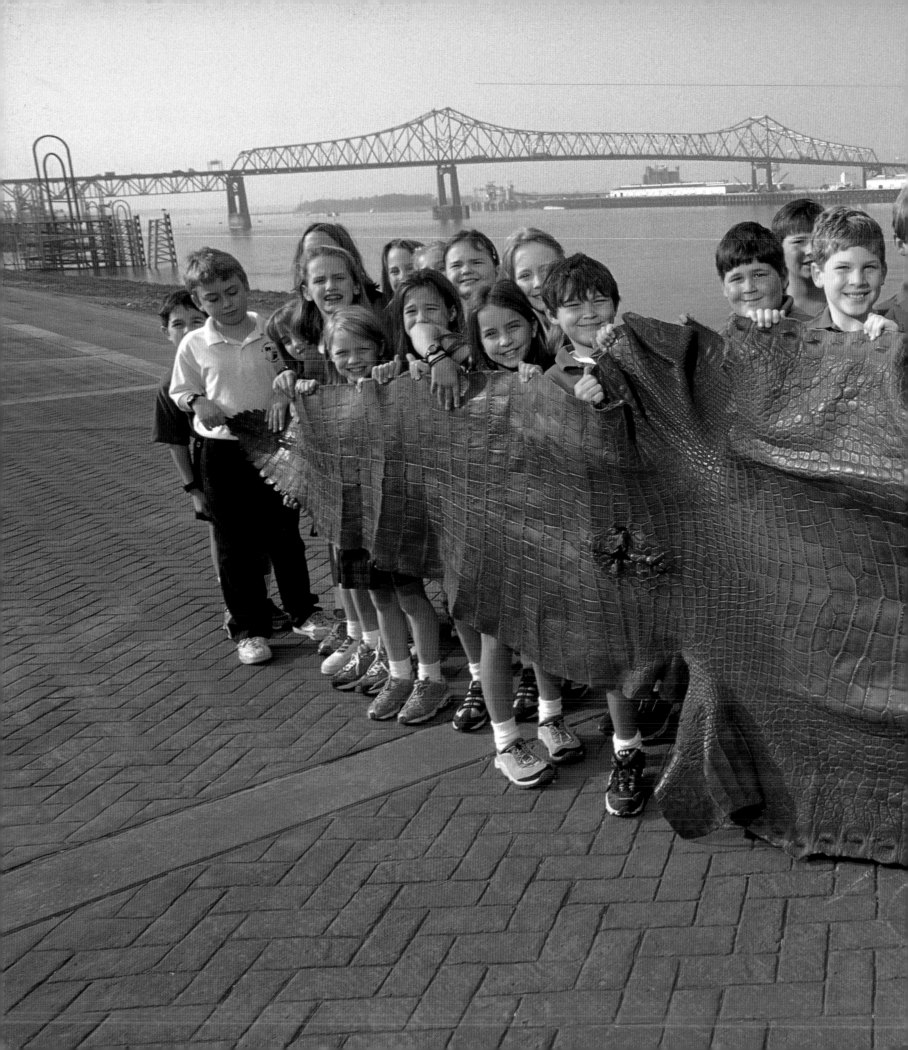

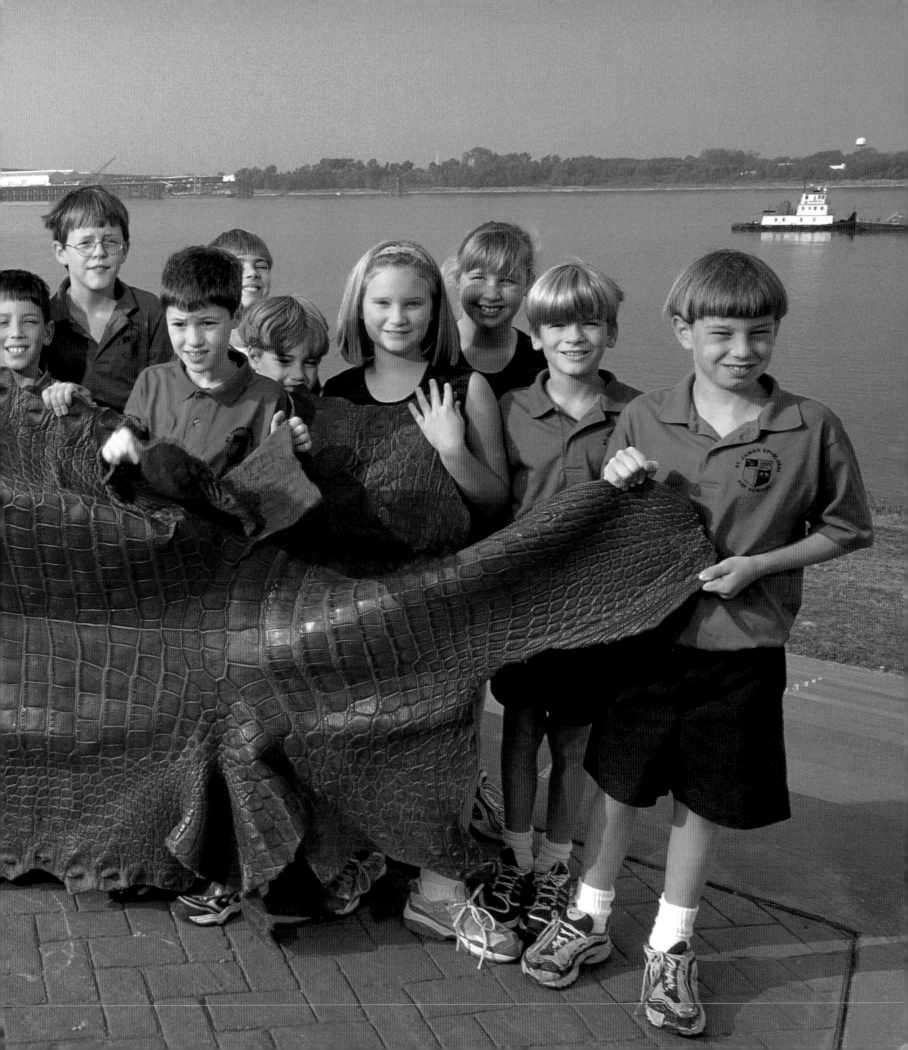

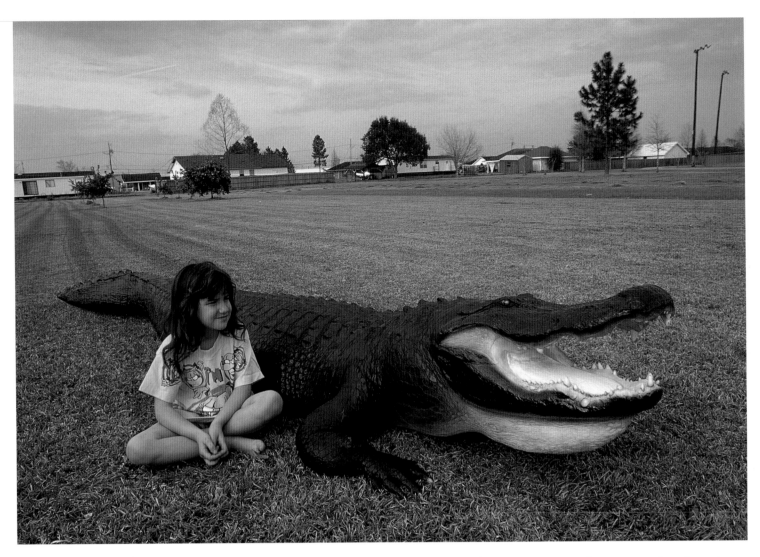

Brandy Scharwath with a 13' 4" alligator mounted by her dad, Bruce.

Students of St. James Episcopal Day School hold an alligator hide 15' 6" long. The skin, owned by Don Ashley, is the longest whole skin in existence *(previous spread)*.

authors as guests. The building Al uses for a repair shop is across a quaint courtyard patio and was built in 1799. He boasts that he has repaired over 300,000 items in his career, but one of his more memorable jobs involved him skinning a nine-foot alligator that a gift shop had hired him to mount for a display. He recalled, "I was in my early twenties and had never mounted anything that large. The gator was on a table underneath my parents' house. It was a tight space. When I began to cut, the alligator's tail swung out and its body in toward me with so much force it knocked me through the wall behind me." The reptile obviously was not quite dead.

I saw modern-day taxidermist Bruce Scharwath from Pauline, Louisiana, finish up a beautiful mount on a 13' 4" alligator. When I photographed it with his daughter Brandy in his backyard, the large creature dwarfed her. Bruce specializes in mounting deer and alligators. He charged his customer $1,000 for that one. The skin came from a 982-pound breeder on Ron Whitaker's alligator farm. Ron and his partner used to get some of the eggs they incubated from a fifteen-acre pen with numerous ponds. When skin prices declined, Ron wanted out, so he left his partner with the growing houses and small alligators; Ron kept the big gators for his personal enjoyment.

The cycle of alligator ranching begins in June or July, when the farmers collect eggs from wild nests, usually in the marsh, where they can be seen from a helicopter, small plane, or even an ultralight. Ron would use a helicopter; when he spotted a nest, he threw a PVC pole from the hovering helicopter into the nearby mud, then marked the spot on the map, making it easy to find later.

Farmers contract with landowners for the egg rights on their property. They must later return 14 percent of the alligators they hatch to the wild. This is done when the animals reach four feet in length. Initially the farmers pay the landowner five to six dollars per egg. (That price got as high as twelve dollars in 2001.) Ron figured that by the time he added in the helicopter and airboat costs, he was paying between eight and ten dollars to get an egg to his incubator. Two months later, in August, the eggs hatch. By keeping his incubator at 89° and 100 percent humidity, Ron got above a 90 percent hatch rate. A day after emerging from their shells, the hatchlings are moved to a growing house, where the basic requirements are warm water and a place for the alligators to move around and eat. The growing house is kept at 89°, which studies have proven is the temperature at which gators grow the fastest. Ron told me it takes about three days for the young to digest their yolk sacks. After that, he would feed them finely ground nutria or fish five days a week, letting them have extra digestion time on weekends. According to Ron, young alligators can grow from one-quarter to three-quarters of an inch each week. Alligators convert food at a two-to-one ratio: Every two pounds of food will add a pound of weight to the animal. Just like a litter of puppies, gators grow at different rates. Ron said he would have 25 percent at market size in eighteen months, 50 percent ready after twenty-four months, and the rest would take twenty-six to twenty-eight months. His goal was to get them to market at four feet. When alligators get bigger than that, they eat more, grow slower, take up more space, and start to get aggressive. Ron explained that after the first year, the gators need twice as much space to grow at the same rate.

Sale of the alligators is ruled by supply and demand. When he needed space for new hatchlings, Ron would call a buyer, or when a processor was out of skins, they would call Ron. He would sell his alligators alive or dead, whole or skinned and salted—whatever the client wanted. Some of the larger farms do all their own skinning as well as meat processing. Once an alligator is skinned, the hide can be salted, rolled up and refrigerated until it is taken to a tannery. Tanning is the multistep process that usually includes dyeing. Finally a cutter and product maker fashion the skins into shoes, belts, or whatever.

The Louisiana alligator farming industry had an inventory of 519,000 animals on December 31, 2000. In 1999, the revenue from Louisiana alligator hunting and farming was as follows:

Farm skins	$10,877,894
Farm meat	$ 2,483,020
Wild harvest skins	$ 5,344,850
Wild harvest meat	$ 5,118,250

That's a grand total of $23,824,014. If we add the farm-harvest and wild-harvest income from the rest of the states, the total goes over $30,000,000 as estimated by Don Ashley. Then factor in the money that's made by the processing houses, middlemen, tanners, cutters, designers, manufacturers, and retailers, and you'll find the industry is worth some major bucks. In a report by Ken Roberts, the total economic impact of alligator farming, wild harvests, egg collection, and swamp tours in Louisiana is estimated at fifty-four million dollars a year. A well-managed alligator program serves to keep the landowner happy, the tax coffers full, and the swamps and marshes in good condition to support wildlife as well as recreation and to provide hurricane protection. Not bad.

Ted Joanen—with the help of Allan Ensminger, Robert Chabreck, Larry McNease, and others, not to mention 76,000 acres of Rockefeller marsh, oil revenues, and a will to work—proved that the alligator is a renewable resource. There is a sign at the nature trail at Sabine National Wildlife Refuge that reads: The alligator was never an endangered species in Cameron Parish. That

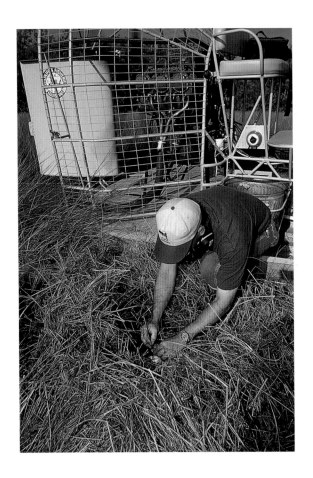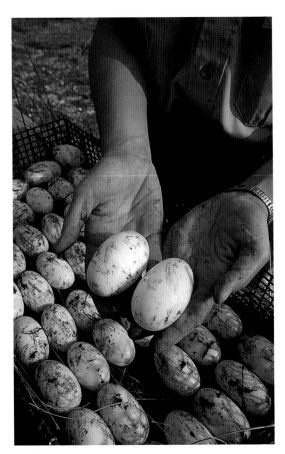
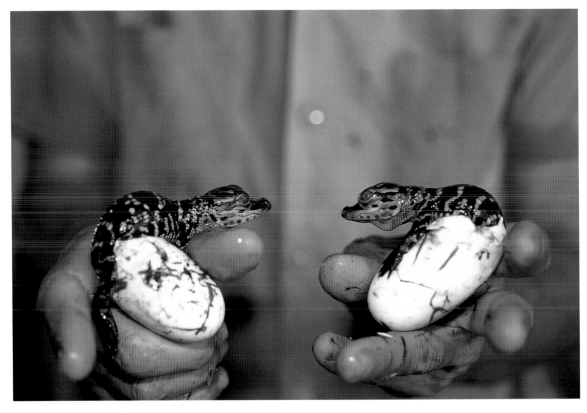

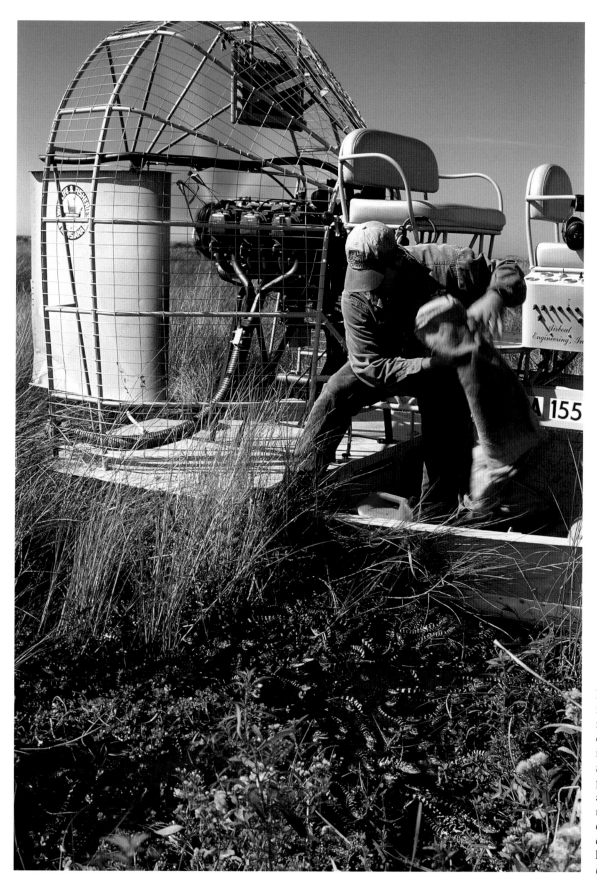

Eggs collected by Rocke-feller Refuge biologists are marked so they can be oriented the same way in the incubator basket *(far left, top)*. Later, after DNA samples are taken, the hatchlings are released back into the marsh *(left)*. Alligator ranchers also incubate and hatch eggs. These two babies are held by Ted Falgout *(far left, bottom)*.

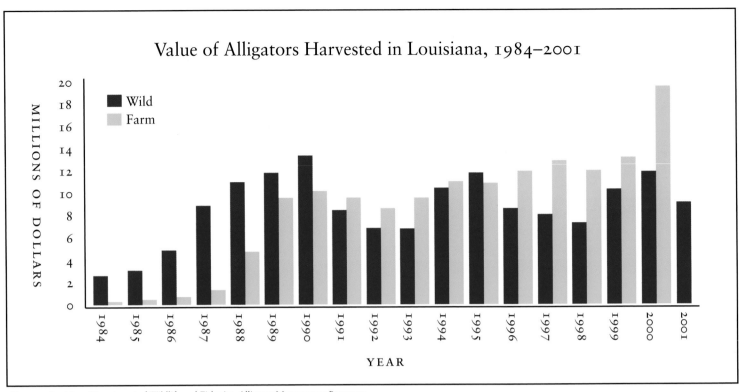

Value of Alligators Harvested in Louisiana, 1984–2001

MILLIONS OF DOLLARS

- ■ Wild
- ▨ Farm

YEAR

Courtesy Louisiana Department of Wildlife and Fisheries, Alligator Management Programs

statement could be extended to cover all of coastal Louisiana, which had a low-ebb estimate of 75,000 creatures, leaving approximately 3,750 breeding females. That's a viable number to manage a comeback.

"We had the first neighbor watch in those days," Ted told me. "The landowners and the courts cooperated tremendously in the comeback. And they did come back; by 1970 we were already having a few problems with nuisance alligators and had to move a lot of reptiles around."

It was time for a harvest. Over the decade of study since the state had closed the season, biologists had figured out how many alligators they wanted to take and when, but solving the problems of poaching, illegal skins, and different laws in various states was the tough part. Ted told me that he and his colleagues thought and thought and thought until they finally came up with the tagging program. Numbered metal tags were given to landowners with alligator habitat. When hunters brought in their gators, a tag had to be permanently attached to a certain place on each animal's skin. Untagged skins were illegal. As an added safeguard, the hunters were told the day before the first season in 1972 to leave a foot on the skins. This ensured that skins taken before opening day could not be sneaked in and tagged.

I got to go on the first hunt of the regulated era in Cameron Parish, Louisiana. Marty Stouffer and I hooked up with Garland Richard, a true Cajun. Garland had lived off the marsh his whole life—trapping, fishing, and alligator hunting. He spoke French to his fellow trappers, English to us. We took off early on opening day in his mud boat. Garland had set his lines in some canals near Creole, Louisiana. His method—using a stout line with a large hook hung over a cane pole angled toward the canal—is still used today. The hook is baited with blackbird, coot, or a piece of beef melt, and is hung about a foot above the water. The other end of the line is secured to a tree, if any are near, or a thick pole driven deep into the mud. Garland had baited and set out the lines the previous

day. When we came to one that was down, his partner would slowly pull the line in; then, with a splash and a roll, the gator would surface to be shot in the head by Garland's rifle.

Since this was the first year alligators had been hunted since 1962, we caught a lot of big ones. We took a pickup load back to Garland's house, where he and friends skinned the animals. That night we ate some slices from the tail that Garland's wife fried up. They looked like pork chops and tasted like the same crossed with a piece of chicken.

The 1972 and 1973 alligator hunting seasons were a success with 1,350 and 2,921 hides taken, respectively. But problems arose in December 1973 when President Richard Nixon signed the Endangered Species Act—one of the best pieces of wildlife legislation ever passed, in my opinion. However, it did not work for the alligators in Louisiana, where it effectively shut down the season, preventing anyone from making a profit and thereby removing incentives for environmental upkeep.

Paul Coriel, once a Rockefeller researcher and county agent for wildlife, now director of the wildlife co-op at LSU, also emphasized the alligator's value as a renewable resource. The revenue from the industry is needed to keep up the tax base in coastal parishes, some of which have very little agricultural and industrial land. These parishes rely on income from alligators, duck-hunting leases and other recreation, seafood, and oil to fund schools and build and maintain roads.

The marshes and swamps have untold value to Louisiana, Texas, Mississippi, Alabama, Florida, and all other coastal states. McIlhenny claimed we could protect wildlife by just having a refuge (habitat) for them. True, very true at one time, but not now that man has monkeyed with just about everything in the lower forty-eight states; today there are very few natural habitats large enough to sustain all native species in proper balance. We still have to set aside habitat as McIlhenny suggested, but we also have to manage it. In Louisiana our need for energy to run hair dryers, computers, and mosquito zappers, along with our desire to live behind levees in a flood-free environment, has changed the natural landscape and caused many problems, the most serious being coastal erosion. Look at Rockefeller refuge alone—86,000 acres in 1920 and 76,000 acres today. In tampering with our environment we have rendered it vulnerable, and only by taking an active role can we preserve our wetland resources while making the most of what they have to offer. It goes back to Ted's neighborhood watch; one of the main cogs in the wheel is the landowner. If he gets revenue from his wetlands, from alligator skins or eggs or from duck hunting, he is more inclined to maintain and manage freshwater habitat, which costs money. If the saltwater intrudes, we have more erosion; we lose land, lose hurricane protection, and lose nursery grounds for vast numbers of other species.

Alligators need a wet habitat such as cypress swamps *(below)*, lakes, bayous, and marsh.

This aerial shot of Rockefeller Refuge *(overleaf)* shows a water-control structure that regulates the salinity and water levels in a freshwater impoundment.

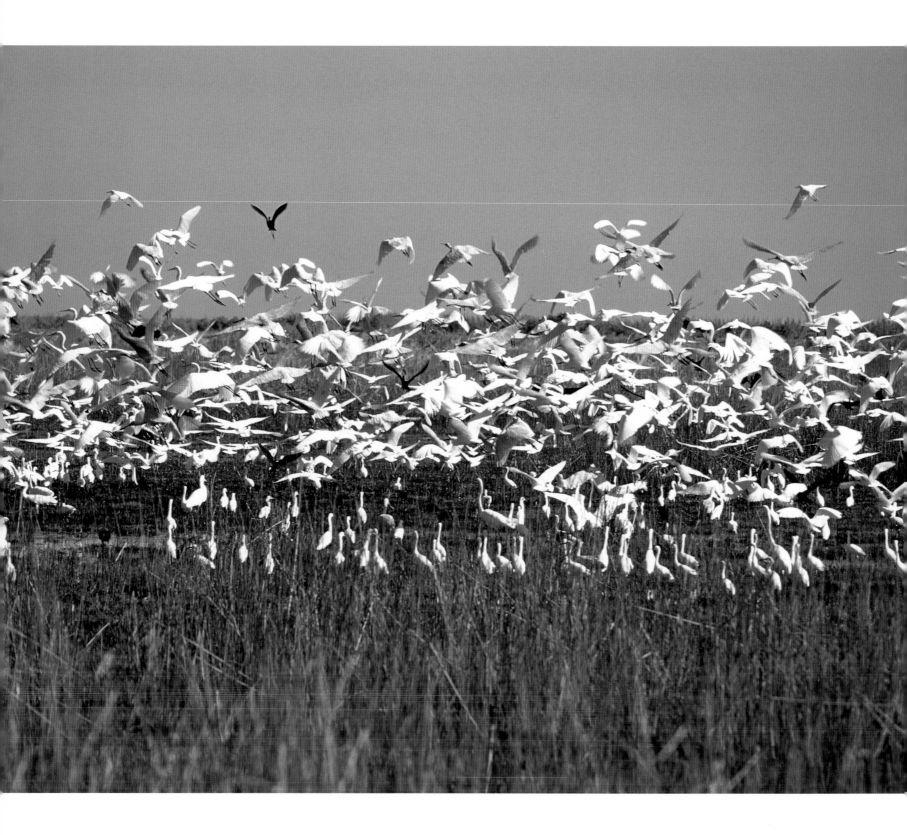

The wetlands alligators love also serve as habitat for many types of nongame species, such as these nesting roseate spoonbills *(above)* and this multi-species flock containing egrets, ibis, and spoonbills *(left)*.

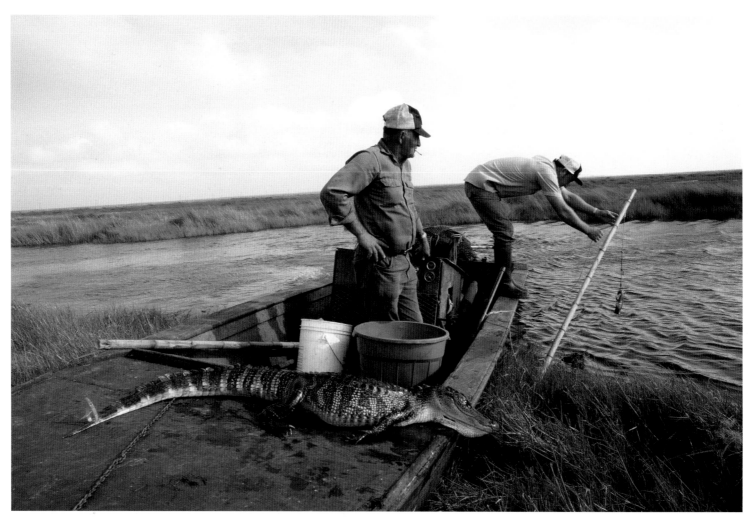

Old-time hunters like Garland Richard *(above)* skinned their own alligators and salted their hides. Today most hunters take their catch to a processing house like Wayne Sagrera's near Abbeville, Louisiana *(right)*.

The Endangered Species Act was good because it attracted attention to some spectacular species of wildlife such as the bald eagle, red wolf, and brown pelican, as well as humbler species like the humpback chub. It focused on habitat for these species, thus giving help to all wildlife. Along with Earth Day, the legislation became an educational tool. Kids learned a gentler way to think of nature. Boys stopped popping cardinals with their BB guns, fourth graders started making endangered species posters, and sixth graders began to discuss coastal erosion. With the world becoming ever more populated, it is increasingly important that we take care to protect our wildlife from the changes we humans make as we mold nature to suit our needs. Legislation like the Endangered Species Act can be of great help, but it can also hurt in some instances. It takes strong character and intelligence to use our laws for the benefit of all creatures, and to know when to stop using them when they become unnecessary.

With the passage of the Endangered Species Act, the fate of the alligator was in federal hands, and as no animal on the list could be hunted, the 1974 season was closed. A contingent from Rockefeller brought their data to Washington and succeeded in getting the alligator delisted in three Louisiana parishes. In 1975–77 the commercial harvest continued, until a limited market caused the season to be closed again in 1978. The Convention on International Trade in Endangered Species of Wild Fauna and Flora (CITES) banned the international trade of crocodilian skins. By 1979 CITES had developed regulations to control the flow of non-endangered crocodilians, thereby allowing world trade of abundant species and disallowing trade of rare crocodilians.

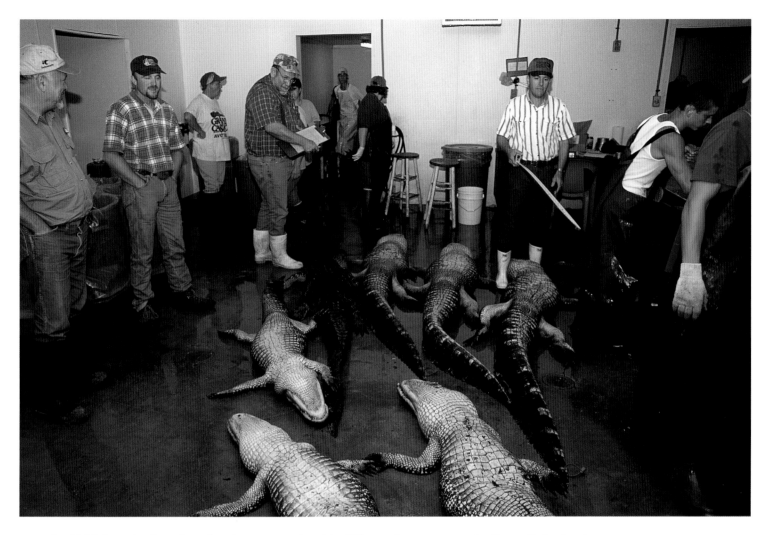

In 2001 I made three hunting forays—each with different hunters, not the live-off-the-land Cajun type like Garland, but men with normal jobs who love hunting, fishing, and being outdoors. On opening day of the season I joined Merval Landry, a former grocery store owner who now manages a large tract of swamp for a land company. Merval had ninety-four tags, and his ex-son-in-law, Bobby Boudreaux, added a special touch to their hanging baits by spraying them with foul-smelling pogie oil. The oil must have worked, for Merval got his quota in three days. We hunted in the Atchafalaya Basin below Morgan City.

Next I drove over to Grand Chenier in a rainstorm to meet the Cameron Parish Clerk of Court, Carl Broussard. We hunted in open marsh south of Highway 82 with his uncle Dan and a real Cajun-looking fellow named Alfred Boudreaux, who drove me around in a small bateau. I was beginning to think you had to have a Boudreaux on every alligator hunt. The ominous gray clouds made an excellent backdrop as we caught six gators that afternoon.

My last hunt was with Ted Falgout, whose day job is being Bayou Lafouche Port President, though for the joy of it he also is an alligator farmer as well as trapper. He and his brother Erole run an alligator farm behind their home in Galliano, Louisiana. They also have one of the state's biggest breeding ponds: The large size makes it more natural and successful. Ted's hunting techniques were a little different from those of others I had hunted with. First, he did not angle his poles to hang the bait. His poles were put in straight, and the bait just lay beside it. In a few places on a spoil bank of a canal, he just set his bait on the ground.

71

Skinning alligators is seasonal work, but those who do it make a good wage. Some workers prefer large alligators *(middle right)*. Jackie Este *(far right)* can skin 125 small ones in a day with the help of his partner. No part of the alligator is wasted. The belly skin *(top right)* and the meat *(bottom right)* are most valuable, but feet, teeth, and heads are also used in various products.

Alligators are more active at night. Perhaps these two are enjoying the sunset, but more likely they are preparing to search for food as the twilight fades *(overleaf)*.

Hunting is one of Ted's passions, and you can say he gets all he can out of his game. He saved the carcasses of the American coots he shot last year during waterfowl season (after he made gumbo with the breasts) to use for alligator bait this year. All three of these hunters took the whole alligator to the processing house rather than skinning their own as Garland had.

Today state, federal, and international regulations make it uneconomical for a farmer, tanner, or product maker to buy or sell illegal skins. The environmental community's thoughts in the 1970s were that even if alligators could be hunted in a sustainable way, this would hurt other, rarer crocodilians by generating an interest in alligator products. Don Ashley says that Ted Joanen proved them wrong by taking control of the skins with tags. Soon there were so many high-quality legal skins on the market that nobody wanted to take a chance on getting caught with an illegal skin. Don Ashley thinks that less than 5 percent of the skins currently sold worldwide are unregulated. Poaching might be a thing of the past. Ted Joanen tells me that all the serious alligator poachers may have died off. His friend, Dave Hall, a U.S. Fish and Wildlife Service enforcement agent, would probably disagree, saying he arrested them all. I'd guess they are both right. Dave caught a bunch of wildlife outlaws in his career.

One arrest he told me about started with a tip from an FBI agent in North Carolina. The agent gave Dave the name of a man who wanted to sell some alligator skins. Dave set up a sting operation in New Orleans at Zimmerman's Tannery. Big Zim, a monster of a man, had been caught, fined, and had spent a few days in jail for handling illegal alligators. According to Dave, Big Zim was one of the greatest tanners and an honorable man, despite his few transgressions. He agreed to help. Monroe Jackson, the stingee, talked his brother-in-law, who owned an eighteen-wheeler, into helping transport the skins. Jackson thought using a truck that usually made produce runs would not attract attention. Dave found out about the truck and wanted it. He knew he could get it; the Lacey Act allows vehicles used in wildlife crimes to be confiscated. This, of course, makes the penalty worse. The culprits made things difficult by hiding the truck and bringing the skins to the tannery in a rented station wagon. Dave was posing as a buyer at the tannery. When enforcement officers made the bust and learned the truck was hidden, Dave had to convince Jackson that he was a legitimate outlaw to get him to reveal the truck's location. As part of the act, Dave got very belligerent, which resulted in him getting beat up by his friends, the arresting officers. Monroe fell for the ruse and told him where the truck was hidden. Like rum runners during prohibition, alligator poachers were doing big business up until the properly managed trapping season began in the 1970s.

Allan "Woody" Woodward is head of Alligator Research Projects for the Florida Fish and Wildlife Conservation Commission. Though Florida also has a large population of *Alligator mississippiensis*, Woody explained that the creatures' habitat is much different from Louisiana's—spread out in isolated pockets of swamp and many lakes until you get down to the Everglades. A lot of these lakes have very little vegetation, and nesting areas sometimes adjoin residential and recreational areas. Florida also doesn't have as many private wetlands. For these reasons alligator management evolved a little differently in Florida. Woody's team can find some nests by helicopter for research and egg collection, but many more are hidden under the canopy of swamp forest. Much of their population work is done by night eye-shine counts. By consistently counting the same lakes, they can follow pop-

ulation trends and interpolate, such as Louisiana does on aerial counts.

Historically alligator hunting and hides have been big business in Florida. The Florida Fish and Wildlife Conservation Commission estimated that 2.5 million alligators were taken in the state over the ten-year period from 1891 to 1901. In the 1770s naturalist explorer William Bartram tells tales of a multitude of alligators attacking his canoe on the St. Johns River and a female leading a hundred fifteen-inch young. Perhaps an exaggerated account, but there is no denying that alligators were there in large numbers even into the twentieth century, until man became more than a match for the reptiles. In 1961 the season was shut down due to poaching and habitat loss. Alligators had become rare, and Florida's population reached a low ebb of about 250,000 animals. With protection and management, the species increased, and Florida started the experimental nuisance program in 1977. That year a little over five hundred alligators were taken. The state implemented an experimental hunt in 1978 on private lands, and finally in 1988 it opened statewide private and public hunts.

In the year 2000, Florida harvested 27,417 alligators from twenty-three active farms, along with 2,547 from the sport/lottery hunts, 3,804 from private lands, and 6,254 by nuisance trappers. This translated to a cash value of $8,511,422 for skins and meat.

Besides keeping track of all these numbers, Woody directs research on alligator mortality at Lake Griffin in west central Florida. Since 1997, more that 390 alligators have died mysteriously on this lake, along with numerous soft-shell turtles and longnose gar. The gators have all been large—over five feet. A

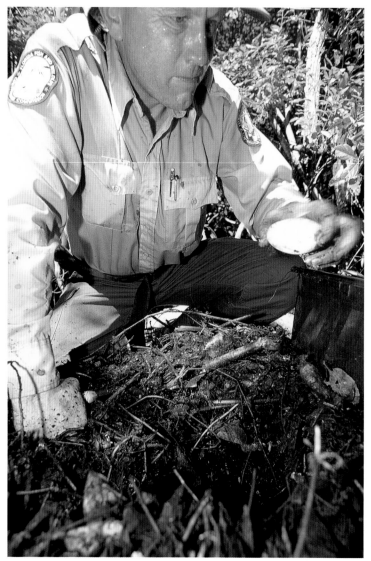

Biologist Allan "Woody" Woodward (above) inspects an egg from a nest—part of his ongoing studies of alligator mortality in the muck-laden Lake Griffin, Florida (right).

very abnormal loss. Woody's office, with twelve other agencies and organizations, is investigating this conundrum. The sick alligators all had brain lesions and died of complications of a nervous system disease. There are many theories as to what is causing the fatal condition, but no conclusions.

In July 2001 I accompanied Woody on a research trip to Lake Griffin. We took off at dawn with four airboats. Phil Wilkinson, an expert "passive trapper," was along to help. He is retired from the South Carolina Department of Natural Resources. Rather than noosing alligators from a boat at night like Ruth Elsey does to get her specimens, Phil sets elaborate snares around the nest in the evening and comes back the next morning to see what he's caught. He is usually very successful. Also along were five folks from the U.S. Geological Survey—part of the group of thirteen (Central Florida Lakes Wildlife Initiative) who are doing the mortality research. Our group of two boats caught females on two of three nests. Large females. Woody said that for some reason the females on Lake Griffin are bigger, but they lay fewer fertile eggs. Could all be part of the problem.

If you could surf through a day's worth of Discovery Channel programs, you probably wouldn't see as much wildlife as I did on the edge of Lake Griffin—a lake with serious eutrophication problems, one that used to be a bass-fishing paradise, one that has a layer of muck over six feet deep and has accumulated tons of pesticides and fertilizers in runoff from now-defunct muck farms. Muck

farms, started in the 1940s, are levied, drained, and irrigated vegetable farms that are heavily fertilized. Woody expertly hugged the shore, looking for alligator trails into the surrounding maple, bay, and cypress swamp impenetrable for most humans, but not for a mother alligator looking for a nest site. At one time there were 250 nests on this lake. Now it's supposed to be in trouble, but to my eyes it seemed to be thriving. I saw rich diversity and great numbers of wildlife. But perhaps the alligator is telling us something. Maybe what I was seeing was the last big rain before the drought, that it will all crash in a short time period.

From the bow of Woody's boat I looked down into the eight inches of clear water resting on top of the muck. Muck is mainly dead algae combined with some siltation. Woody stuck in a pole to show me how thick and deep it was—six feet where we tested. The footprints and tail tracks of both large and small alligators were easily visible. It's no trouble for an alligator to traverse this muck between shore and deep water where a human would sink in and struggle, and a weak swimmer could possibly drown. I watched soft- and hard-shell turtles, minnows, garfish, and frogs swim and hop away from us as the airboat stirred up a cloud of the brownish-red muck as we skimmed over the shallow water.

Medium-sized alligators splashed and sank into deeper water as hatchlings from the previous year hid in the roots along the bank. Anhinga drying their wings on dead branches dove into the water before us. Half-grown purple gallinules, not pretty in their sparse covering of grayish-black

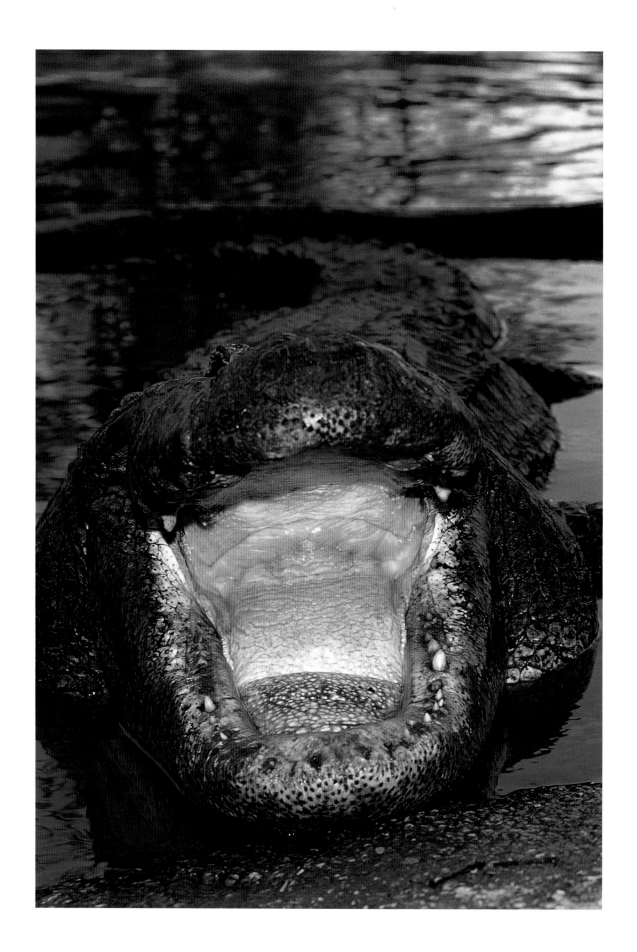

fledgling feathers, gawkily ran across the aquatic vegetation in pursuit of their beautiful and elegant parents. Herons, egrets, ibis, and limpkins flushed off their fishing grounds. I was in awe as Woody reached his destination nest.

It was under a canopy of scrubby trees and protected by thorny blackberry vines about ten feet from the lake. I noted that it was a little smaller than the mounds of wire grass in the Louisiana marsh. It was composed of mud, leaves, and other types of surrounding vegetation. Woody took a lot of measurements, temperature readings, and other notes on the nest. I commented that he was getting much more data than his counterparts in Louisiana. Woody said, "With the mortality problems here we don't want to leave any doors unopened. To solve this problem we need every bit of information."

As he marked the eggs so he could incubate them in the same orientation, his face was dripping with sweat like a faucet with a substantial leak. It's hot hard work that alligator biologists love and endure. Long days and long nights, mosquitoes, fire ants, muck, mud, and weather extremes—but the rewards are great for those who love to work in the outdoors and contribute to the health of our wildlife populations.

On leaving, I asked Woody for the name of a nuisance hunter I could go out with, a real character. He told me Rufus Stratton. I thought he must be something, for two other people had recommended him to me. So I called Rufus, a friendly-sounding fellow on the phone, and he invited me right on over to his nineteen acres of piney woods just outside of St. Augustine, Florida, where he is the nuisance trapper for St. Johns County.

With the comeback of the alligator population since the seventies and the increase of human population near wetlands and waterways, encounters with alligators have become more prevalent. Most states with alligators have developed a nuisance program. Florida leads the way with 6,254 nuisance alligators destroyed in 2000—and many more relocated. The program began on an experimental basis in 1977, with 535 bad gators taken from eleven counties. Deemed a success, the program was officially opened statewide in 1978, and 1,871 alligators were taken that year. Today, with about forty nuisance trappers responding to complaints in sixty-seven counties, Florida saves money by putting the program in the private sector. Licensed nuisance trappers like Rufus Stratton are allowed to keep the skin and meat. The money that comes from the sale of these products is their pay. Nuisance calls are screened by the Florida Fish and Wildlife Conservation Commission, and if an animal warrants removal, they pass the information on to the closest trapper, who is required to respond immediately. With this system, alligators who threaten people, property, pets, or livestock are taken or moved.

I arrived at Rufus's place after lunch so we'd have plenty of time to talk before we went out to look for a big gator that night. He took me directly to his processing shed, where his daughter has the job of skinning the gators and processing the meat. She had left a wheelbarrow full of alligator

Always smiling, nuisance alligator trapper Rufus Stratton holds one of the larger of the eight hundred heads he stores in a backyard tractor trailer *(above)*. Alligator smile *(left)*.

Alligators lined up like stepping stones (overleaf); James Bond could easily run across their backs, like he did in the movie *Live and Let Die.*

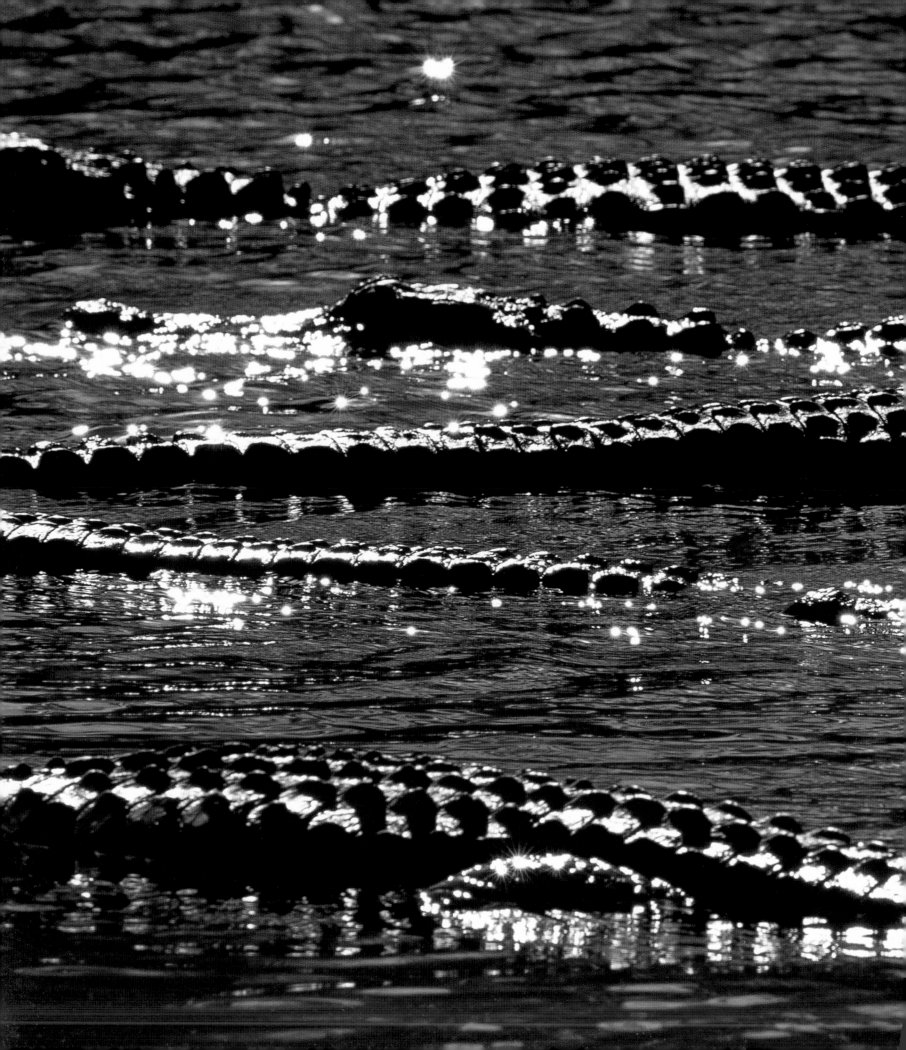

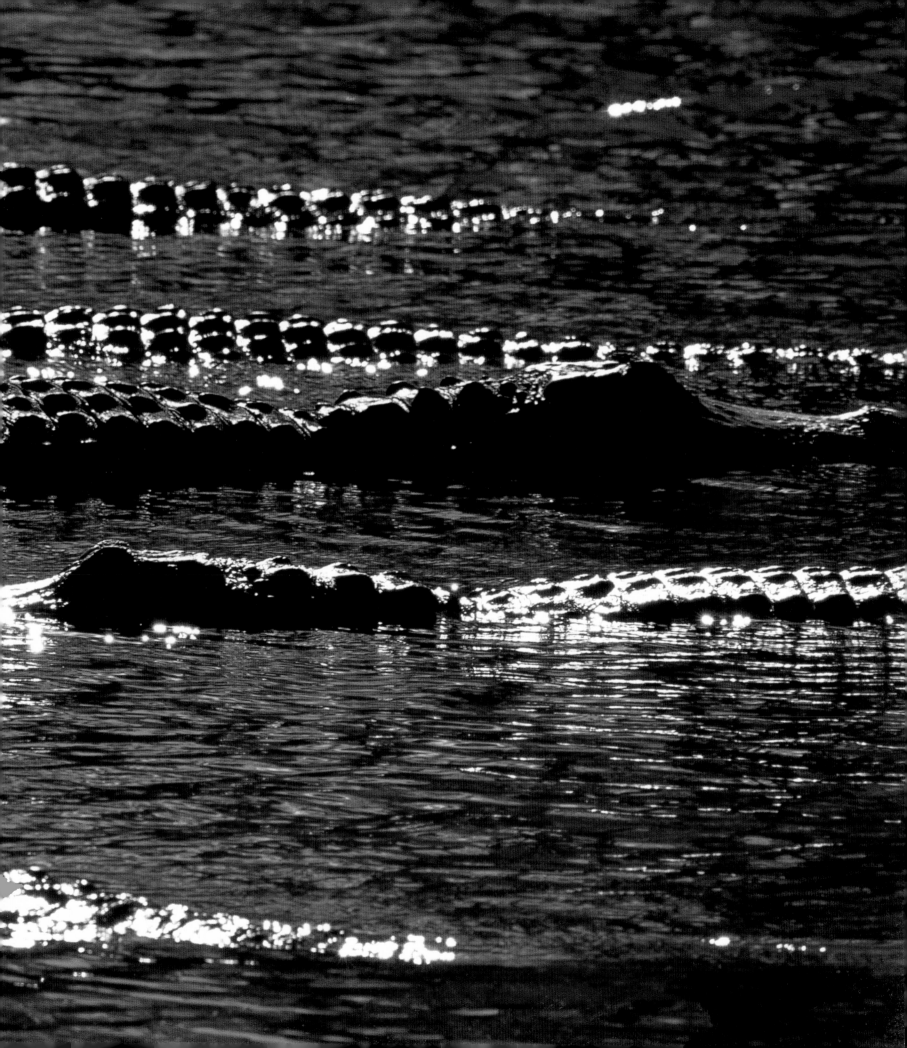

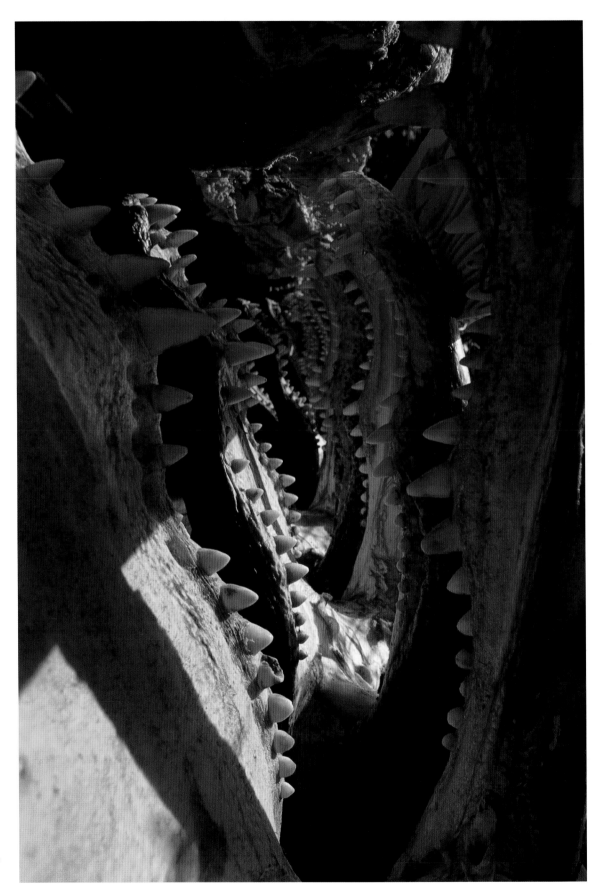

Alligator heads curing after a formaldehyde bath.

Although about five hundred alligators live in the Wakulla River, just beyond the buoy rope, swimmers enjoy Wakulla Springs State Park, Florida *(overleaf)*.

parts from last night's catch. Rufus told me to follow as he pushed it through a gap in the pine trees back into the woods. I saw a group of black vultures feeding on the carcasses of many alligators. They flushed briefly as Rufus dumped out new groceries for them. It was an alligator boneyard, where scavengers ate the meat and the rest decomposed back to nature. I picked up a few teeth lying amongst the bones, and Rufus began his tales.

We walked back to a shed and a tractor-trailer. Both were full of cured alligator skulls—over eight hundred of them, and mostly large. Rufus had soaked them in formaldehyde to preserve them. He stopped doing this a few years back when a friend walked up as he was dropping a head into a barrel of this chemical. His buddy stopped fifty feet away; it smelled too bad for him to come any closer. Rufus realized he had been dunking heads for so long that he could not even smell the chemicals anymore. He said, "I figured I had to stop because my lungs were clogged up too. It took me six months to clear them up after I quit using formaldehyde."

I asked him what the heads were for, and he told me as soon as he was too old to trap nuisance alligators he would sell the heads at flea markets for his retirement income. Not near ready to quit, Rufus is seventy-four years old. His robust and barrel-like physique is solid and strong from hard outdoor work his whole life. From 2:00 P.M. to 2:00 A.M. his tales never stopped. He never lost a fight when he was a young scrapper. In those years he was a wildlife outlaw and poacher. He told me of running from game agents in a dune buggy while stealing sea turtle eggs, which he used to eat raw and also sell. He poached deer and alligators at night. Sometimes poachers make the best nuisance trappers; not only are they good at catching alligators, but when a poacher goes legit it also takes an outlaw out of the loop.

Rufus once sold a head that was thirty-two inches long for five hundred dollars. It came from a 13' 7" alligator. The biggest gator he's ever come across was a fourteen footer that he caught alive and sold to the amusement park Bush Gardens. It weighed 735 pounds when he captured it. It weighed 1,000 pounds when it died a year later. A tourist had thrown a teddy bear and some plastic bags into the pen. The big gator ate them and died from a stomach blockage.

After dark we put Rufus's boat in the St. Johns River and motored up a little creek to a paper mill. Here a ten-foot alligator had been frightening employees. With a small headlamp Rufus sat on the bow with his harpoon, noose, and crossbow as his grandson drove the skiff. We searched for six hours, seeing a few smaller alligators but not the culprit. I wondered where all the alligators were that William Bartram saw in this river. Rufus said some are harder to catch than others. I am sure he will eventually get this one. A nuisance trapper since 1978, Rufus has caught four thousand alligators in his lifetime. He makes it a matter of honor to get the right gator and not take any extra ones just because they are in the area of the bad one.

After the wrestling show Nate
helps a young spectator pose
for a souvenir photo.

III ALLIGATOR *Tourism*

THE eighty-seven-years-young Annie Miller yelled sweetly, "Baby . . . Baby . . . Boomer . . . Mike!" just as she did twenty-two years ago on the first of her Louisiana swamp tours that I took. That time we went out in an open Boston Whaler–type boat and sat in lawn chairs. This past summer, 2001, it was a twenty-four-foot-long, custom-made, Coast Guard–approved bateau with a 150 hp Mariner outboard motor. Annie's approved to take twenty-four passengers in this comfortable boat that she drove expertly through a saltwater exclusion gate only two inches wider than the craft.

Annie was born into the reptile business. Her parents, Emile and Dora Billiot, caught alligators and sold them to zoos and carnivals. When Emile died, Dora caught snakes with Annie, sometimes up to a hundred pounds per day. They sold them to research labs for fifty cents a pound. In 1979 Betty Reed of the Terrebonne Parish Tourist Office talked Annie into taking people out into the marsh to see alligators and other wildlife. With snakes getting harder to find, Annie jumped at the chance for something new. Her business boomed when the World's Fair came to Louisiana in 1984. Thousands and thousands of satisfied customers later, Annie is slowing down and letting her son Jimmy take over most tours.

Annie was one of the first to befriend alligators and feed them chicken parts. It's a practice illegal in most areas and can cause problems, with the alligators losing fear of humans, but it seems to work in Annie's marsh. She says the alligators know the sound of her motor and voice and are still fearful of other boats. This she proved while feeding alligators on the trip I made with her this past summer. Three times when another boat passed us, the gator she was feeding submerged and would not come out again until Annie had called "Baby . . . baby" for five to ten minutes.

When I took Annie's tour in 1980, four-foot alligators used their tails to launch half their bodies'

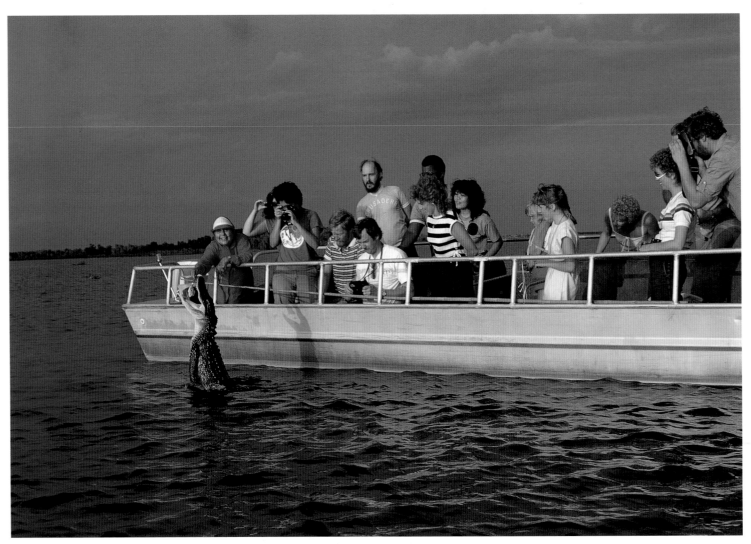

Alligator Annie Miller—in 1984
(above) and in 2001 *(right)*—has
not changed much since she be-
came one of the first to take pas-
sengers on swamp tours featur-
ing alligators.

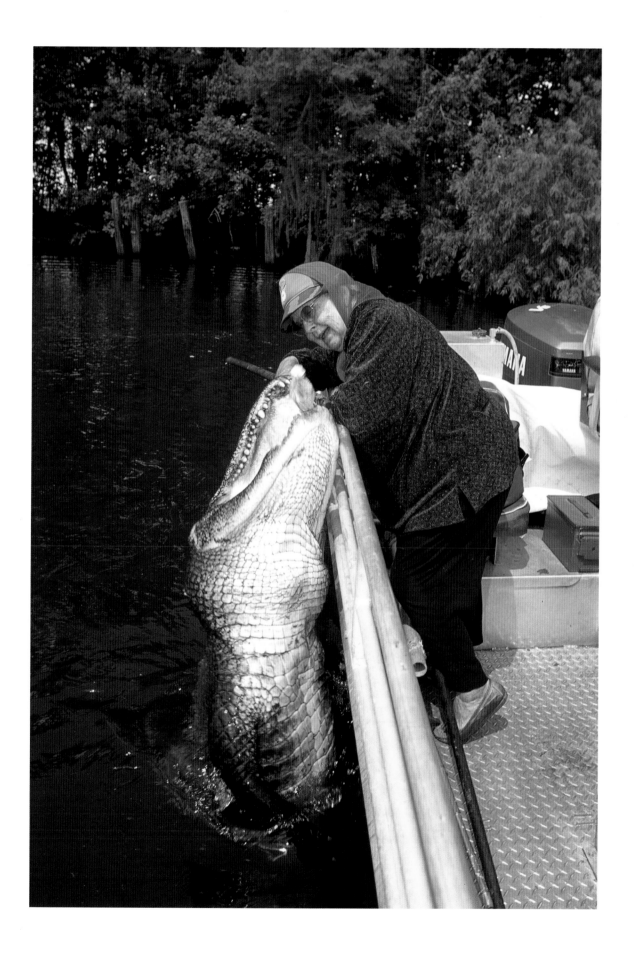

At Wildlife Gardens near Gibson, Louisiana, you can rent one of the four cabins and feed small alligators from your porch.

length out of the water and grab a chicken part off Annie's stick. One of these gators, Boomer, has grown to at least twelve feet and looks like a prehistoric garbage disposal taking food from diminutive Annie, with her scarf tied over her camouflage cap. The head, throat, and upper body of this massive creature dwarf Annie. Alligator Annie has exuberance for all wildlife and exclaims with joy at seeing a great blue heron or a turtle as if she has just seen it for the first time.

A few miles down the road from Annie, in Gibson, Louisiana, is Betty Provost's Wildlife Gardens, the only alligator bed and breakfast I know of. Betty and her husband, James, who died in 1997, started raising exotic birds as a hobby. When the economy slowed in the 1980s, James decided he had to make some money off his hobby or get rid of the birds. He established the Wildlife Gardens in 1986 and found that his guests, especially French tourists, wanted to see alligators. They added alligators and four rustic cabins. The primitive cabins are comfortable, but the best part are their decks, which hang out over a small bayou. When I was there the water was low and completely covered with duckweed, a tiny green aquatic plant. The solid-looking cover parted as five small alligators, two spiny soft-shell turtles, and one red-eared turtle swam to our deck. From the small bag of alligator chow Betty provided us with, I threw out a few pieces. The semi-wild creatures chomped down on my offering, one they obviously were used to.

You can walk through a natural swamp on about one mile of trails, where you pass different pens that contain raccoons draped over branches, sleeping high in the trees, as well as whitetail deer, a fox, Russian black boar, and alligators of all sizes. The sounds are amazing. Here the trill of the warbler, the buzz of the insects, the ribbit of the frogs, the bellow of the alligator, and the shrill scream of the peacock let you know that you are in the swamp. Midway on the trail is a very authentic-looking Cajun cabin with artifacts from the days when Creole families really lived off the land. Close to the kitchen where Betty serves the bed and breakfast patrons her delicious homemade biscuits are the exotic birds: many species of ducks, peacocks, turkeys, doves, and more. Occasionally, Betty's son will take guests out on a night tour of a nearby swamp to see the shine of the alligators' eyes.

At LaPlace, Louisiana, I joined ex–river pilot George Billiot, Cajun Pride Swamp Tours guide, better known as "Wildman" to his passengers, on a two-hour cruise into the swamps adjoining Lake Pontchartrain. Hooked up to a microphone as he navigated small bayous and canals in a covered pontoon barge, he entertainingly pointed out raccoons, egrets, herons, and small alligators. With the accuracy of a Yankees pitcher, he threw marshmallows to the coons and gators. As we rounded the bend he warned us we would see a big gator, and we did. Wildman stood out on a feeding platform and had that gnarly eleven-foot gator jump up for a piece of chicken, then he asked, "Do you want to see him jump higher?" "Yeah!" yelled the thirty passengers, mainly families from Texas, Virginia, Canada, and France. George held up his clear plastic pail full of chicken and said, "It's a bigger target. The alligator thinks it's more food, so he'll work harder for it."

Alligators are opportunistic hunters, remember. All they have is time—time to wait for a fish, egret, nutria, grackle, raccoon, deer, dog, or frog to get too close. They will stalk food occasionally, but more often they wait in a place where the food will come to them. Alligators' energy is explosive; they can't sustain it for long periods of time.

Wild man went on to show us an alligator nest, a humpbacked injured gator, a Cajun cabin, and finally brought out a twelve-inch baby to pass around the boat. Some of the children touched and held it with glee, while others were scared or too timid to touch it, but all faces gleamed with wonder and excitement. Cajun Pride Swamp Tours also offers private canoe trips to see alligators at closer quarters.

One of the other first-class tours is Dr. Paul Wagner's Honey Island Swamp Tour near Slidell, Louisiana. Paul is a wetlands ecologist, and for twenty years, along with his wife, Sue, he has been

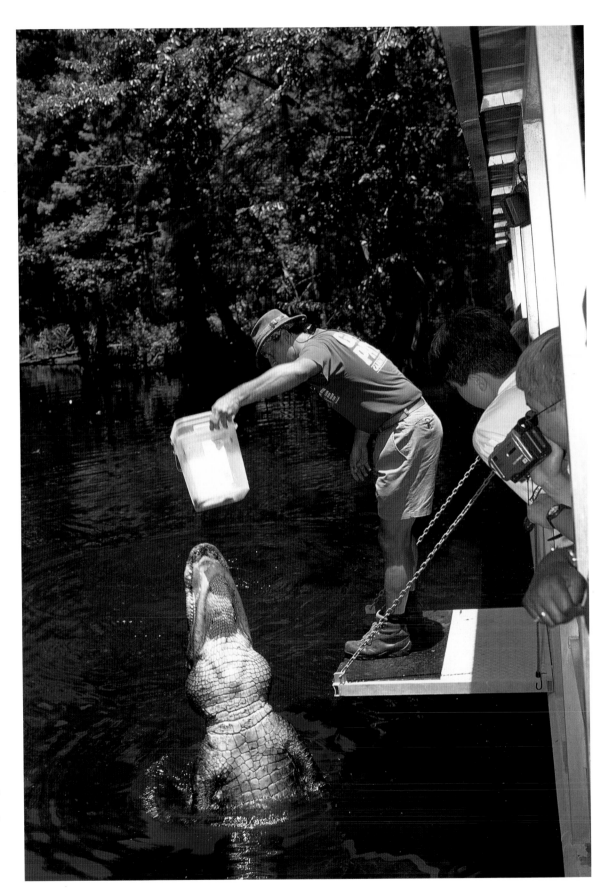

"Wildman" George Billiot, Cajun Pride Swamp Tour guide, gets a large alligator to jump high *(right)* and later brings out a baby for his passengers to hold *(far right)*.

doing tours that almost always include alligators. With his doctorate degree in ecology, Paul gives one of the most educational tours out there in a beautiful cypress tupelo swamp. The Pearl River flows down the center of the Mississippi, and near the coast it unbraids into multiple channels and forms a great swamp habitat that meets the coastal marsh. I have seen many big alligators there as well as otter, deer, turkey, nutria, and tons of wintering waterfowl. Numerous times in the past I have seen newspaper articles about an escaped convict loose in the swamp, or a car that went over the rail of one of the bridges across the many channels of the Pearl. All of them begin, "In a snake, alligator, and mosquito infested swamp, John Doe . . . "

Well, I've been there numerous times, and yes, there are snakes, alligators, and mosquitoes in that swamp. Infested, I would say no, but I would really like to see the style manual that gives all those journalists that sentence.

Another not-to-be-missed place in Louisiana is off the beaten track. Eight miles above Natchitoches on Highway LA 1, Bayou Pierre Gator Park and Show is a small but growing version of Gatorland and St. Augustine Alligator Farm. Terry and Deborah Rogers started in the alligator farm business with Terry's dad, and then the price on skins dropped. They were having a hard time making a living, so they decided to open a tourist attraction. With plenty of gators already, all they needed to do was design the site. They divided the land into three parts—the marsh, where Big Al, a large male

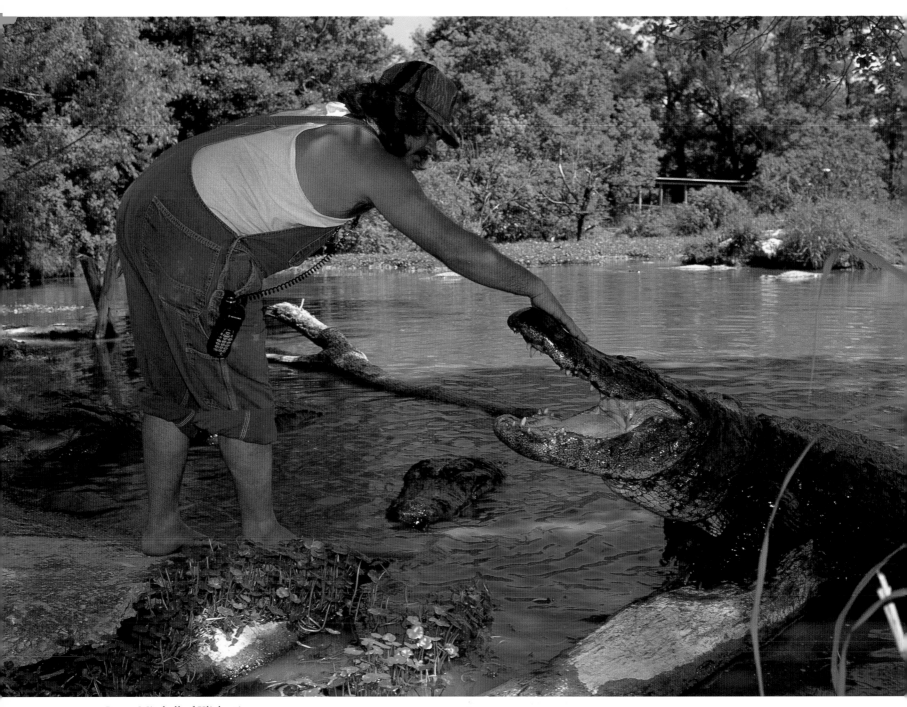

Bruce Mitchell of Kliebert's
Turtle and Alligator Farm pats
a thirteen-footer on the snout.
Kids, don't try this at home.

over eight hundred pounds, lives; the swamp, with a lot of medium-sized gators; and the island, where they do a feeding show similar to those at the Florida attractions. The artwork and educational signs are very creative. Wild turkeys stroll along the boardwalk, apparently fearless of the alligators below.

Terry tells me that kids' favorite place at the park is where he set up three pumps that pour water into contraptions that then spin or pour water throughout a system of pipes and buckets. Terry serves alligator in his snack bar, next to his well-stocked gift shop. Bayou Pierre is open between the two scariest days of the year, Tax Day (April 15) and Halloween (October 31).

Last but not least is Kliebert's Turtle and Alligator Tours. Just off I-55 in Hammond, Louisiana, this is not your typical tourist stop. It's a working turtle and alligator farm that happens to add on tours. Harvey Kliebert, founder and owner, probably knows just as much about alligator behavior as any biologist, scientist, or Ph.D. He built his breeding pond in 1954 and stocked it with hatchling gators. Today it's a pen full of monsters. It was here, one spring, that I heard my first simultaneous bellowing. Early one May morning I crept up between the breeding pond and a smaller growing pond full of younger alligators. The smaller ones were in a row with thirty or more bellowing together, as well as the big ones in the breeding pond. It was a spine-chilling sound. Once they saw me, they stopped. So I got situated and kind of hidden, and Bruce Mitchell, Harvey's son-in-law, fired up a chain saw. That got them going again.

Bruce posed for me with one of his big males, twelve to thirteen feet long. Barefoot in his blue jean coveralls, Bruce patted the big boy on the head, saying, "Up, up, up." The very large gator raised his head and opened his mouth for a chicken leg. Four or five other gators were near, two with mouths open and many close enough to leap up in one second and grab Bruce.

Then he told me a harrowing story. He was leading a tour and got behind the fence to feed as usual. No concrete pad like today. Two dozen tourists were outside the fence. He had a piece of nutria meat in his right hand and was swinging it up to throw when a wall of water appeared before him. A big gator called Jumper grabbed his hand and the nutria meat—proving that an alligator doesn't know the difference between a hand and a handout. Bruce tried to jerk free of the gator's mouth, and when that didn't work, he attempted to actually pull his hand off his arm because he did not want to be dragged into the pond and run the chance of a gator roll. The gator was pulling him, standing up, toward the water. Bruce had a pistol and drew it, but he could not get an angle for a kill shot, so he reholstered the gun and started poking the gator's eyes and ears.

Jumper pulled Bruce though the shallow water. Bruce was still stabbing at its eyes, being dragged on his feet to the middle of pond, when another gator entered the fray, charging. Bruce hit the new gator on the snout, and it turned and bit down on Jumper's head. Jumper opened his eyes, saw Bruce, and let go. Bruce walked out the far side of the pond and returned to his group, planning to finish the tour, but his wife, Harvey's daughter, heard all of the commotion and insisted on taking Bruce to the hospital, where he got seventy-three stitches in his right hand. Bruce gave the incident little thought that day, but when he got to bed that night, he closed his eyes only to see the big gator attacking again.

The hand healed well and gave him no trouble, until a few months later when his middle knuckle started bothering him. He took out his pocket knife and opened it up to find a duckweed seed under the skin.

Harvey and Bruce also have two ponds with thousands of red-eared turtles in them. The turtles lay eggs that are collected and incubated; the babies are then sold overseas in the pet trade. The tours begin at noon each day, as Bruce does not want to disturb the nesting turtles during the morning while they lay. James Taylor is currently the tour guide—a bearded, grizzled-looking man wearing a leather hat and an alligator-tooth necklace. He talks slowly, mixing alligator facts with humorous

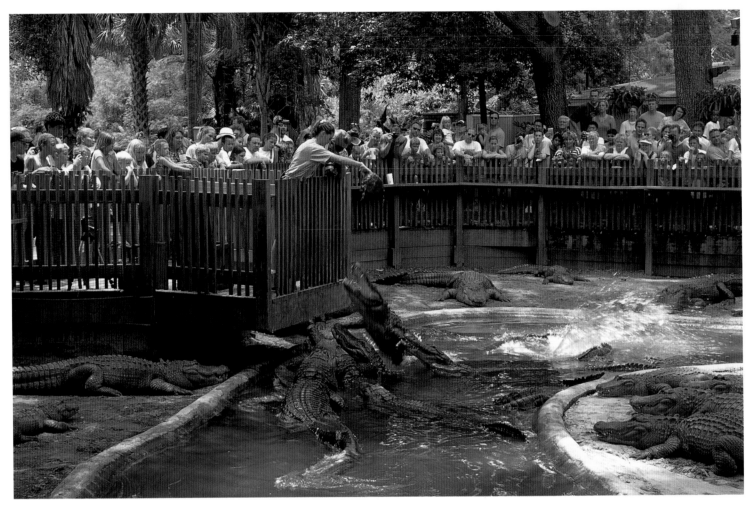

quips as he leads mostly school groups and foreign tourists. The tour circles around the turtle ponds to various pens and pools with different sized alligators. The highlight, of course, is the breeding pond, where James feeds a few of the fifty-six-year-old thirteen-footers from a platform. I doubt you will get to see the show Bruce put on ever again.

I have brochures for thirty-five Cajun/alligator swamp tours in Louisiana, and there are probably just as many more. All ten states with alligator populations likely have eco-tours that will show you alligators. Florida reigns in this category. The seventy-three million tourists that visit the state each year come to its warm beaches and its theme parks. Most want to taste an orange and see an alligator. There are many alligator attractions in Florida; two of the biggest are Gatorland and St. Augustine Alligator Farm. I spent a lot of time at both because they are exciting, educational, and well kept. They rival some of the finest zoos.

My first stop was St. Augustine Alligator Farm, located on the Atlantic coast in the oldest continuously occupied settlement in the United States. It's a farm in name only, for it's really a zoo and, founded in 1893, one of the first eco-tourist stops in the state of Florida.

One early June morning I was waiting by the feeding-show pond for John Brueggen, general curator, when a bellow disturbed the sound of the wild and captive birds throughout the park. I glanced toward the pond as a different big gator from the one I'd just heard inflated, arched its head, and bellowed. The vibrations caused the bony scutes on its back to launch water drops into the sky—like rain in reverse. An alligator's bellow is an awesome sound I have heard many nights camped in the

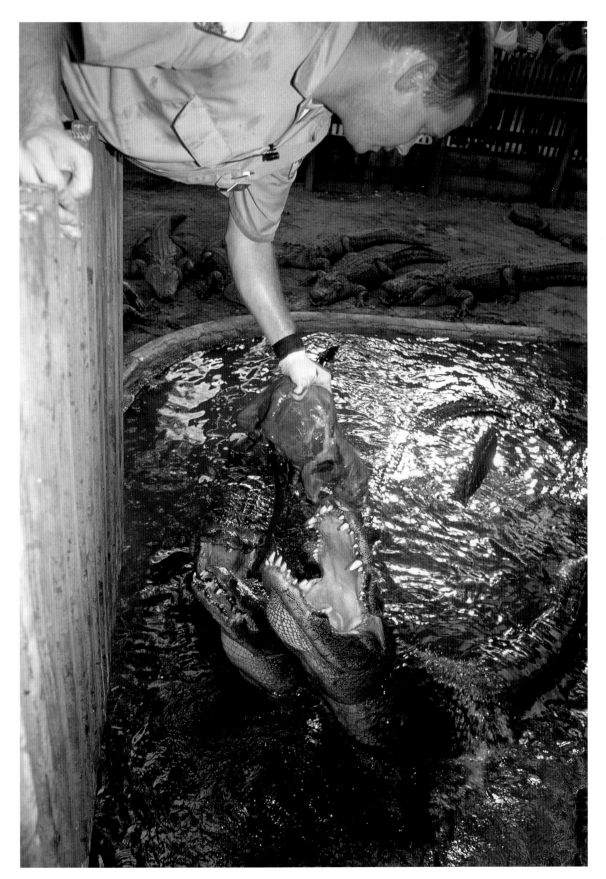

Shelly Triplett *(far left)* and Jim Darlington *(left)* feed alligators in the twice-a-day feeding show at St. Augustine Alligator Farm, Florida.

Captive gators get wider and flatter than their wild counterparts *(overleaf)*.

Atchafalaya Basin, a sound not unlike a low compression Lugger engine. You can feel the vibrations in the air, and Kent Vliet tells me that there is more to it than we can hear. Before the audible sounds, a low-frequency sound is issued that other alligators can hear. Kent said that by playing taped bellows back slowly, the human ear can pick it up.

Kent did his doctoral research at St. Augustine in a unique way that landed him a starring role in a National Geographic film on alligators. His dissertation was on courtship behavior, and he quickly realized that to see and study these subtle movements he needed to be in the water at eye level with his subjects. He spent forty hours in the breeding pond, swimming around with a dummy alligator in front of him. He noticed that when the females pressed the males down, testing their strength, the musk glands extended, giving an olfactory stimulant to go along with the physical stimulus. Bellowing, he told me, helps animals locate each other and clearly causes males and females to move together. He also explained the creatures' learning capacity, saying, "Alligators can learn in two to eight repetitions." At St. Augustine he was sure they could hear the noise of the truck bringing food. They are especially quick to learn when food is involved. In captivity they know their keeper and the feeding schedule. In the wild, when they find a good food source, they will adapt to it and utilize it to the fullest extent.

I asked John Brueggen what was unique about St. Augustine compared with other alligator attractions across the Southeast. John said the Alligator Farm is the oldest and the only zoological park to have all twenty-three species of the family Crocodylidae. David Drysdale, the owner, wanted to do something new and different for the farm's hundredth anniversary, so they changed the alligator wrestling area into the World of Crocodiles. In a short stroll you can see at close range of all the species and observe for yourself the broad snouts of the alligators and caimans and compare them to the slender, pointed snouts of the crocodiles. Most interesting to me were the green eyes and skinny, sharp-toothed nose of the false gharial—strange, weird, gnarly, yet beautiful.

Three times a day the staff gives a show about alligators, and twice daily they have a feeding where they toss large hunks of nutria and beaver to the hungry beasts. Reptile curator David Kledzek and I discussed the reluctance of one or two fathers per show to take their toddler children off their shoulders. The show won't start until this is done, for a child who falls from Dad's shoulders is just like a piece of nutria to the alligators. It is due to this and other precautions that St. Augustine has never had an accident. David said that parents are smart enough to teach their children not to touch a hot stove, but seem to lack the knowledge of the dangers of wildlife. Whether pushing the kids in front of a bison in Yellowstone for a photo, or balancing them on the fence for the alligator feeding show, adults can seem as oblivious as children to the threat that animals may pose.

We talked on about these dangers, and he mentioned how casually Africans thought about getting eaten by a crocodile while doing the wash down by the river, just as we think about another car-wreck death—just one of the hazards of life.

Beyond the feeding pen, the crocodile exhibits, the tropical birds, and the barnyard animals is a boardwalk that winds through their alligator swamp and rookery. Here sixty large alligators live under the nests of egrets, herons, ibis, spoonbills, and other colonial birds. It's a symbiotic relationship. The alligators benefit from the occasional fallen eggs or bird and sometimes will leap up to grab a bird right off a branch. The birds benefit by not having to worry about raccoons and other tree-climbing egg thieves, which could do considerably more damage than the big reptiles.

Over the past thirty years I have spent many days hidden in tree blinds at rookeries. There have always been alligators lurking below the nests. I always assumed an alligator happened into the area by chance and lucked into a fallen baby bird, and that with the patience of Job he was willing to wait around for a month or longer for another windfall.

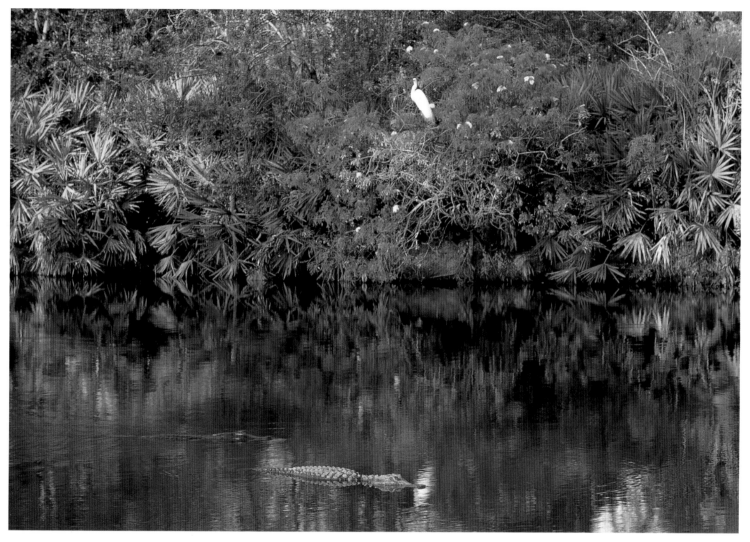

In talking to the folks at St. Augustine, Gatorland, Kliebert's, and Everglades Alligator Farm, however, I learned that as soon as they finished their swampy breeding ponds for alligators, the birds appeared. Like the mysterious message in the movie *Field of Dreams:* If you build it, they will come. It seems the birds are willing to sacrifice a few babies and eggs for good overall protection.

Colonial birds and alligators have a symbiotic relationship in the wild and at alligator attractions like Gatorland.

Before St. Augustine Alligator Farm had all twenty-three species of Crocodylidae, Gomex—a monster of a saltwater crocodile caught in New Guinea—was their main attraction. The big croc was brought to the United States by Arthur Jones, a wealthy man who had a private zoo, then eventually sold to St. Augustine. John said the crocodile was almost as well known as Shamu, the killer whale at Seaworld. When Gomex died in 1997, he was 17' 9½" long and weighed seventeen hundred pounds. St. Augustine now has a special room for him, where he is mounted and on display.

Upon leaving the zoo you can't miss a pair of albino alligators in separate small ponds that are covered to keep the sun off of their sunburn-susceptible pure white skin. They have pink eyes, marking them as true albinos. Gerald Savoie of Cut Off, Louisiana, found them in a wild nest near Myrtle Grove, Louisiana, in 1991. There were seven white ones along with numerous normal-colored siblings. Over the next eight years, collecting eggs for his farm, he had two nests that fairly consistently produced a few albino hatchlings. There are probably two females and at least one male with recessive genes that cause albinism.

101

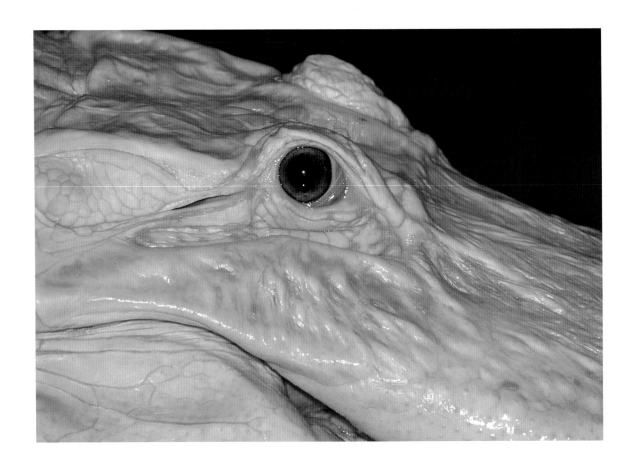

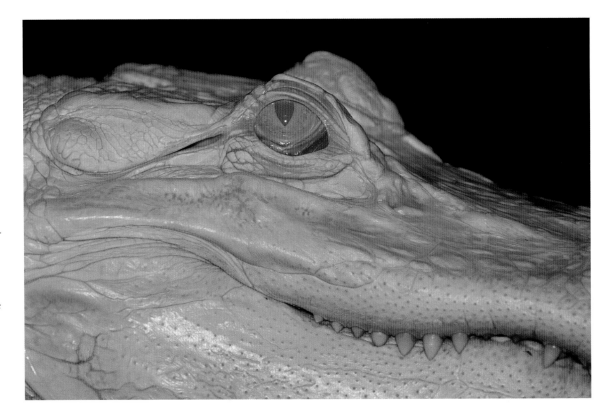

The two types of white alligators. True albinos have pink eyes *(bottom right)*, while leucistic alligators' eyes are blue *(top right)*. Both are rare and would be easy prey in the wild. The Audubon Institute in New Orleans has displayed leucistic alligators almost since they were found in 1987 *(far right)*.

Gerald told me there are twenty-three of his albino alligators alive now. He said another group was found elsewhere in the 1980s, and a few of those are alive in other zoos. In Gerald's area, drought moved saltwater into the females' nesting grounds, and he thinks they have moved, so it's unlikely he'll find anymore of these strange, luminous creatures.

Rarer yet are the leucistic (loo-SYS-tic) alligators owned by Burlington Resources, Inc. Fourteen exist out of eighteen hatchlings born near Houma, Louisiana, in 1987. They were found on a wild nest just after they hatched and, being all white, would have been easy prey for the great blue heron or other predators. Both albinos and leucistic alligators are identical to others of their species with the exception of their skin, which lacks melanin, a black pigment that gives alligators their trademark color. Albinos have pink eyes because the blood vessels are not hidden by the pigment of the pupil and retina. In leucistic alligators, some pigment is retained in the eyes, causing them to be blue. Frank Ellender, a wetlands specialist for Burlington Resources, took me on a tour of the alligator farm where nine of these white alligators are kept. The fourteen-year-old reptiles range from 9 to 10½ feet in length. He keeps them in growing houses that were once used on the LLE Alligator Farm. Here they are safe from the burning rays of the sun. When I entered one of the stalls, I noticed the gator that started off looking like white chocolate began to turn pinkish. Frank told me when they get excited the blood runs into vessels near the skin surface, causing the white to look pink.

While I was there, Remy Lazare, the keeper of the white alligators at the Audubon Zoo, drove up with two of the white reptiles the zoo had been holding. Burlington is getting out of the alligator business and is donating all the animals to the Audubon Institute, which has been exhibiting some of them since 1987. These rare, intriguing creatures are very valuable, drawing crowds wherever they are.

I saw another true albino in Miami at the Parrot Jungle, where I went to meet Joe Wasilewski and watch him do a snake show in this beautiful garden of tropical plants decorated with parrots of many colors. Joe, a tall, sandy redhead, is full of energy. He needs it, for he does four reptile shows a day at Parrot Jungle, then he goes out to Florida Power & Light's nuclear power plant to catch baby American crocodiles. After his fourth show, I photographed him with the albino alligator, then we headed out to his study site. At the lab he grabbed a sack of baby crocs he had caught previously, and we found Neil, his helper, ready with the airboat. Off into the maze of canals we went. Florida Power & Light needs lots of water to cool the nuclear reactors, so they designed a system of canals to cool and recirculate the water so it can be used again and again.

The power plant became operational in 1970. Six years later the first American crocodiles showed up, and two years after that, in 1978, they nested. Joe was hired in 1989 to monitor the population. Since the Endangered Species Act afforded them protection in the early seventies, a population of approximately 220 crocs has grown to 800. They are divided between three areas: the power plant, north Key Largo, and Florida Bay.

"Dean of Alligator Wrestlers" Tim Williams *(below)* has a million stories about wrestling alligators at Gatorland, Florida, where he is now head of media relations. The Jumparoo is one of Gatorland's featured shows *(right)*.

We zipped out to the nest where Joe had collected the previous night and released the measured, weighed, and microchip-tagged babies to grow and be caught again someday. When that happens, scanner guns similar to those in supermarkets will read the microchips. It was not long until we found a nest actively hatching, and I got to hold an egg as a young crocodile crawled out of its shell to see the dark of night for the first time. This only other crocodilian in North America is rare but increasing fast due to Joe's and others' efforts. Its range also includes Central America and a small portion of South America.

Gatorland, between Kissimmee and Orlando, is another place you can see the American crocodile, as well as three other species, but they specialize in alligators. Gatorland was officially opened fifty-two years ago by Owen Godwin Sr. At that time it featured alligators and snakes. For a small donation, tourists driving down Highway 441 could visit and see Seminole Indians (who lived on the property) wrestle alligators. Six years later, Owen changed the name to Gatorland, Alligator Capital of the World, and promoted the world's largest captive crocodile, Bone Crusher, as his grand attraction. The massive reptile measured fifteen feet long and weighed eleven hundred pounds.

Owen passed along the business to his son Frank, who ran Gatorland for years, and when Frank retired he turned over the reins to Mark McHugh, his son-in-law, who now keeps the place going—no small feat considering it gets about a half million visitors a year. Tim Williams, whose card reads "Dean of Gator Wrestlers," is also director of media production. He showed me around the exciting attraction. When I asked Tim what Gatorland and alligators mean to Florida tourism, he said, "People come to Florida to visit the beaches, visit Mickey Mouse, and see an alligator. So it's very important."

Boardwalks crisscross a large pond with two hundred alligators and a few American crocodiles. One section is the feeding area. The show is called Jumparoo. Four times a day the staff string chicken on a clothesline-like apparatus and jiggle it to entice some very large gators to jump.

Here I saw my first alligator wrestler since I was a kid traveling through Florida with my parents. Nate, a lanky dude, put on a great show. He told me his goal is to entertain the crowd and to sneak in a little knowledge about a creature he loves to work with. "I like to trick people into learning something," he said.

At Gatorland they call it Florida Cracker Alligator Wrestling, I guess to differentiate it from Seminole Indian Wrestling down in the Everglades. Most everybody I asked said alligator wrestling started with the Indians. In the time before refrigeration, a live alligator was a good food in the cupboard. So wrestling probably began with an Indian jumping on an alligator's back, subduing it, and then tying it up and putting it in the pen for a future meal. For today's tourists, it's just a show.

Nate starts his wrestling routine by entering a large pen, within which is an island surrounded by a moat. The island serves as the wrestling arena. Covered grandstands hold four hundred people—all with a good view. There are ten alligators seven to nine feet long in the moat. Nate chooses his opponent, jumps down into the water, and grabs it by the tail. As the big gator struggles to pull away, Nate perseveres and gets the animal up on the island, then leaps on its back. Carefully he slides his hands up to the jaw, then quickly grabs the mouth to hold it shut—all the time joking with the audience and telling a few alligator facts. Then he takes the snout in one hand and grabs some loose skin on the chin with the other and pulls the mouth open as he bends the whole head back toward himself. About this time he asks the crowd what the most dangerous part of an alligator is. Half yell, "The tail!" The other half yell, "The teeth!" Nate says, "Half of you are right. Now think about it; which part am I holding?" The crowd gets it real quick. Then Nate puts his chin over the snout and releases his opponent, basically holding the alligator's mouth open with his chin.

Some alligator wrestlers in the past, such as Ross Allen, who could be called the father of snake and alligator shows, would grab an alligator in a deeper pond by swimming after it, wrestle the creature underwater, then drag it onto land to do the rest of the show.

Tim explained that along with teaching the new wrestlers how to handle the alligators, he gives them a script: "Once they know it, we allow them to ad-lib, but they still make sure to drop the educational points in." I asked Tim about safety and injuries, and he said, "If you work with alligators long enough, you're going to get bit, probably not badly, but bit. Race car drivers have wrecks, painters get paint on themselves, carpenters smash their fingers, and alligator wrestlers get bit." Attacks on alligator wrestlers, trappers, farmers, and others who work with the animal are considered provoked and happen more often than unprovoked attacks.

Tim's first job was at St. Augustine Alligator Farm learning to work with snakes with the legendary Ross Allen. During that time Chris Lightburn, an old black man who had been the wrestler for years, had a car wreck going for lunch. Ross had to train Tim to take over the alligator wrestling. I asked Tim if he had ever been bitten, and he said, "Chris used to tell us all that an alligator has its time, and someday you're going to relax and the gator is going to bite you." It finally happened to Tim, and he was mildly embarrassed when a home video of the incident, taken by someone in the crowd, turned up on television.

Tim was doing a wrestling show at the time he was bitten: "I grabbed the gator and went to catch the mouth with my right hand and slid my hand up, but I wasn't paying attention to what I was doing. I just slid my hand inside his mouth, and he bit down all the way through my hand. He held on for several moments. I had him with my free hand so he wouldn't shake; I could feel him trying to turn me loose, so I let go with my free hand, and he spit out the one he had and grabbed the

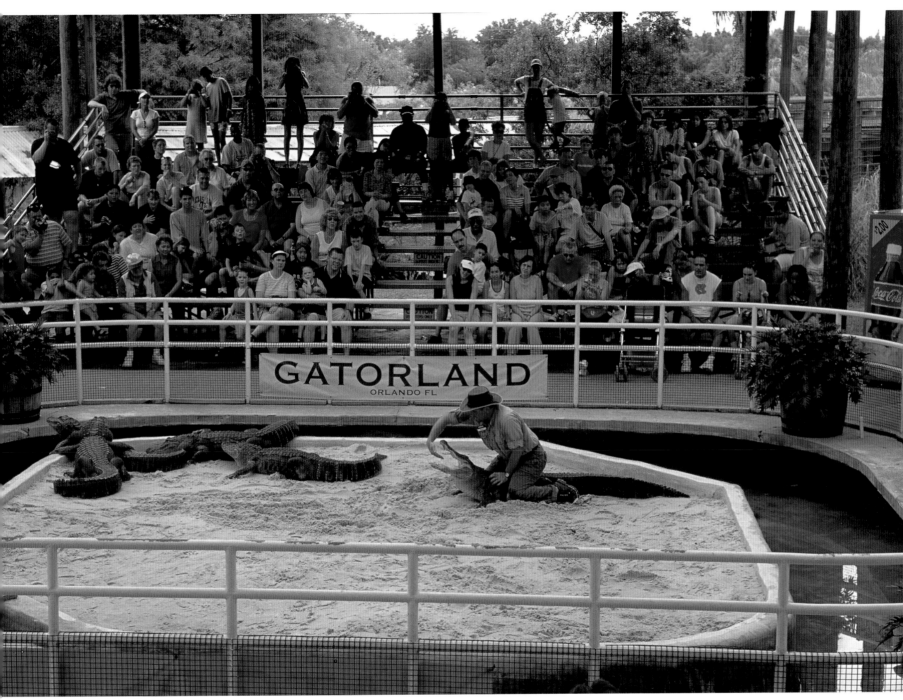

Bret Chism, alligator handler
at Gatorland, daringly puts his
hand in an alligator's mouth at
their 400-seat wrestling arena.

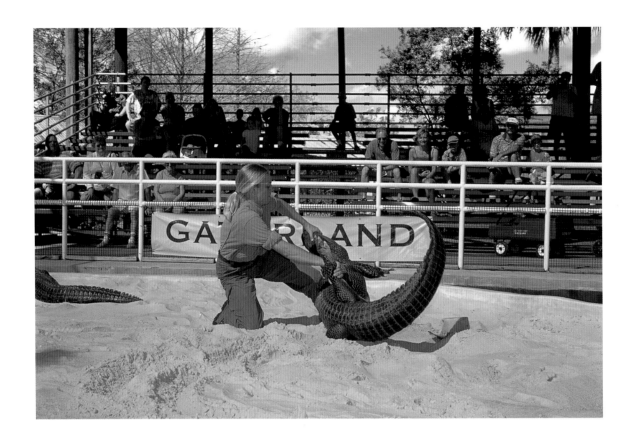

Babs Steorts, the only female wrestler the author came across, quickly spins an eight-foot alligator to put it to sleep in her show *(top right)*. Nate Sweeting hand feeds a whole chicken to an alligator at the Jumparoo show *(bottom right)*. The alligator-shaped building at Jungle Adventures in Florida is difficult to miss *(far right)*.

Pops and other large gators are the stars at Gatorland's breeding pond and bird rookery *(overleaf)*.

thumb on my left hand and bit it. But I finished the show. It was painful and we had some extra color. There was a guy in the audience with a video camera, and he shot the whole thing. He sent me a tape, but he also sent a copy to Real TV, and they showed it on national TV." Tim laughed as he added, "I can't be famous for doing something right."

When a tourist asks what an alligator bite feels like, he tells them, "If you put a bunch of nails all the way through a door, then slam it on your hand, that is what it feels like." Tim's analogy on the gator bellow is that it "sounds like an old Harley Davidson trying but just not quite starting."

"I know sixteen alligator wrestlers, and most have been bit," Tom Cattell told me after a sign that read "Alligator meat for sale. Outback Gator Ranch" enticed me to pull into his mother's gator farm and gift shop. He'll give you a thirty-minute tour for five dollars. Tom wrestled for three years at Holiday Park near Fort Lauderdale and has yet to be bitten. However, he told me he had almost pulled a "Kenny Cypress" the day before while feeding five-and-a-half-footers in the growing barns. He said, "I bent over to pick up a sack of feed when a gator lunged up at me with its mouth open and just missed to hit a board above my head." Kenny Cypress, Seminole Indian chief and famous alligator wrestler, got caught in a freak accident. He was one of the braver wrestlers and would put his head in an alligator's open mouth. Alligators have an instinctive trigger in their tongues; when anything touches their tongues, their mouths slam shut. Once during his act, a drop of sweat from Kenny's forehead hit the alligator's tongue, and he got locked in the gator's jaws. It took several helpers to free him; luckily, he suffered only minor injuries.

Alligator wrestlers remind me of Grand Canyon rowboat men. There are those who *have* flipped a boat in a rapid and those who *will*. So we can say that there are gator wrestlers who have been bitten and those who will be. The danger and the drama of the alligator's sharp teeth, powerful jaws, and prehistoric look are what excite and interest all of us, but Tim says Gatorland and all the other eco-tourism stops in alligator country are good for the gators and all wildlife. Even with all the showmanship, the tourist still comes away with a little knowledge. Over the years the Godwins and Gator-

land have also helped the University of Florida with scientific studies on alligator reproduction and other subjects.

Jungle Adventures is another alligator attraction that's worth the stop. Driving on Highway 50 from Orlando to the Kennedy Space Center, you can't miss it, especially if you have kids in the car; the alligator-shaped building is better than a billboard. First you enter the alligator mouth for a photograph, then you pass through the gift shop and onto a bridge that takes you out to an island of animals. The complete tour includes a reptile show, during which a staff member, for a fee, takes a picture of you holding a small alligator and puts it on a button for you. The button proceeds go

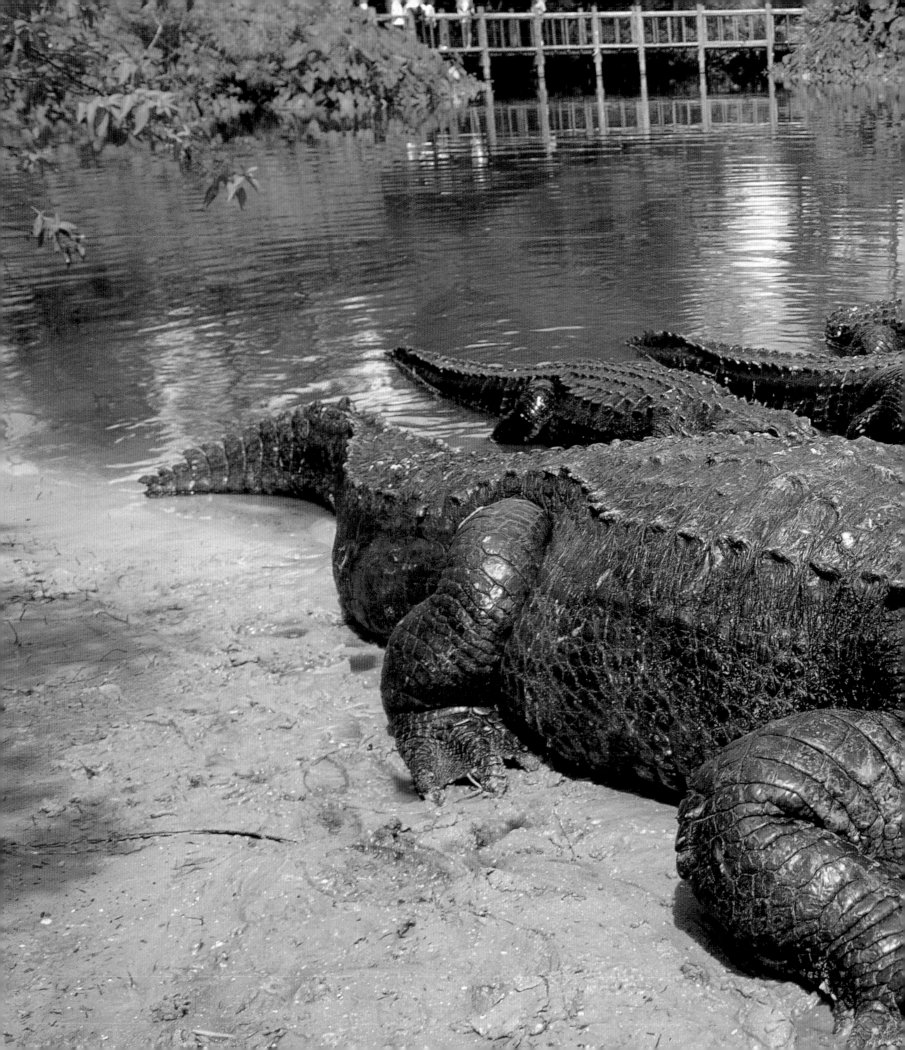

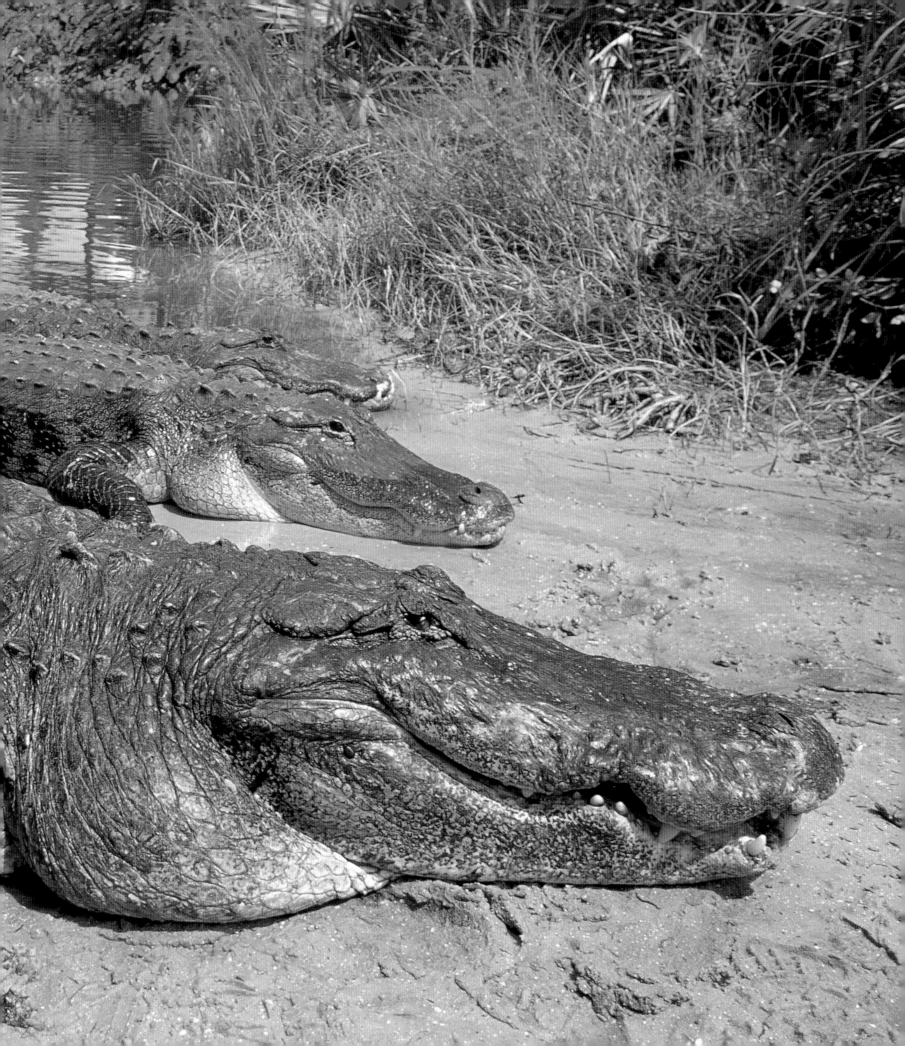

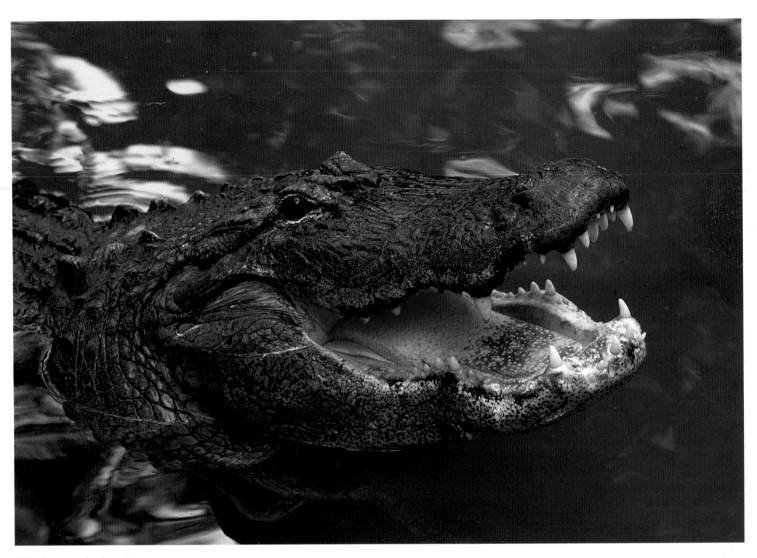

Whether you look at St. Augustine Alligator Farm *(above)* or beneath the mangroves in the Everglades National Park *(right)*, Florida's state reptile is as easy to see as an orange tree, a beach, or Mickey Mouse.

toward saving the Florida panther, two of which are on display. You learn about these rare mammals as well as about wolves, then you're taken through an Indian village. The tour ends with a boat ride around the island and a feeding show.

The alligators jump high out of a lake completely covered in duckweed, trying to reach the meat above their heads. The black behemoths cruising through the duckweed are an awesome sight—such a contrast. The jumps at all these feeding shows are mind-boggling: The strength and agility of the animals and the heights to which they leap always woo the crowd, some whose previous views of alligators were those lying lethargically in the sun.

The Everglades Alligator Farm in Homestead, another sure stop for alligator lovers, has more animals in its breeding pond than any other place I've encountered—twenty-two hundred big alligators. The ten-acre pond has a lot of vegetation and quiet places away from the tour trails to promote breeding. The staff collects the eggs; this is a working alligator farm.

Don, a new handler, was doing the shows the day I visited. A brave young man who had over two hundred reptile pets as a kid, he had been at the farm for three months. I asked where he had learned about alligators, and he said he had hunted them from an airboat with lottery sport-hunting permits. I asked if he snared or harpooned them, and he replied that he jumped off the boat and wrestled them. He thrilled the crowd at the feeding show when one of the alligators grabbed the five-gallon

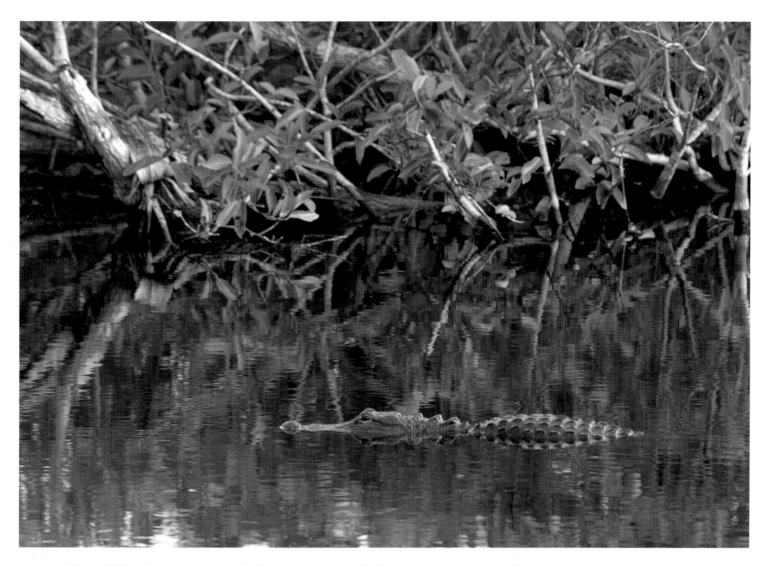

bucket full of chicken from him and a feeding frenzy erupted. About 50 of the 2,200 alligators were on the bank with Don, fighting for the bucket. I heard a kid tell his mother, "It looks like a wrestlemania."

The bucket of chicken is for the tourists. Once a week they really feed the alligators by driving a truck into the pen and dumping a thousand pounds of chicken.

If you want excitement in your quest to see Florida's favorite reptile, try an airboat tour. They are available virtually everywhere, with a higher concentration in the Everglades. Everglades Alligator Farm provides airboat tours, and there are at least nine along the Tamiami Trail (Highway 41). A flashy sign showing all sorts of reptile activities will have the kids in the back seat screaming to stop and ride the airboat, see the wrestling show, or eat some fried alligator. Along the road that skirts the northern boundary of Everglades National Park and passes through the Big Cypress National Preserve, you can stop just about anywhere and see a wild alligator swimming in the adjacent canal. Sometimes you have to look hard, for they are camouflaged. On the tour you are guaranteed to see alligators. I took two. The first was with Captain Todd Braden of Gator Ventures.

This airboat tour company has an office, gift shop, and small bar at the Black Hammock Marina on the southeast shore of Lake Jessup. I met Todd—forty-four, barefoot, and suntanned—drinking a beer at the screened-in bar. It was a hot July afternoon. Two fans cooled us somewhat as Todd

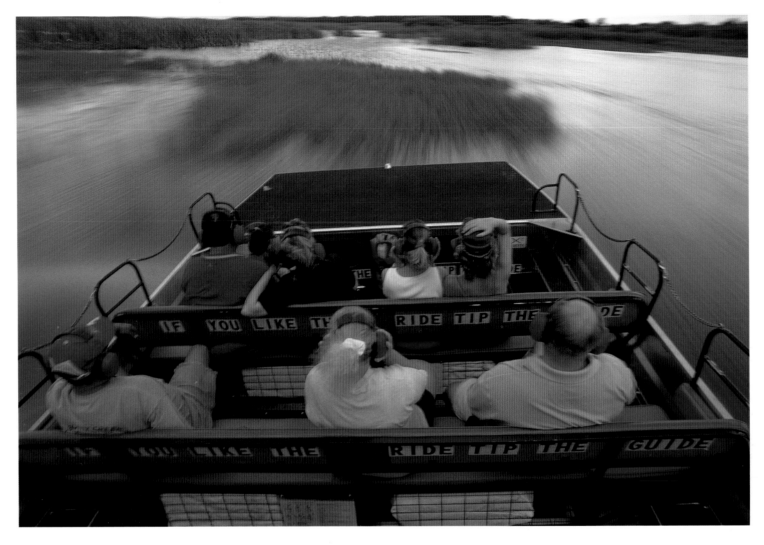

told me some of his history. He grew up on the lake, which used to have more alligators than any place in Florida. I asked him to tell me a passenger story, and he said, "About a month ago a five-year-old girl was sitting on the deck with her parents right behind her as we pulled up to a big gator, which slid down into a hole. So I told the folks, 'Oh well, we didn't get to see much of that one,' when all of a sudden, BOOM, the big alligator came lunging out of the water, mouth open, almost to the deck. Another couple of feet and he could have grabbed the little girl." Todd figures there was another alligator already in the hole, causing the mad dash out. The little girl never flinched, he reported.

Todd also serves as a guide for alligator and duck hunts. Sometimes he has to fetch the fallen ducks quickly as alligators and water moccasins will try to get to them first. He told me that when he was a small kid he would swim for the ducks his dad shot. He qualified this startling statement by saying there were not as many alligators then.

The next morning I rode with Todd twice as he took out family groups. His boat holds six passengers, so it's an intimate tour. He started along the south shore, where there is a beautiful grove of moss-covered baldcypress trees with hundreds of cypress knees pointing skyward. On both trips I saw an osprey fly by with a fish in its claws. Todd crossed the lake and entered a cattail marsh, where we flushed numerous birds, including the stately great blue heron. This four-foot-tall bird launched off its perch with neck extended, gaining flight speed, then cranked its neck in, folding it like the pipe

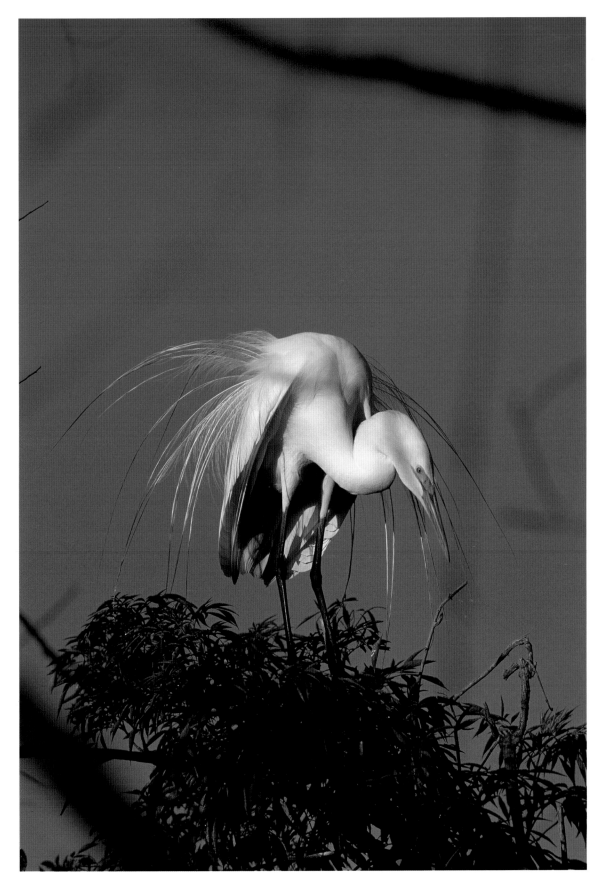

Boggy Creek and other
Florida airboat tours take
passengers on exciting rides
(far left) to see alligators
and other wildlife such as
great egrets *(left)*.

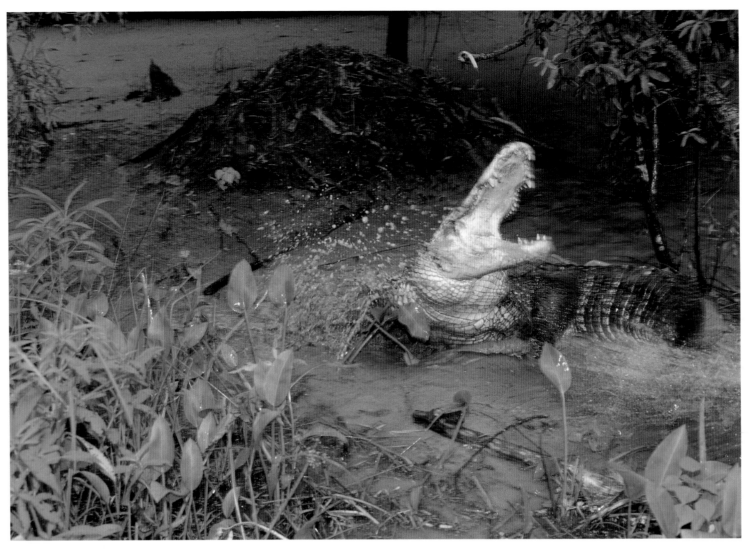

An angry mother alligator guards her nest *(above)*. Less dangerous are the "Gators on the Geaux"—seventy uniquely sculpted alligators in Lake Charles, Louisiana. This one is the Lumigator *(right)*.

under your sink. Over the course of both trips we saw about eighty baby alligators, fifty medium-sized animals, and five large ones. Todd told me his winter tour groups see many more large alligators; that's when they are out basking in the sun.

The trips' highlight was a protective female who had some of her previous year's hatchlings nearby. When we idled by, she charged, mouth agape and hissing loudly.

Boggy Creek Airboat Ride was my next adventure. I found the tour at a surprisingly rich spot on the south shore of Lake Tohopekaliga. (Many call it "Toho" for short because the Indian word meaning "sleeping tiger" is hard to pronounce.) I say surprisingly because they were only about ten miles south of the entertainment megalopolis of Orlando/Kissimmee/St. Cloud. The location makes Boggy Creek one of the biggest airboat tours, taking out almost 150,000 people a year.

Before the tour began, Captain Scott Williams and manager Joe Clements told me how some families come down for a tour with too much Disney World in their brains and have a hard time realizing they are seeing wild and real alligators.

When the next group arrived, I jumped into the mate's seat with Captain Scott, and we left the boat ramp to travel into a sea of aquatic vegetation. Birds were everywhere: osprey, egrets, herons, and the rare Everglades kite. This cool bird swooped down and picked up an apple snail in the vegetation, then landed atop a navigation marker and used its special curved beak to extract the snail.

Wow! I looked all over for these birds back in 1972 and never got to see one eat. Apple snails are this hawk's exclusive diet. We saw a few small alligators, then Scott headed down a canal where an aggressive female lay atop her nest. Two teenage girls from Ohio giggled and moved away from the bow of the boat as the mother hissed aggressively at us. Later, speeding through the marsh grass like we were in the middle of the Everglades, we saw a whitetail doe with two spotted fawns, a large buck, and a flock of wild turkeys feeding in the marsh. The turkeys flushed and flew back to the protective woods of the shoreline hammock.

After a short trip up a feeder creek lined with baldcypress trees, we returned to the dock. Rich in wildlife, it is a great tour. Scott asked me to come back in the fall and winter, when he sees up to twenty bald eagles a trip.

At the end of alligator season, Cameron Parish celebrates with a typical Louisiana festival on the banks of the Mermentau River. It was a beautiful early October day when I visited the Alligator Harvest Festival. Beauty queens promenaded around as a Cajun band struck up their accordions and washboards. The party began with the blessing of the fleet. With crabs boiling and alligator meat frying, everybody was having fun when they awarded Brandon Herbert a plaque for the biggest alligator caught in Cameron Parish the previous year. The skin was 12' 9" long from a twelve-foot gator.

Just north of the festival is the gateway city to southwest Louisiana, Lake Charles, where the local symphony had a very successful fundraiser with alligators. Not live alligators, but alligator art, in an event similar to the Cows on Parade exhibit in Chicago. The symphony board came up with the idea to ask for $1,250 from businesses or individuals to purchase one of seventy Gators on the Geaux. All of the gators were made from the same standing model and are just over five feet tall. Local artists finished each one in their own unique ways. The names of these sculptures intrigued me, such as Pearly Gate-R in front of the Methodist Church, Local Lendigator in front of a Savings and Loan, and Aquagator beside a local water park. Others were Spagator and Meatballs, Baked Allitator, Navigator, Litigator, and Irrigator. There was even a TailGator over by McNeese University. Go "art gator" hunting with a map from the Southwest Louisiana Convention and Visitors Bureau, and you'll have a good time without even getting your feet wet.

The bureau's offices are between I-10 and Lake Charles, where they have a brand new visitor's center with a large natural pond that contains four live alligators. Thirty miles away you can see three more large alligators in a pen at the Louisiana Oil and Gas Park in Jennings, Louisiana, where they

also have four alligator babies. If you're inclined to take the scenic route, drive on the Creole Nature Trail, which will take you right by Cameron Prairie and Sabine National Wildlife Refuges. At either of these you're almost guaranteed to see a wild alligator year round. On the Sabine Walking Trail on Highway 27 about twenty-three miles south of Sulphur, Louisiana, you can see very large alligators right next to the walkway. Stay on the trail or you might end up stepping on a floatant. You will share the trail with swamp cottontail rabbits and birds of many colors. Two of my favorites are the fulvous whistling duck and the flamingo-colored roseate spoonbill. A sharp-eyed ornithologist can see forty to sixty birds there on the mile and a half walk.

Back in Lake Charles, I saw the Art-A-Gator in

The University of Florida's mascot alligator, Albert *(above)*. Aerial view of a cornfield maze near Baton Rouge, Louisiana *(right)*.

front of Central School, where the Arts and Humanities Council leases space to the symphony. At one end of the main floor Gumbo Gator guards the entrance to a Mardi Gras costume museum. Convention and Visitors Bureau personnel wear this gator suit at various events. Michelle McInnis, one of the people who has worn it, told me kids like to beat on its head and pull the tail. I saw something similar happen to the Florida Gator mascot at the LSU/Florida football game in Tiger Stadium. The seven-foot-tall gator had been leading cheers and jumping wildly alongside the cheerleaders (each with a gator tattoo on her cheek) as Florida racked up six touchdowns. When a mom brought a two-year-old girl to the fence to see the mascot, two older kids ran up and started pounding the gator's big fake mouth. It's hard to be a friendly gator.

Just above Beaumont, Texas, is the Big Thicket, now a national preserve; it's always been wild with black bears and alligators. Before Texas was a state the area was called the alligator circuit, because itinerant Methodist preachers supplemented their meager incomes by killing alligators along the way and selling the hides in town.

Alligators turn up in movies like *Live and Let Die*, in which James Bond runs over the heads of crocs, or in *Romancing the Stone*, where we see the bad guy feeding his snappers. The *Indiana Jones and the Temple of Doom* alligator scene was filmed at Gatorland. *Tarzan's Secret Treasure* (1941) was filmed at what is now Wakulla Springs State Park, south of Tallahassee, Florida. It is one of the easiest places to see alligators in a beautiful natural habitat. In the movie Johnny Weissmuller or a

stunt double wrestles a creature that appears to be a crocodile. It must have been brought to the park. I guess the five hundred alligators that lived nearby weren't enough. On both the glass-bottom and wildlife boat tours, the guides will show where Tarzan scenes were filmed. The park was also the set for *Creature from the Black Lagoon.*

All along the Gulf Coast, and especially in Florida, you can see all the gator logos, toys, signs, and gadgets that you can think of. I have seen gator pens, clips, necklaces, puppets, masks, chains, ceramics, postcards, books, photographs, bumper stickers, skins, skulls, mailboxes, yard statues, ashtrays, teeth, backscratchers, and toys that squeak, swim, walk, bite, or are just cuddly like teddy bears. From the smallest gas station to the giant gift shop at Gatorland, there is no end to the things you can accumulate for an alligator collection. Driving south on I-75 above Gainesville, a billboard with a large alligator painted on it sucked me into a tourist information center/gas station/gift shop. The sign read "See 13-foot alligator." He was in there all right, dead, mounted, and surrounded by a hundred fifty small alligator skulls for sale. When I asked the clerk what most tourists say when they find out the gator's not alive, she said, "My

sign doesn't say anything about it being alive." Guess what else they have for sale there? Oranges.

I found another novelty on the outskirts of Baton Rouge, Louisiana, where in September and October, for a small fee, you can walk through an alligator maze carved out of an eight-acre corn patch, or fly over it and see the whole alligator, five hundred feet long with the words "Louisiana Yard Dog" included in the design. This is Donald and Vickie Courville's handiwork; their company, D and V Farms, grows corn for backyard squirrel food.

The list goes on and on. The reptile is everywhere. According to *Parade* magazine, Michael Jackson's Neverland Zoo Foundation near Santa Barbara, California, has permits to keep alligators, among other animals. A Tilapia farm in Colorado uses alligators to eat the fish waste and also does wrestling shows. Gerald Savoie has loaned one of his albino alligators to a reptile attraction in South

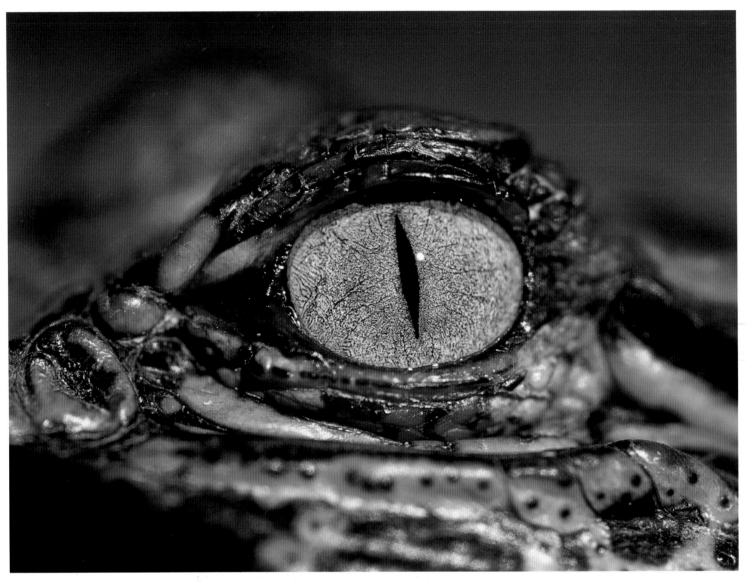

Dakota. Most every state has had at least a traveling reptile show that includes an alligator as its featured attraction.

I have seen alligators from eight inches to near fourteen feet in swamps, marshes, lakes, bayous, as well as backyards, zoos, and gift-shop shelves. They have intrigued as well as scared me as I've studied, written about, and photographed them. I am not bored.

After thousands of hours and photographs, I could still spend a day, a week, a summer watching alligators. To me water-based habitats are the perfect world, and the perfect creature for that habitat is the alligator. Long, muscular, with tough skin, deadly teeth, acute senses, webbed feet, a great voice, and a handsome form—at least to me—alligators can swim and wallow in the mud, observe all wetland wildlife both above and below the water, eat whatever they please, rest and relax whenever they choose, and be virtually unbothered by mosquitoes. They are the ultimate marsh machines. I am jealous.

Peekaboo. American alligators, whether large or small, are able to conceal themselves in their aquatic environment *(left)*. The intriguing eye of a young gator *(far left)*.

CROCODYLIDAE

Chinese alligator
Alligator sinensis

Common caiman
Caiman crocodilus

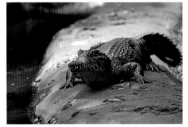

Broad-snouted caiman
Caiman latirostris

Cuvier's smooth-fronted caiman
Paleosuchus palpebrosus

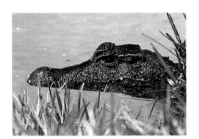

Schneider's smooth-fronted
caiman *Paleosuchus trigonatus*

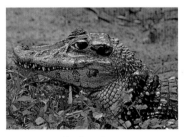

Black caiman
Melanosuchus niger

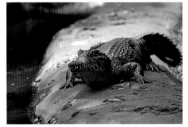

Yacaré
Caiman yacare

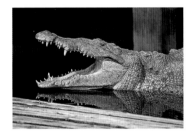

American crocodile
Crocodylus acutus

Morelet's crocodile
Crocodylus moreletii

Cuban crocodile
Crocodylus rhombifer

Orinoco crocodile
Crocodylus intermedius

A FAMILY ALBUM

Nile crocodile
Crocodylus niloticus

African slender-snouted crocodile
Crocodylus cataphractus

Indo-Pacific crocodile
Crocodylus porosus

Mugger
Crocodylus palustris

Johnstone's crocodile
Crocodylus johnsoni

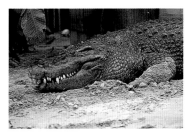

New Guinea crocodile
Crocodylus novaeguineae

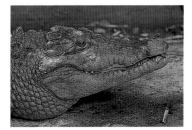

Philippine crocodile
Crocodylus mindorensis

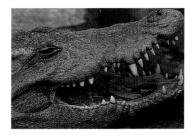

Siamese crocodile
Crocodylus siamensis

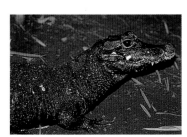

Dwarf crocodile
Osteolaemus tetraspis

False gharial
Tomistoma schlegelii

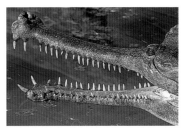

Gharial
Gavialis gangeticus

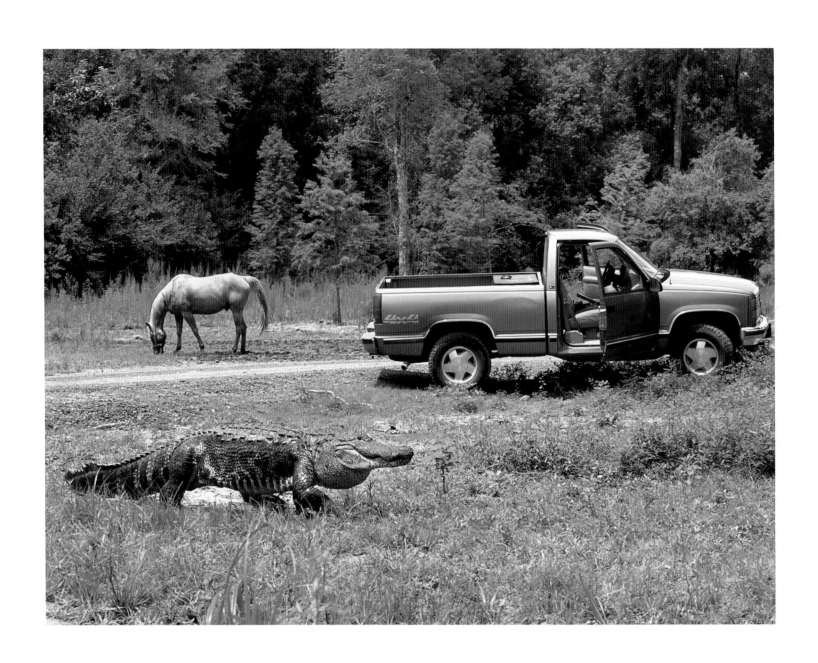

Appendix

ALLIGATOR ZOOS AND TOURIST ATTRACTIONS

The author visited and found these to be worthwhile stops for any traveler interested in alligators. There are of course many he did not visit. To find out more about the area you are visiting you can contact the state or local tourism office in that area.

ALLIGATOR ANNIE MILLER'S SWAMP AND
MARSH TOURS
100 Alligator Lane
Houma, LA 70360
985-879-3934
www.alligatorannie.com
alligatorannie@webtv.net
One of the first in the swamp tour business. Alligator Annie Miller and her son Jimmy specialize in showing passengers large alligators as well as other wildlife. Swamp and marsh habitat.

ALLIGATOR BAYOU TOURS
35019 Alligator Bayou Road
Prairieville, LA 70769
225-642-8297
www.alligatorbayou.com
Swamp tour in large boat. Large alligators in pen. Boat ramp and canoe rental. Gift shop, bar restaurant.

ANNIE MILLER'S SON'S SWAMP AND MARSH TOURS
3718 Southdown Mandalay Rd.
Houma, LA 70360
1-800-341-5441
www.annie-miller.com
anniemiller@cajun.net

THE ATCHAFALAYA EXPERIENCE
338 North Sterling Street
Lafayette, LA 70501
337-233-7816
http://members.aol.com/biosdchene/bois.htm
boisdchene@aol.com
Boat tours in Lake Martin and Atchafalaya Basin to see alligators, bird rookeries, and baldcypress swamps. Owner and guide Coerte Voorhes also speaks French.

AUDUBON ZOOLOGICAL GARDEN
6500 Magazine Street
New Orleans, LA 70118
504-581-4629
www.auduboninstitute.org
A major city zoo with animals in natural habitat enclosures. The Louisiana swamp exhibit houses alligators, black bears, raccoons, and more in a swamplike setting. Also have leucistic alligators. Alligator feeding shows during warmer months. Gift shop and restaurant.

BAYOU PIERRE GATOR PARK AND SHOW
380 Old Bayou Pierre Road
Natchitoches, LA 71457
1-877-354-7001
www.alligatorpark.net
Well-designed attraction built around hundreds of alligators. Small alligators to hold for photograph, as well as feeding show and interaction with domestic animals. Alligator snacks and a well-stocked gift shop. Open April 15 to October 31.

BOGGY CREEK AIRBOAT RIDE
2001 E. Southport Road
Kissimmee, FL 34746
AND
3702 Big Bass Road
Kissimmee, FL 34744
407-344-9550
www.southportpark.com
Airboat rides in two lakes near Orlando. Author rode on Lake Tohopekaliga, where you will see more alligators. Also campground, boat ramp, and fishing guides.

BREC's BATON ROUGE ZOO
3601 Thomas Road
Baton Rouge, LA 70704
225-775-3877
www.brzoo.org
My hometown zoo has six alligators on exhibit. Attractive zoo with plans for more native animal displays. Gift shop and snack bar.

CAJUN PRIDE SWAMP TOURS
P.O. Box 2181
LaPlace, LA 70069
1-800-467-0758
www.cajunprideswamptours.com
Swamp tours on large, covered pontoon boat or private tours by canoe. Many alligators are seen and fed on each tour. Gift shop and alligator snacks. Tour bus service from New Orleans.

DR. WAGNER'S HONEY ISLAND SWAMP TOURS, INC.
106 Holly Ridge Drive
Slidell, LA 70461
985-641-1769
Long-running swamp tour in the famous Honey Island Swamp. Paul Wagner has doctorate in ecology and gives very educational tours. Gift shop and snack bar. Tour bus service from New Orleans.

EVERGLADES ALLIGATOR FARM
40351 S.W. 192nd Avenue
Homestead, FL 33034
305-247-2628
gatorfarm@aol.com
The alligator attraction with the most alligators in their breeding pond. Feeding show, reptile show, alligator wrestling, and airboat tours. It is also a working alligator farm. Gift shop and snack bar. Near the entrance to Everglades National Park.

EVERGLADES OUTPOST
35601 S.W. 192nd Avenue
Homestead, FL 33034
305-247-8000
www.evergladesoutpost.org
evergladesrefuge@aol.com
Bob Freer runs a wildlife rehab center, where he takes care of injured and orphaned wildlife. Can become a member and take tours. Very interactive museum with antique alligator products and artifacts.

GATORLAND
14501 S. Orange Blossom Trail
Orlando, FL 32837
1-800-393-5297
www.gatorland.com
customerservice@gatorland.com
A large alligator attraction with a big feeding pond, where you can see the Jumparoo show. Breeding pond with natural heron rookery. Wrestling and other wildlife shows. Photographer on hand to take your picture with snakes, alligators, or even sitting on the back of an eight-foot alligator. Snack bar and large gift shop has alligator leather craftsmen inside.

GATORAMA
6180 U.S. Highway 27
Palmdale, FL 33944
863-675-0623
www.gatorama.com
Author just took a quick peek here. Breeding pond with large alligators. Numerous species of crocodiles. Gift shop and snack bar.

JUNGLE ADVENTURES
26205 East Highway (S.R.) 50
Christmas, FL 32709
407-568-2885
www.jungleadventures.com
info@jungleadventures.com
An alligator-shaped entrance to a building that houses gift shop and snack bar. Two-hour tour that includes a reptile show, other animals, or Indian village, boat trip, and alligator feeding show. Can get your picture holding an alligator on a key-chain button.

THE JUNGLE GARDENS OF AVERY ISLAND
P.O. Box 126
Avery Island, LA 70513
Drive-through tour that you could also walk. Many ponds that have wild alligators in them. Largest pond has one of the first egret rookeries on artificial platforms. Famous for its camilla and azalea gardens. Can visit Tabasco factory nearby. Gift shop.

KLIEBERT'S TURTLE AND ALLIGATOR TOURS
41083 West Yellow Water Road
Hammond, LA 70403
1-800-854-9164
A working alligator and turtle farm. You can see thousands of turtles in their breeding pens. Alligators of all sizes including some of the biggest you will see anywhere. Gift shop. Specializes in school groups.

PARROT JUNGLE
Miami, FL
www.parrotjungle.com
A must-see even though the alligators and crocodiles are few in number. The albino alligator, many species of parrots, and tropical landscape are impressive. Large gift shop, a restaurant. Reptile and parrot shows.

ST. AUGUSTINE ALLIGATOR FARM
Route A1A South
St. Augustine, FL 32084
904-824-3337
www.alligatorfarm.com
Very attractive alligator attraction; the only place in the world to see all twenty-three species of crocodilians. Alligator show, reptile show, and feeding shows. Large gift shop and snack bar. Boardwalk around breeding pond provides easy access for photographing bird rookery.

WAKULLA SPRINGS STATE PARK
550 Wakulla Park Drive
Wakulla Springs, FL 32327-0390
850-224-5950
www.dep.state.fl.us/parks/wakulla/wakulla.html
State park with lodge, hiking trails, and swimming in crystal clear spring water. Wildlife and glass-bottom boat rides, where you will see alligators and many other species of tame wildlife. Restaurant, hotel, and gift shop.

WILDLIFE GARDENS
5306 N. Bayou Black Drive
Gibson, LA 70356
985-575-3676
www.wildlifegardens.com
Bed and breakfast with four rustic cabins overlooking a small bayou where you can feed alligators up to five feet in length. Short system of trails through swamp where you can see alligators and other captive creatures.

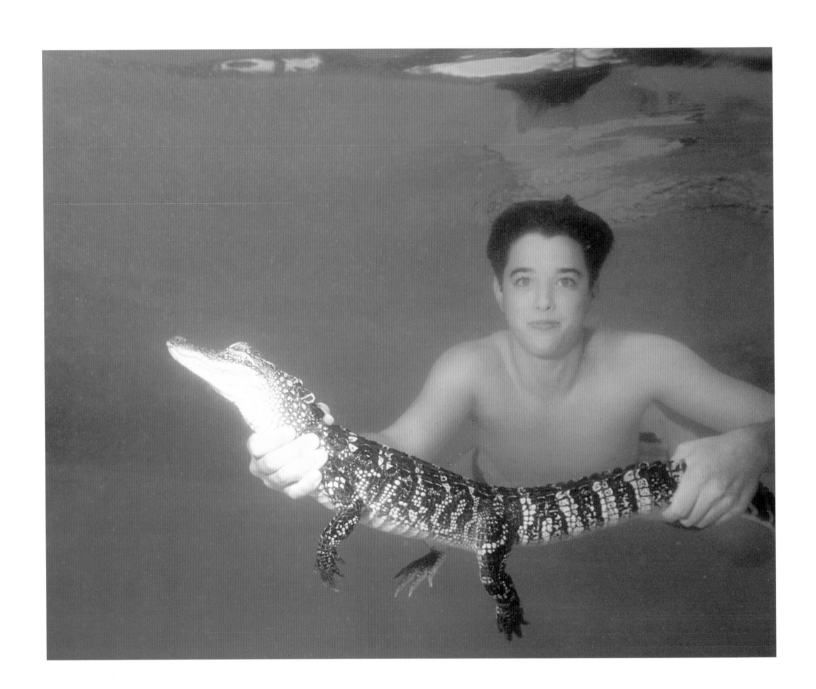

Bibliography

The author looked at many books, magazine articles, and web sites during the writing of this book. The quantity and quality of information were outstanding. Listed below are some of the sources he found most helpful; there are, of course, many more. The author also read and drew information from a number of scientific papers authored by researchers such as Chris Brocha, Ruth Elsey, Ted Joanen, F. Wayne King, Noel Kinler, Val Lance, Greg Linscombe, Larry McNease, Ken Roberts, Dave Taylor, Kent Vliet, and Allan Woodward, among others.

BOOKS

Alderton, David. *Crocodiles and Alligators of the World*. London: Blandford Publishing, 1991.

Barrett, Norman. *Crocodiles and Alligators*. New York: Franklin Watts, Inc., 1989.

Behler, John and Deborah. *Alligators and Crocodiles*. Stillwater, Minn.: Voyageur Press, 1998.

Bothwell, Dick. *The Great Outdoors Book of Alligators*. St. Petersburg, Fla.: Great Outdoors Publishing Company, 1962.

DeCaro, Frank. *Louisiana Sojourns*. Baton Rouge: Louisiana State University Press, 1998.

Dundee, Harold A., and Douglas A. Rossman. *The Amphibians and Reptiles of Louisiana*. Baton Rouge: Louisiana State University Press, 1989.

Glasgow, Vaughn. *A Social History of the American Alligator*. New York: St. Martin's Press, 1991.

Graham, Alistair. *Eyelids of Morning*. San Francisco: Chronicle Books, 1990.

McCarthy Kevin. *Alligator Tales*. Florida: Pineapple Press, Inc., 1998.

McIlhenny E. A. *The Alligator's Life History*. California: Ten Speed Press, 1987.

Penny, Malcolm. *Alligators and Crocodiles*. New York: Crescent Books, 1991.

Ross, Charles, ed. *Crocodiles and Alligators*. New York: Weldon Owen Productions, 1989.

Rue, Leonard Lee III. *Alligators and Crocodiles*. New York: Todtri Productions Unlimited, 1994.

Taylor, Barbara. *Crocodiles*. New York: Lorenz Books, Anness Publishing, Inc., 2000

WEB PAGES

C. C. Lockwood's Gator Page
http://www.cclockwood.com/gatorcam/index.htm

Croc Links
http://nersp.nerdc.ufl.edu/%7Ebiolab/crocpage.html

Natural History and Conservation
http://www.crocodilian.com

Florida Museum of Natural History, Herpetology Page
http://www.flmnh.ufl.edu/natsci/herpetology/herpetology.htm

Louisiana Fur and Alligator Advisory Council
http://www.alligatorfur.com

The American Alligator
http://www.ifas.ufl.edu/AgriGator/gators

Notes on Photographs

All photographs were taken with a Nikon F-5 and ten different Nikkor lenses ranging from 16mm to 500mm. Film was mostly Fuji Velvia and Fuji Provia, although a few of the older images were shot on Kodachrome 64. New to this project was Nikon's Nikkor AF VR 80-400mm ED zoom lens. The VR stands for vibration reduction; this lens works quite well when time or place does not give you a chance to set up a tripod.

 More information on the photographs and a site to order prints from this book can be found at www.cclockwood.com.